Inclusive Arts Practice and Research

Inclusive Arts Practice and Research interrogates an exciting and newly emergent field: the creative collaborations between learning-disabled and non-learning-disabled artists that are increasingly taking place in performance and the visual arts.

Alice Fox and Hannah Macpherson interview artists, curators and key practitioners in the UK and USA. The authors introduce and articulate this new practice, and situate it in relation to associated approaches. Fox and Macpherson candidly describe the tensions and difficulties involved, and explore how the work sits within contemporary art and critical theory.

This publication inhabits the philosophy of Inclusive Arts Practice, with Jo Offer, Alice Fox and Kelvin Burke making up the design team behind the striking look of the book, which contains over 250 full-colour images, plus essays and illustrated statements. *Inclusive Arts Practice and Research* is a landmark publication in an emerging field of creative practice across all the arts. It presents a radical call for collaboration on equal terms, and will be an invaluable resource for anyone studying, researching or working within this dynamic new territory.

'*Inclusive Arts Practice and Research* uses text, photos and graphics to chart the challenges, processes and rewards of ethical collaborative practice of people with and without learning differences. We find out about ways of working together that are respectful, fun and fruitful, and illuminate the richness of shared life. This book is an important new entry in the emerging field of work with and by people with intellectual differences and their allies.'

Professor Petra Kuppers, Professor of English, Art and Design, Theatre and Women's Studies, University of Michigan

'This is an illuminating and humane book, grounded in rigorous research and providing a significant contribution to the discourses of inclusive arts practice. Carefully structured and highly accessible in its design and textual presentation, it presents a series of chapters that engage seriously and intelligently with themes that run through the complex field of Inclusive Arts. Chapters cover issues of terminology, audience encounters, guiding examples of "how to practice", and deal with the thorny questions of "quality" and "labels" in relation to Inclusive Arts. A major strength is the way the authors weave together a rich collection of vivid illustrations and imagery, with conversations with learning-disabled artists, artistic directors and curators, sensitively presented to underpin the core argument that the work of learning-disabled artists should be taken seriously.'

Professor Sarah Whatley, Professor of Dance and Director of the Centre for Dance Research (C-DaRE), Coventry School of Art and Design, Coventry University

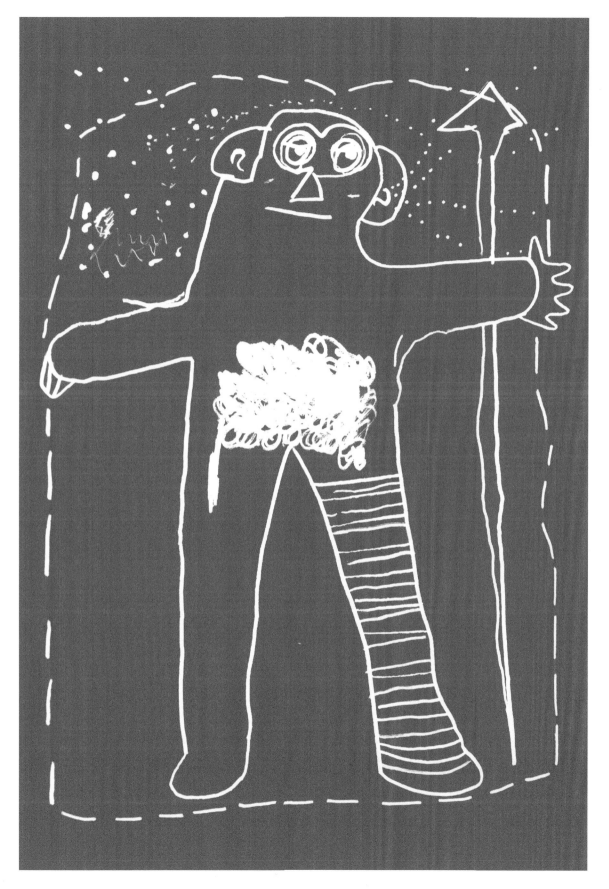

Inclusive Arts Practice and Research

A Critical Manifesto

Alice Fox and Hannah Macpherson

Routledge
Taylor & Francis Group

LONDON AND NEW YORK

First published 2015 by Routledge
2 Park Square, Milton Park, Abingdon, Oxon OX14 4RN
and by Routledge
711 Third Avenue, New York, NY 10017

Routledge is an imprint of the Taylor & Francis Group, an informa business
© 2015 Alice Fox and Hannah Macpherson

British Library Cataloguing-in-Publication Data
A catalogue record for this book is available from the British Library
Library of Congress Cataloging-in-Publication Data
Fox, Alice.
Inclusive arts practice and research : a critical manifesto / Alice Fox and Hannah Macpherson.

Library of Congress Cataloging-in-Publication Data
Includes bibliographical references.
1. Artists with mental disabilities. 2. Arts--Therapeutic use. 3. Group work in art. 4. Artistic collaboration. I. Macpherson, Hannah. II. Title.
NX164.M45F69 2015
700.87--dc23
2014043689

ISBN: 978-1-138-84099-7 (hbk)
ISBN: 978-1-138-84100-0 (pbk)
ISBN: 978-1-315-73255-8 (ebk)

Typeset in Avenir by Jo Offer and Petergates.co.uk

Contents

Foreword
by Anna Cutler, Tate Modern

New technologies, expanded connectivity, global networks and instant access to information are having an enormous influence on social and cultural attitudes and behaviours around the world. Such new global geographies present us with growing opportunities to challenge mainstream forms of production, participation, ownership and construction of meaning; pushing at the boundaries of what we understand arts practice to be now, and what we imagine it might become in the future.

This is a potentially exciting opportunity that invites us to rethink the contribution of those who have been excluded from the 'art' conversation (some more so than others). Enter *Inclusive Arts Practice and Research*, which arrives as a welcome intervention in working out what all this change means and helps us un-learn and un-know what we thought was familiar terrain. In their own words, Alice Fox and Hannah Macpherson explain that Inclusive Arts '… is used here to describe creative collaborations between learning-disabled and non-learning-disabled artists'. This definition expresses a particular form of artistic production and participation; it questions ownership and the construction of meaning and sets these centre-stage as the very articulation of the Inclusive Arts agenda. The edge just moved centre.

This book makes two key contributions to contemporary arts practice. First, it sets out what one might expect to encounter today in the (under-represented) field of Inclusive Arts. This includes philosophical and ethical issues, practical needs in real situations, how to approach research through practice, as well as drawing out ideological and political frames inherent in such work. In doing so, it shares a wide range of experiences and knowledge from across the sector and from representatives within the sector who have had limited exposure to date. Second, it invites a wider debate beyond its specialist focus by offering ways of thinking that challenge hierarchies of knowledge and constructs of normativity. For the authors, these also resonate with certain feminist approaches and practices that invite us to think differently and from a perspective of difference in and about art and who it 'belongs' to.

Inclusive Arts Practice and Research offers clarity and examples in practice, and provides personal stories by participants who articulate and represent their own sense of value in their artistic experiences. The book makes visible the tensions and complexities involved in doing this work, the taboos and difficulties, but it also expresses the possibility of things being different through the practice itself; what Alice Fox and Hannah Macpherson describe as 'creative exchange', the inspiration that sits at the heart of their work. *Inclusive Arts Practice and Research* is an open and generous call for co-constructed hope based on the potential for creative exchange. When do we get started?

Anna Cutler, Director of Learning, Tate Modern, London

Foreword

by Kelvin Burke, Rocket Artist

Photos
Art
writing
Photos
writing
Photos
writing
Photos
Photos

Kelvin Burke, Rocket Artists

Author biographies

 Alice Fox is a Principal Lecturer and Associate Head in the College of Arts and Humanities, University of Brighton, researching Inclusive Arts Practice and education. Alice is also Course Leader and founder of the pioneering MA Inclusive Arts Practice, and Artistic Director of the Arts Council England-funded learning-disabled Rocket Artists. This group has been awarded significant funds from Arts Council England to deliver their programme of high-quality exhibitions and performances. During 2013, the Rockets worked in partnership with the Southbank Centre to deliver the Side by Side project – an international exhibition and symposium of Inclusive Arts that this book builds upon. In 2008, Alice collaboratively directed and performed Smudged, an inclusive performance with the Rocket Artists at Tate Modern, and in 2010 performed and exhibited Measures of Bodies at the Brussels Medical Museum. Alice has published in The New Museum Community, *10 Must Reads: Inclusion*, and co-authored *Community–University Partnerships, Access to Art: From Day Centre to Tate Modern*, and *Art in the Woods: An Exploration of a Community–University Environmental Arts Project* published by NIACE (National Institute of Adult Continuing Education).

 Dr Hannah Macpherson is a Senior Lecturer in Human Geography at the University of Brighton. Her interests include feminist, post-structural and new-materialist theories with a research focus on the physical and imaginative spaces of disability, landscape and arts practice. She enjoys creative, collaborative research and writing projects that intend to make a positive difference in the world. Her work has appeared in a range of peer-reviewed academic journals including *Environment and Planning*, *Cultural Geographies* and *The Senses & Society*, and she has published numerous book chapters. She coordinates the disability ethics and aesthetics research group at the University of Brighton, and has just completed an Arts & Humanities Research Council-funded research project on visual arts practice for resilience.

Design team biographies

Jo Offer is a Senior Lecturer in the School of Art, Design and Media, University of Brighton, and teaches on the MA Inclusive Arts Practice. She coordinated the Rocket Artists group for the Side by Side exhibition, symposium and publication. She facilitates collaborative workshops between Rocket Artists and MA Inclusive Arts Practice students, and has been developing ground-breaking explorations into Inclusive Art and Design processes with undergraduate art students and the Rocket Artists. As a practising designer, she has frequently collaborated with Kelvin Burke since 2011, researching new, inclusive possibilities for design and art practice.

Kelvin Burke has been a member of the Arts Council England-funded learning-disabled Rocket Artists since 2008, and was a member of the steering committee, curation team and performance group for the Side by Side exhibition at London's Southbank Centre. As a visual artist, he has exhibited at the Spirit Level gallery, Southbank Centre, London; Outside In: The Art of Inclusion, Crawford Galley, Cork; Measures of Bodies, Brussels; Creative Mix, Outsider Art Gallery and Kunstwerkplaats studios, Amsterdam; and the Tight Modern and the Creative Minds Conference, Brighton. Since 2011 he has frequently collaborated with Jo Offer on art and design projects, including this book, and has co-developed and co-delivered MA and undergraduate projects at the University of Brighton.

Kelvin on being a Rocket Artist: 'Art pictures, frames, jars, boxes. Jane, Jo, my dance partner Alice – on train, drawings, meetings, London, Holland'

Kelvin on being in the University: 'Perfect. Do more pictures and words with art partner Jo, Rockets, students'

Acknowledgements

In many ways this book is about love (and its absence) and is a product of love. Love in all its complex and various forms. This book couldn't have been produced without the web of relations and attunements that have held us together, held our children and held our heads when we'd had enough. So our thanks go to the family, friends and colleagues that have been there for us, especially Jane Fox and Rik Appleby; to the Rockets for their inspirational creativity; to Kelvin Burke and Jo Offer for their fantastic design input and unrelenting support; to Alice's sons Felix and Jago for their brave, enquiring and generous approach to the world; to the ladies at Sunshine Day Nursery for their loving care of baby Niamh; and to the editorial team at Routledge for their enthusiasm and patience. Of course this project also required time and money – something that has been kindly given to us by Arts Council England and the University of Brighton.

The process of the book coming into being was an inclusive project that integrated the insights and images of learning-disabled artists, their non-disabled collaborators and academics.

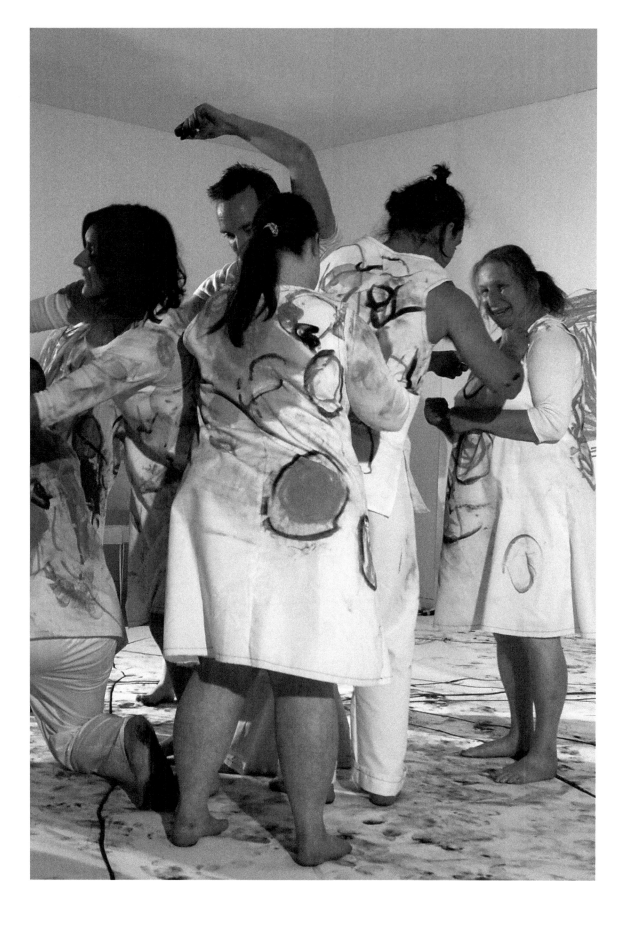

Situating
Inclusive Arts
aesthetics, politics,
encounters

Situating Inclusive Arts

Introduction

In this chapter we discuss the field of Inclusive Arts and situate it in relationship to associated approaches – including explaining how this work relates to, yet is distinct from, Outsider Art, Socially Engaged Practice, Disability Art, Art Therapy and other associated forms of Contemporary Art. We also reflect on the socially transformative potential of this work for collaborators and audiences. The ideas in this book have been developed from conversations with key practitioners, artists and commissioners in the field of Inclusive Arts, and from Alice's twelve years of experience working alongside the learning-disabled Rocket Artists.

What is Inclusive Arts?

Inclusive Arts is used here to describe creative collaborations between learning-disabled and non-learning-disabled artists. Inclusive Arts seeks to support the development of competence, knowledge and skills, such that collaborations can result in high-quality artwork or creative experiences. The collaborative processes of Inclusive Arts thus intend to support a mutually beneficial two-way creative exchange that enables all the artists involved to learn (and unlearn) from each other. In essence, it is an 'aesthetic of exchange' that places the non-disabled artist in the more radical role of collaborator and proposes a shift away from the traditional notion of 'worthy helper'. Through redefining this role, and shedding the notion of the formally trained 'expert' artist, we try to explore the valuable and skilful contribution that learning-disabled artists can bring to the arts. Of course, collaborative forms of Inclusive Art are just one of a number of ways in which learning-disabled artists practice, but we think when collaboration happens between learning-disabled artists and their non-disabled collaborators it should be recognized and celebrated, not downplayed.

Inclusive Arts is an important field of creative practice because it can help realize the creative potential of people with learning disabilities and facilitate modes of communication and self-advocacy. The processes involved in producing Inclusive Art may promote new visions of how society might be. This does not mean that Inclusive Arts pursues a singular aesthetic effect or social goal. As the conversations and illustrations of practice begin to emerge in this book, Inclusive Art productions (just like other forms of Contemporary Art) can be beautiful, life-affirming, funny, disorientating, upsetting, ironic, sexual, pleasurable, disturbing, distancing, loving, legible, illegible, or all of the above.

Not all Inclusive Art is considered good art or good socio-political practice. Rather, Inclusive Artwork must negotiate a difficult set of relations with disablism, stereotype, cliché, essentialism, exclusion and voyeurism. As in all artistic experimentation, there can be failures. However, this book illustrates some key successes and reflects on the ingredients that have helped the Rocket Artists get their work to the Tate and the Southbank, and reveals how other collaborative partnerships produce the high-quality, high-profile work that is illustrated here. Of course, the paradox we inhabit is that the term Inclusive Arts presupposes exclusion. In a bet-

ter world, Inclusive Arts would be such an everyday form of practice that it would not need to be given this name; rather, it would be considered an art form that engages with the productivity of difference and the challenges of communication (in its most expanded sense).

▶ Chris Pavia,
 Lucy Bennett
 Stopgap Dance
 Company
 UK
 Trespass
 2011/2012

Why use the term 'Inclusive Arts'?

We agonized over whether to use the term Inclusive Arts in this book. There are problems with the term and its association with certain oppressive or tokenistic inclusion agendas. In fact, social inclusion policies and an associated politics of diversity have had both negative and positive consequences for those people regarded as 'needing including'. For example, Ahmed (2012) identifies how discursive commitments to inclusion and diversity in certain institutional contexts are

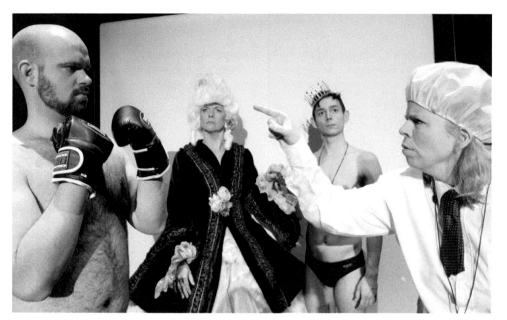

▲ Glad Theatre
　Glad Foundation
　Denmark

The Shadows
2012

Glad Theatre challenges
actors and audiences by
creating raw and courageous
productions.

'non-performatives' which do not bring about what they name. And in the United
Kingdom, instrumental arts and social inclusion projects have come under heavy
criticism from a range of quarters for being neither good art, nor good social work
(Belfiore 2002; Bishop 2006).

In contrast to these rather bleak accounts of arts and inclusion agendas that
have circulated in Britain in recent years, illustrated here are examples of highly
successful, genuinely collaborative projects that use the 'aesthetics of exchange'
to explore the world views of collaborators, foster genuinely meaningful dialogue,
show what inclusion can look like 'in the doing', and question the nature of social
reality. We think such projects are a success because they are underpinned by
highly skilled and attuned facilitators who have a long-term commitment to this
field (discussed in more detail in Chapter Three). We considered other terms to
describe this practice, such as 'interaction', 'the aesthetics of encounter', or 'side-
by-side collaboration'. However, we chose to continue to use the term Inclusive
Arts because it is simple and many existing groups that practice collaboratively
identify with it.

Of course, we recognize that in the practice of Inclusive Arts there will always
be moments of separation, integration, inequality, inclusion and exclusion – these
occur through the space, with other people and with the materials that are be-
ing used. There is no perfectly inclusive project – if it was that easy we wouldn't
have had to write a whole book about it. Therefore, in this book, Inclusive Arts
describes something of the operating principles, practices and ideals that people
who work successfully alongside people with learning disabilities share: the prac-
tices and their effects are what matter, where one aim is to minimize exclusion and
find a plane of equality (Ranciere 2009) through the practice of art.

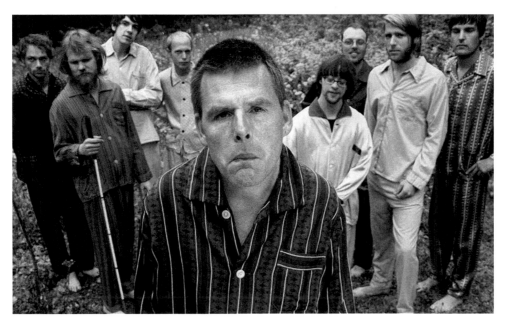

▲ Station 17, Germany

▶ Evelyn Morrissey KCAT Ireland
Emma Textiles 180 x 68 x 12cm
2012
With shipping care note

▼ Bethan Kendrick with
Emma, Side by Side
performance, Southbank
Centre, London, 2013

PLease
be careFUL with
Emma
She IS VERY sensitive
by The way ! ~~I Be~~ want to
be payed

Thank you
EveLyn

(She doent Like
to be PULLED
and cail her Emma
OR She WILL be UPSet
and She LoVes Peanet
butter on crackers)

5

What sorts of inclusions occur through Inclusive Arts Practice?

For the learning-disabled Rockets Artists and their collaborators, the sorts of inclusions that are operating in the studio or other art space are two-way – at times the Rockets are generously including other artists into their own creative worlds, at other points the Rockets and the art students are sharing their knowledge of particular practices and techniques. Such collaboration doesn't necessarily mean 50:50; rather, it can mean each person bringing complementary skills to a project. This can include choreography, company management and curation.

Interestingly, what we have also witnessed through the Rockets, and through our experiences of other Inclusive Art groups, is that the inclusions that occur in the practice of art making are not limited to the relationships between people. Rather, they also encompass the relationships held with the art materials, processes, technologies and spaces that are being used – certain materials, technologies and studio spaces can literally be more accommodating and thus more inclusive than others. In this way, there is a materiality to the interactions and forms of 'inclusion' (broadly conceived) that are occurring. In Chapter Three we explore this point in more depth and reflect on how certain materials and practices aid the process of Inclusive Art making.

Learning disabilities, intellectual disabilities, learning-disabled or learning difficulty? Some notes on terminology

In this book the terms 'people with learning disabilities' and 'learning-disabled artists' are used. The term 'people with learning disabilities' reflects current policy discourse in the United Kingdom, and is the term most often used to describe people who have a cognitive condition that significantly affects the way they learn new things. Using 'people with' helps to emphasize that this diverse group are people first and foremost. These learning disabilities are often defined on a spectrum, from mild to moderate or severe. Some people with so-called mild learning disability can talk easily and look after themselves. However, people with profound and multiple learning disability may find it extremely challenging to communicate or may have more than one disability. In England, the Department of Health estimated that 65,000 children and 145,000 English adults had severe or profound learning disabilities, and 1.2 million had mild or moderate learning disabilities (Department of Health 2009).

The term 'learning-disabled artists' is used in this text to indicate that people with learning disabilities are disabled by society, including the structures and institutions of learning that exist in society. This reflects the insights of the social model of disability (although for a fuller discussion see Goodey 2011). What is most important to note is that learning disability is a socially constructed, histori-

cally contingent and contested category of being human. Language is dynamic, and even new terminology for disability that aims to dignify difference tends to be quickly appropriated and used negatively due to fear of difference (Sinason 2010). In the United States, the term 'intellectual disability' tends to be used, the term learning disability referring only to those people with relatively mild learning difficulties such as dyslexia. While in the United Kingdom, despite alternatives such as 'intellectual disabilities' or 'learning difficulties' being proffered by advocacy movements and used elsewhere in English-speaking countries, 'learning disability' continues to be the predominant term in policy, medical and psychological discourse (Emerson and Hatton 2008).

Thus our decision to use the term 'people with learning disabilities' in this book is pragmatic – it is widely recognized by those who work in the field in the United Kingdom, and we hope that using the term helps to ensure ongoing interdisciplinary conversations and attracts professionals in the field who can then see the fantastic collaborative work that is shown here. It replaces problematic historical terminology such as 'mental retardation', 'fools', 'mental handicap' and 'idiocy'. Although we understand that some people will also reject the term learning disability and its difficult roots in individualizing medical and psychological discourse, using any term is difficult because it risks setting up a binary of 'us' and 'them' which we hope to, at least partially, overcome through arts practice.

What contribution does Inclusive Art make to Contemporary Art?

Inclusive Art is participating in the continuing redefinition of what art is or can be. It is redefining what art making is, and where quality artistic output can come from. Inclusive Art can be understood to be related to a range of collaborative and socially engaged practices. These include community arts, relational aesthetics, dialogic art, littoral art, experimental communities, participatory, interventionist or research-based art. Such practices stem in part from the work of Allan Kaprow in the late 1960s; the integration of feminist education theory into art practice; and the productions and writing of Suzanne Lacy.

Unlike some social and participatory practice, Inclusive Artists do not tend to conceptualize participants as primarily 'in need of help or representation' (although they may feel pressure to do so in order to pursue certain funding streams). Rather, they consider and value the creative contribution that each participant can make. Thus Inclusive Art is not justified by a deficit logic; instead, there is a creative case for collaborating with learning-disabled artists based on the unique contributions they can bring to a work. So while socially engaged art that falls under the term 'relational aesthetics' (Bourriaud 2002) has tended to be the result of a single artist's vision (a strategy that risks treating people as materials), Inclusive Arts places a greater emphasis on collaboration, communication, exchange, relationships and the creative talent of collaborators.

Thus Inclusive Arts Practice has similarities to forms of dialogic and social practice that place an emphasis on process (Kester 2004; Lacy 2010; Helguera 2011). This emphasis on process has been referred to elsewhere as involving 'the de-materialization of art' (Lippard 1997). In fact, for Lippard the move from art objects to public performances and installations represented an anti-capitalist move away from the commodity status of art. We share an affection for performance and its somewhat irreducible nature; however, in Chapter Three we also discuss the importance of another form of 'material thinking' which is very aware of the properties of particular art materials and their relative merits in helping people to express themselves. This may involve a visual Inclusive Arts practitioner carefully selecting 'materials that listen' and spaces that are 'conducive to listening' rather than focusing solely on the human relations in a work (see also Macpherson and Fox, forthcoming).

In this way, the relational component of Inclusive Arts can be understood as existing both between people, and between people, materials and the spaces within which they practice, exhibit and perform. Some critics suggest that this sort of collaborative, socially engaged work might be an invalid form of Contemporary Art because of 'a prioritization of social effect over artistic quality' (Bishop 2006, p. 181). However, we believe artistic quality and social engagement are not necessarily in opposition. Rather, Inclusive Art raises questions over where the aesthetic for which the work is being appreciated exists – the art might sit primarily in the final products; in the process (and the capacity to convey that to a wider audience); in the encounters and exchanges between different artists and how they are negotiated; or in the construction of frameworks or conceptual ideas within which high-quality work can be made. Some of these answers to the question 'Where is the art in all of this?' are explored in more detail in Chapters Two and Three.

◀ Tina Jenner
Rocket Artists
Untitled
Important Things
project
Indian Ink on paper
2007

▶ Ntiense Eno
Amooquaye Intoart
UK
**Bookmark for
'Touching Down In
Utopia' by Hubert
Moore**
Indian Ink on card
2014

What are the potential aesthetic effects of Inclusive Arts?

There is no single, overarching aesthetic effect to Inclusive Arts Practice. Communication (through and with a variety of media and movements) tends to be central. However, Inclusive Arts does not have to rely on simplistic forms of positive identification or communication in order to be judged a success. Rather, absurdity, shock, eccentricity, doubt, confusion, disgust, antagonism or sheer pleasure might also be aesthetic effects that Inclusive Arts Practice achieves. This is partly illustrated here in the work of Kelvin Burke and Jo Offer, the inclusive design team behind this book, who were also commissioned to produce a CD cover for Heavy Load. This commission involved making and rendering some packing cases that looked as if they had

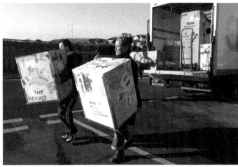
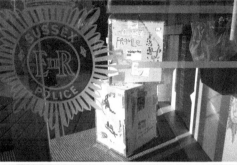

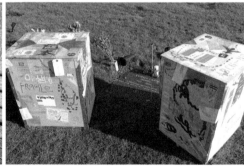

▲ Kelvin Burke, Jo Offer, Rocket Artists
Going Places
Mixed media installation
2012

"We took boxes, with Jane – police station, stuck in my mums garden, beach, tunnel, in a tree." – Kelvin

"We started off working on a design brief and ended up with a happening." – Jo

▶ Boxes appearing on the Wild Things CD cover

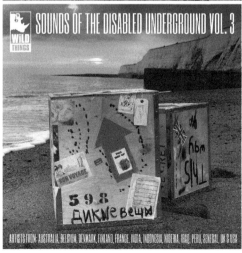

been taken on extensive travels. The pictures here trace the process of this work, revealing where Kelvin suggested they travel with these boxes – including the police station, his mother's grave, and stopping by the side of the road where someone was unloading a van in order to look like they were also being unloaded.

Such outputs reveal some of the ways in which people with learning disabilities' culture, logics and modes of existence disrupt certain taken-for-granted elements of society and ideas of what art is and can be (a point we explore in more detail in Chapter Three). They also touch on a range of aesthetic markers of existence and indicate that Inclusive Arts can elucidate a complex constellation of concerns – including the roles of love, death and pleasure in the lives of people with learning disabilities. The potential for learning-disabled artists to engage with topics such as sex and death, and with practices such as life drawing, remain taboos in the context of their everyday lives – a point we address in more depth in the final chapter.

Is this Outsider Art?

Outsider Art – art produced by people with no formal training who exist on the margins of society – is a definition given to work that is constructed outside of the critical Contemporary Art world (MacLagan 2009). The idea of Outsider Art (a phrase coined by Roger Cardinal in 1972) is a synonym for Jean Dubuffet's term Art Brut (where 'brut' means literally raw or unsweetened). Inclusive Art is also produced by people who might be considered outsiders, who sometimes have limited formal training. However, while Outsider Art is often thought to be con-taminated by too conscious a relationship with the art world, and is often associ-ated with myths of 'authenticity', 'purity' or a 'lone genius' artist, the emphasis in Inclusive Arts is on the entire humanity of the producers of work (not just their dif-ferences), and on the potential of collaboration and creative exchange with people from diverse backgrounds as well as with the critical Contemporary Art world.

There have been some attempts to describe the aesthetic qualities of Outsider Artists' work. For example, James Brett, founder of The Museum of Everything, suggests that there is very little appraisal of time, a limited notion of the market, and limited self-conscious intention. However, when claims are made that there is a specific aesthetic to learning-disabled artists' work, we risk claiming that their work is 'all the same', solely emphasizing difference, essentializing their outputs, and ultimately devaluing their work and their roles as individual artists and as col-laborators. As Massimiliano Gioni, in a conversation with Brett about the exhibition The Appendix of Everything, puts it:

> I'm suspicious when people identify the disabled in the myth of the pri-mal artist: I think that's just a myth of origins. Art is as much about control as it is about expression ... Even in the work of the most disturbed person, there is a logic and control that makes those objects interesting.
>
> (Massimiliano Gioni, Artistic Director of the Trussardi Foundation in Milan, in Brett 2011, p. xii)

Situating Inclusive Arts

Some facilitators and collectors interested in promoting the supposed qualities of Outsider Art are concerned with simply unlocking the desire to create. For example, James Brett states of Outsider Art that 'In the best situations, there is no input, or not substantially so; and for me, the results reflect the creative language all of us have from birth' (Brett 2011, p. xix). However, we prefer to draw attention to the collaborative process and the necessity for high-quality materials, foundations and starting points (see Chapter Three). We are also interested in how learning-disabled artists might find routes for training, and how to help learning-disabled artists place their work in dialogue with other existing forms of Contemporary Art. This is not for the purpose of supporting people to be 'the same as' any so-called 'mainstream', but rather to place their talents and senses of creativity within a wider context and alongside other practising artists from different backgrounds.

For example, Alice Fox's work with the Rockets started with setting up courses at the University of Brighton where the Rockets could work alongside undergraduate and postgraduate students. She would also support the Rockets to look through existing books of artwork and say what they did and didn't like, and why. For people who have experienced very limited opportunities to express their preferences for anything, let alone for art, this was a radical move. We address some of these issues in more depth in our final chapter, where we contemplate the possible futures of Inclusive Arts, training in the field, and the provision of professional training opportunities for learning-disabled artists.

How should work be labelled? If at all...

The issue of biography and the labelling of work produced by, or in conjunction with, learning-disabled artists has been a topic of significant debate in recent years, including in the United Kingdom through a series of Arts Council-funded conferences entitled 'Creative Minds'. Some artists and their organizations would prefer that the work speaks for itself and that the biographies of the artists and their diagnostic labels are not drawn attention to at all. Inclusive Artists must decide, in conjunction with their collaborators or their representatives, what work they want the artwork to do, and what role giving it a label has in that process.

In a gallery context we think that if the biographies of the makers, including their learning disabilities, are ignored entirely, the risk is that we miss the political work their art might do if it is labelled. That is not to say that all Inclusive Artwork should be labelled – labelling something can affect how a piece is 'read' by a viewer, can reinstate labels that the maker might be seeking to overcome, and can burden them with somehow being representative of learning disability. Rather, how a work is labelled is an issue that should be carefully reflected on. Such work, like the whole of this book, is '... forced to walk a tightrope between complicity and critique' (Auslander 1994, p. 31). It is worth heeding Derrida's (1982) warning that 'by using against the edifice the instruments or stones available in the house ... one risks ceaselessly confirming, consolidating ... that which one allegedly deconstructs' (p. 223).

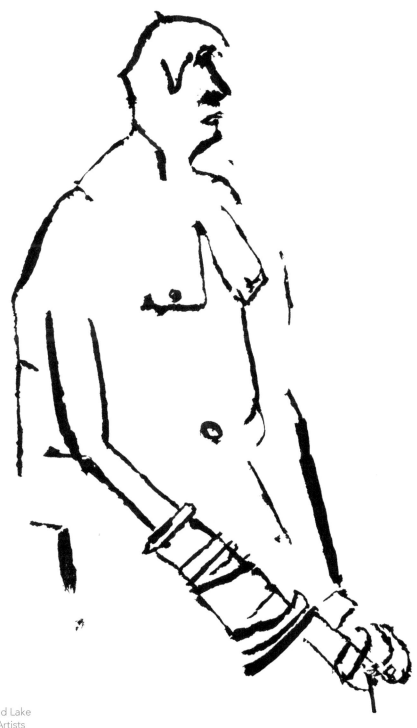

▶ Desmond Lake
Rocket Artists
Untitled
Ink on paper
2006

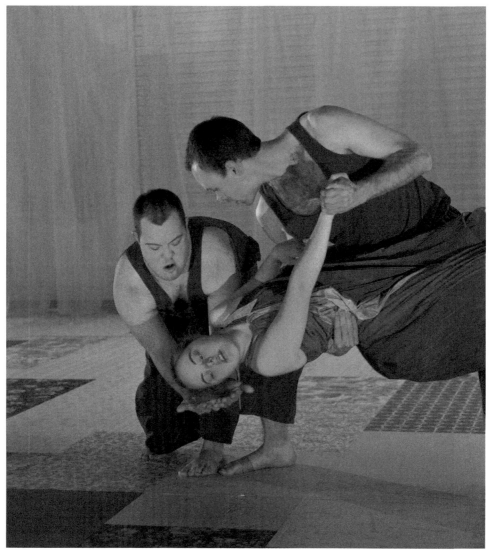

▲ Restless Dance Theatre
Australia

The issue is not only whether medical diagnostic labels should be used when describing work, but also when artwork should be placed within the wider socio-political context of people with learning disabilities' everyday lives. If people view work solely as aesthetic 'entertainment' and ignore the wider context of the everyday lives of people with learning disabilities, the risk is an over-romanticized understanding of their lives. At worst, the art could serve as a band-aid for wider social ills and obscure the harsher realities of learning disability – provoking an 'isn't it all lovely for them, doing their art' response. This is a mistake of some commentaries on Outsider Art, which see characteristics such as 'isolation', 'repetition' and 'crude mark-making' as solely positive, rather than as potentially symptomatic of the socio-historical position of the makers (see Macpherson 2015).

How does this work relate to the everyday lives of people with learning disabilities?

People with learning disabilities tend to be undervalued members of society, are much more likely to live in poverty, and are much more likely to suffer hate crime than their non-disabled counterparts. It is estimated that around 1.5 million people in the UK have a learning disability and over 3,000 of these people have spent over a year in an 'assessment centre', often a long way from family, and which is not designed to be a permanent residence. Many people with learning disabilities do not have access to any regular creative leisure activity outside their residential environment, despite the proven benefits of such activities for health, well-being and resilience (Reynolds 2002; Staricoff 2004; Macpherson et al. 2015).

Taking the United Kingdom as an example, many people with learning disabilities find themselves in abusive situations that violate their human rights (JCHR 2008), and just eight per cent of the estimated total population of adults of working age with a learning disability are thought to be in paid employment (Emerson and Hatton 2008). The majority live in residential care homes or attend daycare,

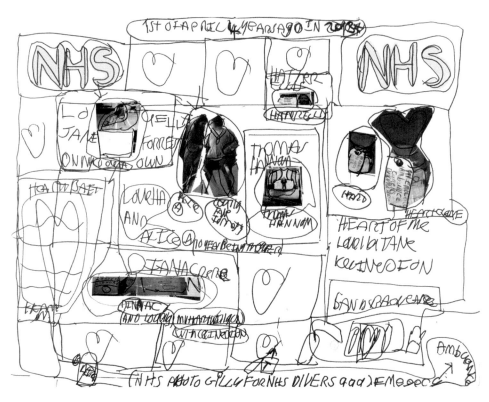

▲ Louella Forrest
Rocket Artists
NHS
Ink and collage on paper
2012

and are currently facing benefit cuts and reductions in services. Their lives tend to be characterized by a high degree of compliance with the goals and agendas of others, and for some their basic human rights are not being met. Many of these challenges and forms of abuse faced by people with learning disabilities in the United Kingdom are held in common with people with learning disabilities globally.

In this context, talking about the role of art in their lives and the role of their lives in the art world may seem irrelevant, unrealistic or simply naïve, but to take this view risks perpetuating the social position that people with learning disabilities often find themselves in, and ignores the role of culture as a producer of personal and social change. At times we think it is important that Inclusive Artists directly address the social context of the lives of people with learning disabilities and practically enable advocacy where appropriate.

That is not to suggest that all work should be explicitly political, limited to social commentary or advocacy. However, we believe Inclusive Art can be just one piece of a socio-political-cultural jigsaw that needs to be put together in order to enhance the lives of people both with and without a learning disability. Social service and health professionals who encounter the artwork can be helped to see the humanity and communication capacities of people they work alongside. Public audience encounters with Inclusive Art can help challenge stigma and oppression, and raise awareness of the creative contributions that people with learning disabilities can make to society. Of course, the outcomes of audience encounters are somewhat uncertain and might, at worst, reinforce stigma (an issue we discuss in Chapter Three). We can only encourage artists to keep producing challenging, risky work that is contextually well informed and that they believe in.

What are the transformative potentials of Inclusive Arts?

Inclusive Arts can be a transformative force in individual people's lives, in researchers' understanding of the category 'learning disability', in forms of creative practice, and a force for societal good. By highlighting the transformative features of Inclusive Art we do not wish to detract from the creative value of the artwork (cf. Holden 2004), we simply wish to highlight that this sort of art making has additional benefits for participants and audiences which extend beyond the art output itself. It is work that, at best, can help us to re-vision how we see the world, how we value people and what we understand as intelligence. Of course, some 'art for art's sake' critics will be sighing at the suggestion of 'transformative potential' or 'social good', as if the mere suggestion of this devalues the work as a Contemporary Art form. As Holden (2004) suggests in his report Capturing Cultural Value:

> The arguments seem to have got stuck in the old intellectual tramlines very quickly: instrumental vs. intrinsic value, floppy bow ties vs. hard-headed 'realists', excellence vs. access. Worse still, the instrumental/intrinsic debate has tended to polarize on class lines: aesthetic values for the middle classes, instrumental outcomes for the poor and disadvantaged.
>
> (Holden 2004, p. 25)

However, collaborative work with marginalized groups does not have to be a purely instrumental form of social work. It can also achieve excellence on a range of measures of artistic quality, and can even challenge those measures. For inclusion and diversity are not the enemies of excellence (Knell and Taylor 2011); rather, there is a creative case for diversity that is gaining increasing recognition (Mahamdallie 2011). For example, prior research has shown that collaboration with people with complex communication needs can help enhance creativity by forcing all practitioners to think about new tempos of work, new spaces of practice, new creative ways of facilitating non-verbal dialogue, and new media through which to enhance creative expression (Macpherson and Bleasedale 2012). Thus in the studio the transformative potential of Inclusive Arts is two-way – everybody can derive creative benefits and new insights into 'self' from collaborative work.

Furthermore, within the studio space or other creative arts environment, there is also often a much needed antidote to the reductionism, stigma and oppression that people with learning disabilities face in their everyday lives. Arts activities also provide a release from the controlled environments encountered in residential, supported living and daycare facilities. For example, research has shown how art activities help in reducing the pressure to be socially normative and enhance a sense of personal freedom (Reynolds 2002).

▶ Kelvin Burke
Rocket Artists
Life Drawing
2012
Festival of the World,
Southbank Centre, London

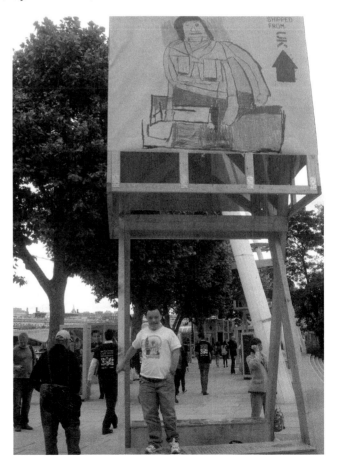

Situating Inclusive Arts

While this book is a hopeful text, we should not overstate the achievements and reach of Inclusive Art activities. There are continuing problems for people with learning disabilities in even accessing mainstream or community creative leisure activities outside residential environments (Reynolds 2002), while poorly facilitated activities may do more harm than good (Springham 2008). Goodley and Moore (2002), in their research on disabled people's performing arts, show that gains made can be quickly neutralized through negative service connections, environments and relationships. Certainly, research in this area needs to acknowledge that the temporary sense of belonging and sense of psychological empowerment that arts projects can achieve does not necessarily relate directly to broader forms of social inclusion or empowerment (White 2009; Hall 2013). Time, commitment, ongoing funding and links not only with services but with mainstream arts organizations and funders are needed for work to achieve the highest standards, including longevity of impact in people's lives (Macpherson et al. 2014). Otherwise we risk this work being inappropriately utilized as a short-term intervention. Issues regarding how we research and document the 'impact' of Inclusive Arts are addressed in Chapter Five on research, while the need for time to forge successful collaborative partnerships, such as Alice's work with the Rockets over the past twelve years, is discussed in more detail in Chapter Three.

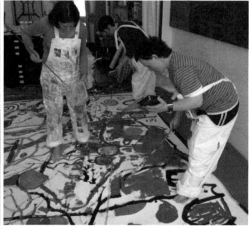

Rocket Artists with University
of Brighton's MA Inclusive Arts
Practice students and staff

➤ Jane Diakonicolas, Martyn Lake
Drawing Conversations
2013

▲ Alice Fox, Kelvin Burke
Studio work
2010

◀ Jane Fox, Tina Jenner
2012

So what is the difference between an Inclusive Artist and a community worker?

The emergence of new forms of socially engaged art practice, including Inclusive Arts, has raised questions regarding how this work might differ from other sorts of community work (Bishop 2006). While clearly there are overlaps, Inclusive Arts primarily pursues good quality art rather than a clearly defined social or political goal (although socio-political issues may emerge as relevant in the process). This requires the artist to have a knowledge of the role and effect of materials or practices during a workshop, and requires an artist who is prepared to take risks rather than practising from a (traditionally conceived) evidence base or ethical standpoint. In this way, the artist-facilitator can push at the boundaries of meaning making and exist as a collaborator in a creative exchange – opening up questions. The demands of funders and those in positions of power can risk limiting artists who work alongside people with learning disabilities to a closed, predetermined approach. Therefore the challenge is to help those people re-envisage what an open Inclusive Arts process can achieve.

Audience encounters 1: What can be achieved when audiences experience this work?

Arts activities alone cannot achieve a better world for people with learning disabilities. However, audience encounters with this work provide promising glimpses of a better world – thus artwork potentially can be a harbinger for a socio-political situation yet to come (cf. Ranciere 2009). It seems, then, that Inclusive Arts, like other forms of art making, inhabits a productive yet contradictory relationship to social change. This relationship is characterized by a tension between a faith in art's autonomy and belief in art as bound to the promise of a better world. As an Inclusive Artist, it is necessary to come to terms with this tension and be aware that the other parts of the socio-political jigsaw also need to be in place, including finances, support assistance and service buy-in, in order to improve the lives of people with learning disabilities.

Audience encounters 2: How does this work change how people with learning disabilities are viewed?

Work by people with visible impairments can be extremely important for addressing how disabled people are looked at and how they see themselves. For many people with visible disabilities (which includes many of those with visible manifestations of learning disability), visual dynamics such as staring, glancing and avoiding can become a mode of oppression and a marker of difference, establishing and maintaining the position of people with unconventional bodies as 'other'. As Garland-Thomson writes:

> *At the most immediate level, disability is constructed through complex rituals of staring and avoidance that occur when people confront a person with an empty sleeve, a prosthetic limb, a scarred face, a stutter.*
> (Garland-Thomson 2007, pp. 18–19)

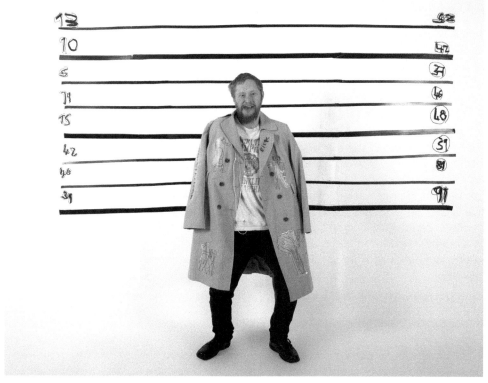

▲ Joseph Gregory
Rocket Artists
Suspected of what?
photographic series
2015

The Rockets' performances, like other performances by people with learning disabilities, play with these issues of disabled visuality at both a symbolic and a corporeal level. Their performance work elevates and draws attention to the sort of body and mind that has tended to be avoided and not highly valued in society. They invite people to look, see and hear; sometimes even to see the involuntary movements that are the antithesis of an idealized controlled and ordered (often masculine) subject of modernity. At best they are seen in ways that unselfconsciously depart from previously established modes of disabling looking, interrupting what Garland-Thomson (2009) refers to as 'conventional regimes' of disabled visuality. In such performances, the Rockets are not passive in their encounters with the audience. Rather (to some extent) they manage the gaze of the live audience by asking them to look and then looking right back at them, even laughing at them (see front cover). This attempt to play with conventional regimes of disabled visuality is just one potential element of the transformative potential of Inclusive Art making through performance, photography and film.

▲ Heavy Load
UK
No Limits Festival, Berlin
2009

Audience encounters 3: What can audiences take away from this work?

Learning disability tends to be a field dominated by policy discourse which follows a 'deficit logic' and modern biomedicine whose medicalization of learning disability can leave the context and humanity of those people with learning disabilities ignored. Yet audience encounters with Inclusive Art productions can help parents, carers, health workers, policy-makers and other members of the public see the talent of the artists and re-evaluate the worth and capacities of individual lives. For example, in Chapter Two we discuss how the Rockets' performance at a conference on childhood disability in Brussels helped conference attendees (who were largely from medical and psychological backgrounds) re-envisage who they were talking about.

Such encounters can help to challenge scientists' understanding of people with learning disabilities as 'recipients' of research, and re-view them as agents of change. Of course, we cannot entirely predict the effect this work will have on

21

any audience. As Holden (2004) rightly states, 'Cultural experience is the sum of the interaction between an individual and an artifact or an experience, and that interaction is unpredictable and must be open' (p. 9). Therefore it seems the best that Inclusive Arts practitioners and their collaborators can do is make work they believe to be of a good quality, rather than necessarily second-guess the audience reception of this work. The audience might bring and reinforce prejudice and negative assumptions about people with learning disabilities through the work, but also they may not. Work that seeks to directly tackle stigma and oppression rather than focusing on talent may inadvertently reinforce stigma and oppression through re-stating it. A quality and talent 'can do' approach to Inclusive Art avoids this pitfall and keeps the focus forward – on producing good art/music/performance.

◀ Rocket Artists
**Measures of
Bodies**
performance at
the Musée de la
Médecine,
Brussels
2010

How does Inclusive Arts differ from Disability Art?

This book is written amid ongoing tensions amongst arts practitioners, commissioners, umbrella organizations and academics surrounding what constitutes Disability Art, the aims and remit of this work, who has the right to practice as a D/disabled artist, and whether such a separate category needs to exist within an arts funding context. Some practitioners and commissioners define Disability Art as any work produced by an artist who identifies as D/disabled. However, for others Disability Art must communicate something of the experience of being D/disabled, and remain with a capital 'D' to emphasize the importance of Disabled identity and politics (Sutherland 2005). Both these definitions have left integrated companies and collaborative companies excluded from certain funding streams. Elsewhere in the arts and humanities, these debates about what classifies as D/disability art and what sort of work should be funded have been explored in some depth (see for example Crutchfield and Epstein 2000; Kuppers 2001; Darke 2003). Some Inclusive Artists would see themselves as facilitating the work of their collaborators as Disabled artists, others would distance themselves from the more inward-looking strands of the Disability Arts movement and share instead an affinity with all those artists who have historically been placed at the margins.

How does Inclusive Arts differ from Art Therapy and occupational therapy?

All arts practice can be therapeutic; however, different approaches to arts facilitation have different underlying motivations and expectations. In Inclusive Arts, the main motivation is to come together to make art or to experience creative exchanges, whereas in Art Therapy and occupational therapy, art is used primarily as a tool to address a problem. Inclusive Arts can be understood to be therapeutic because they provide a supportive environment and encourages communication and creative expression of ideas, experiences and/or ambitions. However, in Inclusive Art the focus is primarily on the artistic product, whereas in Art Therapy the emphasis tends to be on using the art making process for healing and emotional release through work that is not necessarily intended for public display (that is not to say that this won't result in high-quality work, but this is not the primary intention). In occupational therapy, art tends to be used as a tool for empowering the client to fulfil their roles in a variety of environments (Sumsion 2000, p. 308). This tends to involve the use of art as a tool for aiding communication, self-expression, diversion, assessment or treatment planning (Lloyd and Papas 1999).

Inclusive Arts practitioners, occupational therapists and art therapists may have overlapping forms of practice that encourage meaningful content. They may also have a shared appreciation of the importance of non-verbal modes of expression. However, Inclusive Artists may also equip participants with the skills to express themselves adequately to a wider audience than the individual facilitator. Furthermore, Inclusive Arts activities are focused on creative collaborative exchanges, rather than the support of 'function performance' for

occupational roles. As Mark Williams (director and founder of Heart n Soul) put it in a recent interview with The Guardian newspaper:

> If you present yourself as a therapist, that's what you'll always be. There are clearly beneficial and therapeutic aspects to our work, but that's not why we do it. It's always about the art. One of the reasons we're able to attract such great collaborations is that we create an environment where anything is possible. Our singers aren't stuck in genres. They're not over analytical – they're just doing it. There is something about that purity that seems to be the essence of creativity.
>
> (Mark Williams, in Groves 2012)

◀ Rocket Artists
'No' Apron
Fabric, transfers and ink
2014

Rocket Artists performed response to the question "Why do you think that your work is more than therapy?" Creative Minds Conference, Brighton

What are the characteristics of good quality Inclusive Arts?

Historically, quality in the arts has been associated with the refinement and perfection of particular classical techniques and the notion of individual masters and masterpieces. However, in the past century these understandings of quality in the arts have been challenged. In fact, some believe promoting the principle of quality is itself problematic, hierarchical and masculinist, likely to erase rather than promote what it seeks out. Certainly, the term quality can obscure as much as it reveals (Matarasso 2013, p. 4).

We think that while it is difficult to set out hard and fast criteria for quality in Inclusive Arts, it is possible to make distinctions between better and worse practice. For today the debate on participatory art has moved well beyond simplistic advocacy of socially engaged arts as 'inherently good' (Belfiore and Bennett 2008). Best practice matters, and we believe art made with people with learning disabilities can achieve a whole array of markers of quality. The work does not have to be solely about connection, empathy or recognition – in fact, to place learning-disabled artists solely in this category would be to devalue the diversity of their work and burden them with the limiting notion of authenticity. Instead, their work and their collaborative productions are part of a growing Disability Arts culture which is valued both for its quality and for the unique dispositions, experiences, capacities and aesthetic effects that individuals bring to a work.

Such work is achieving existing standards of quality in the arts 'in the wider context of what is considered to be good in the arts today', a principle of quality that Matarasso (2013, p. 9) advocates in his paper. It is also pushing at the boundaries of those existing standards through placing trust in the creative impulses, production skills and curatorial ideas of people with learning disabilities. In Chapter Three we discuss these standards in more depth and call for a greater focus on 'the ethics of encounter' when evaluating quality in Inclusive Arts practice with people with learning disabilities.

We also hope that quality practice will enable a greater recognition of the capacity of learning-disabled artists to challenge who a choreographer, a director, a curator and an artist is. This book's illustrations are dedicated to redefining those parameters and illustrating the diversity and quality of practice stemming from Inclusive Art collaborations. In so doing, we hope to help Inclusive Artists and commentators develop a sensitivity to all the possible aesthetic effects, temporalities, liminalities and tensions that run through their work and the potentials of these in a gallery setting or audience encounter. We also hope to challenge a certain public imaginary of the Contemporary Artist which tends to remain stuck in the idea of an individual personality who is able to validate their work by personally articulating it within a complex conceptual basis.

Work made with people with complex communication needs that is unresolved or provokes discomfort is as important to see as work that is solely uplifting. At the Side by Side symposium at the Royal Festival Hall, some key features of quality Inclusive Arts were identified by participants through a range of formats (music,

gestural, performative, verbal and visual). These features included unpredictability, shared inspiration, being together, taking risks, a freedom to experiment, the potential to shock, and an openness to each other and the diversity of languages (visual, verbal, gestural, sonic) in which we communicate. Everyone seemed to agree that the creative exchanges and development work of Inclusive Arts resulted in productions that could not have been achieved in isolation.

In order to enable and recognize some of these diverse attributes of high-quality Inclusive Art, the collaborator needs to develop a diverse skill set. This is discussed in more depth in Chapter Three, where we explore how effective Inclusive Artists enable choice and freedom, allow time, establish trust, embrace risk and chaos, are open to all forms of communication, and reflect on their practice. An openness to possibility and potential seem to be crucial here if genuine forms of dialogue or encounter are to be opened up. While some people believe such features of arts practitioners are innate personality traits, we believe they are modes of attunement that can be learnt and that, over time, can become habitual. For this to occur, there needs to be a willingness for 'relinquishing power in situations where you are defined as the professional' (Goodley and Moore 2002, p. 64).

In some contexts, the relationship that is established is the artwork and the challenge might be to communicate that to a wider audience. In other contexts, the facilitator may need to be prepared to 'dissolve' into the artwork and think of themselves as developing new 'inter-corporeal' or 'inter-subjective' forms of collective understanding that would not have been possible without the group (Macpherson 2009). In this way the term 'Inclusive Art' might be a little misleading, for it implies a coherent individual stretching out to 'include' another – however, what the practice of Inclusive Art requires is collaborative dialogue: an acceptance of our incompleteness as practitioners and a capacity to unlearn as well as learn from each other. The artist-facilitator is not the expert in this relationship. Rather, they are an artist who is coming into being collaboratively. These capacities of the artist relate to a feminist aesthetic not dissimilar to that advocated by the performances and writing of Peggy Phelan (1993).

What's in the rest of the book?

This book is divided into six illustrated chapters. Chapter Two explores issues of co-curation and audience encounters with work. It includes conversations with Jude Kelly (Artistic Director of the Southbank Centre), Anna Cutler (Director of Learning at the Tate) and Alice herself about the process of inclusively curating the Side by Side exhibition. Chapter Three identifies and illustrates some common features of successful practice and there are conversations with members of the Rockets. Chapter Four presents a series of conversations in more depth with other key practitioners in the field, including Dean Rodney and Mark Williams from Heart n Soul; Declan Kennedy and Andrew Pike from KCAT; Kate Adams (MBE), co-founder of Hastings-based Project Art Works; Charlotte Hollinshead from Action Space; Bethan Kendrick and Jacobus Flynn. These people haven't been on a course or had specific training in this emergent field of practice, they have learnt 'on the job' and share a common ethos – an understanding that there are creative and potentially transformative benefits for everyone through being involved in an Inclusive Arts process. They also understand that inclusion involves a form of two-way exchange and transformation, rather than a process of incorporation.

Chapter Five addresses what Inclusive Arts Research could look like – for, while there has been significant work on how to research the 'social impact' of the arts, there has been less on how research agendas, ambitions and modes of validating knowledge might be shaped by an Inclusive Arts agenda. Chapter Six reflects on the future of Inclusive Arts, with contributions from a host of international Inclusive Arts organizations, and consideration given to defining the field, funding, taboo topics, professionalization, education and training.

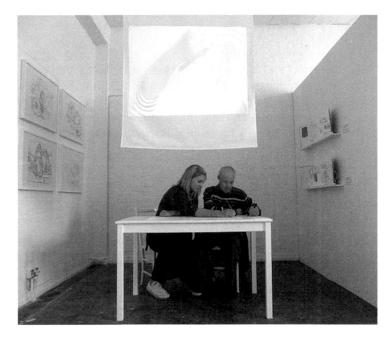

◀ Project Art Works
UK
Fabrica, Brighton
Installation – boxes,
cardboard,
video projection
2014

▶ Martyn Lake,
Jane Diakonicolas
**Drawing
Conversations**
Site-specific
performative
installation
2013

Situating Inclusive Arts

A note from the authors

We hope that academics, critics, students and curators who read this book come away with a greater understanding of the significance, tensions and challenges in this field of arts practice and how these forms of creative collaboration differ from what has traditionally been understood as Outsider Art. We hope artist practitioners who read this book are also inspired to acknowledge their role as collaborators rather than facilitators and to co-produce high-quality, cutting edge work.

We have enjoyed the collaborative process of writing this book together; in fact the act of writing and talking about writing has involved its own forms of artistry and skill akin to those of an Inclusive Artist. Before logical sentences were strung together for the purposes of this book, a much messier interaction occurred. As Worth and Poyner write:

> Speaking about creative practice as a precursor to writing allows for the reflection to emerge from the voice and the body, with breath and energy and rhythm, with dips and pauses, voices overtake each other, with ideas that flip back and forth, reaching for something which has yet to find its form in language, which formulates itself in the creative exchange between two people. This is the pleasurable struggle of attempting to 'draw' the processes of creative practice with words.
>
> (Worth and Poyner 2011, p. 149)

In pinning complex thoughts together in words, there is inevitably a loss of nuance and ambiguity, qualities that are very important for decent conversation about arts practice. We hope that these qualities can be re-introduced in the conversations and creative dialogues which will inevitably follow.

Paradox

We understand that by writing this text we inhabit a paradox. Spoken and written forms of communication have disabling affects that the arts can, at least partially, overcome. Given our positions as university lecturers, we must inhabit this paradox and shuttle between different subject positions and modes of working (see Macpherson 2011), walking the tightrope between complicity and critique – at times challenging and at times working within existing understandings of art, learning disability and scholarship.

A note on editing the conversations in Chapters Three and Four

In editing the transcripts presented here, we have had to confront the tension between conventions of textual representation and retaining the unique voice and speech patterns of learning-disabled artists. Sometimes people with learning disabilities' speech patterns and explanations can challenge what is conventionally

understood to constitute a narrative. This raises questions over how voices are received and the extent to which the onus should be on the listener (or reader) to attune themselves to the voices on the page. We chose to edit extracts for clarity of message and 'sense'. There are other more creative and performative texts that could have been written from the same material that is presented here, but this would have conflicted with our goal of sharing the learning of artists and their organizations in an accessible format. At times, the artwork illustrated here says more with less.

▲ John Cull
Rocket Artists
Where is Frida Kahlo?
Taking Off exhibition
Acrylic on canvas
lifesize portraits 3m x 3m
2005

What this part of the book is about

- Inclusive Art and why it is important

- Inclusive Arts is not Outsider Art or Art Therapy

- Inclusive Arts sits well beside other sorts of art made today

- Inclusive Art does not have to be just fun or pretty – it can be full of lots of different ideas and stories, it might be difficult

- Inclusive Art is important and everybody should have access to it

- Good quality Inclusive Artwork is important for audiences to see and can help change people's attitudes

relational aesthetics • littoral art • community arts • participatory • interventions • experimental communities • dialogic art • research based art

inclusive art

References

Ahmed, S. (2012) *On Being Included: Racism and Diversity in Institutional Life*, Durham, NC: Duke University Press.

Auslander, P. (1994) *Presence and Resistance: Postmodernism and Cultural Politics in Contemporary American Performance*, Ann Arbor, MI: University of Michigan Press.

Belfiore, E. (2002) 'Art as a means towards alleviating social exclusion: Does it really work? – A critique of instrumental cultural policies and social impact studies in the UK' , *International Journal of Cultural Policy*, 8(1): 91–106.

Belfiore, E. and Bennett, O. (2008) *The Social Impact of the Arts: An Intellectual History*, Palgrave Macmillan: Basingstoke.

Bishop, C. (2006) 'The social turn: Collaboration and its discontents', *Artforum*, February: 178–183.

Bourriaud, N. (2002) *Relational Aesthetics*, Dijon-Quetigny: Les Presses du Réel.

Brett, J. (2011) *The Appendix of Everything*, London: The Museum of Everything.

Crutchfield, S. and Epstein, M. (2000) *Points of Contact: Disability, Art, and Culture*, Ann Arbor, MI: University of Michigan Press.

Darke, P. (2003) 'Now I know why disability art is drowning in the River Lethe', in Riddell, S. and Watson, N. (eds), *Disability, Culture and Identity*, Harlow: Pearson/ Prentice Hall.

Department of Health (2009) *Valuing People Now: A New Three-Year Strategy for People with Learning Disabilities*, London: Department of Health.

Derrida, J. (1982) *Margins of Philosophy*, tr. Alan Bass, Chicago, IL: University of Chicago Press.

Emerson, E. and Hatton, C. (2008) *People with Learning Disabilities in England*, CeDR Research Report 2008:1, Lancaster: Centre for Disability Research, Lancaster University.

Garland-Thomson, R. (2009) *Staring: How We Look*, Oxford: Oxford University Press.

Goodey, C.F. (2011) *A History of Intelligence and 'Intellectual Disability': The Shaping of Psychology in Early Modern Europe*, Farnham: Ashgate.

Goodley, D. and Moore, M. (2002) *Disability Arts Against Exclusion*, Birmingham: British Institute of Learning Disabilities Publications.

Groves, N. (2012) 'Arts head: Mark Williams, artistic director, Heart n Soul', The Guardian Culture Professionals Network, 21 August. www.theguardian.com/culture-professionals-network/culture-professionals-blog/2012/aug/21/disability-arts-heart-n-soul-mark-williams-interview

Hall, E. (2013) 'Making and gifting belonging: Creative arts and people with learning disabilities', *Environment and Planning A*, 45(2): 244–262.

Helguera, P. (2011) *Education for Socially Engaged Art*, New York: Jorge Pinto Books.

Holden, J. (2004) *Capturing Cultural Value*, London: Demos.

JCHR (2008) *A Life Like Any Other? Human Rights of Adults with Learning Disabilities*, Seventh Report of Session 2007–08, HL Paper 40-I/HC 73-I, House of Lords/House of Commons Joint Committee on Human Rights, London: The Stationery Office (accessed 4 February 2014). www.publications.parliament.uk/pa/jt200708/jtselect/jtrights/40/40i.pdf

Kester, G.H. (2004) *Conversation Pieces: Community and Communication in Modern Art*, Berkeley, CA: University of California Press.

Knell, J. and Taylor, M. (2011) *Arts Funding, Austerity and the Big Society*, London: Royal Society of Arts. www.artscouncil.org.uk/media/uploads/pdf/RSA-Pamphlets-Arts_Funding_Austerity_ BigSociety.pdf

Kuppers, P. (2001) *Disability and Contemporary Performance: Bodies on Edge*, London and New York: Harwood Academic Press.

Lacy, S. (2010) *Leaving Art: Writings on Performance, Politics, and Publics, 1974–2007*, Durham, NC: Duke University Press.

Lippard, L. (1997) *Six Years: The Dematerialization of the Art Object from 1966 to 1972*, Oakland, CA: University of California Press.

Lloyd, C. and Papas, V. (1999) 'Art as therapy within occupational therapy in mental health settings: A review of the literature', *British Journal of Occupational Therapy*, 62(1): 31–35.

MacLagan, D. (2009) *Outsider Art: From the Margins to the Marketplace*, London: Reaktion Books.

Macpherson, H.M. (2009) 'The inter-corporeal emergence of landscape: Negotiating sight, blindness and ideas of landscape in the British countryside', *Environment and Planning A*, 41(5): 1042–1054.

Macpherson, H.M. (2011) 'Navigating a non-representational research landscape and representing "under-represented groups": From complexity to strategic essentialism (and back)', *Social and Cultural Geography*, 12(6): 544–548.

Macpherson, H.M. (2015) 'Biostratigraphy and disability art: An introduction to the work of Jon Adams', in Hawkins, H. and Straughan, L. (eds), *Geographical Aesthetics: Imagining Space, Staging Encounters*, Farnham: Ashgate (Geography Series).

Macpherson, H.M. and Bleasedale, B. (2012) 'Journeys in ink: Re-presenting the spaces of inclusive arts practice', *Cultural Geographies*, 19(4): 523–534.

Macpherson, H.M. and Fox, A. (forthcoming) 'Listening space: Some lessons from artists with and without learning disabilities'.

Macpherson, H.M., Hart, A. and Heaver, B. (2014) 'Impacts between academic researchers and community partners: Some critical reflections on impact agendas in a "visual arts for resilience" research project', *ACME: An International E-Journal for Critical Geographies*, 13(1): 27–32.

Macpherson, H.M., Hart, A. and Heaver, B. (2015) 'Building resilience through group visual arts activities: Findings from a scoping study with young people who experience mental health complexities and/or learning difficulties', *Journal of Social Work*, in press.

Mahamdallie, H. (2011) 'What is the Creative Case for Diversity?' London: Arts Council England (accessed 1 July 2012). www.artscouncil.org.uk/media/uploads/pdf/What_is_the_Creative_Case_for_Diversity.pdf

Matarasso, F. (2013) 'Creative progression – Reflections on quality in participatory arts', *Unesco Observatory, Multidisciplinary Journal of the Arts*, 3(3): 1–14.

Phelan, P. (1993) *Unmarked: The Politics of Performance*, London and New York: Routledge.

Ranciere, J. (2009) *Aesthetics and Its Discontents*, tr. S. Corcoran, Cambridge: Polity Press.

Reynolds, F. (2002) 'An exploratory survey of opportunities and barriers to creative leisure activity for people with learning disabilities', *British Journal of Learning Disabilities*, 30(2): 63–67.

Sinason, V. (2010) *Mental Handicap and the Human Condition*, London: Free Association Books.

Springham, N. (2008) 'Through the eyes of the law: What is it about art that can harm people?', *International Journal of Art Therapy*, 13(2): 65–73.

Staricoff, R.L. (2004) *Arts in Health: A Review of the Medical Literature*, London: Arts Council England.

Sumsion, T. (2000) 'A revised occupational therapy definition of client centred practice', *British Journal of Occupational Therapy*, 63(7): 304–309.

Sutherland, A. (2005) 'What is Disability Arts?', Disability Arts Online, 1 July (accessed 20 June 2011). www.disabilityartsonline.org.uk/what-is-disability-arts

White, M. (2009) *Arts Development in Community Health: A Social Tonic*, Oxford: Radcliffe Publishing.

Worth, L. and Poyner, H. (2011) 'Collaborative writing: Wrestling the slippery fish', in Kershaw, B. and Nicholson, H. (eds), *Research Methods in Theatre and Performance*, Edinburgh: Edinburgh University Press, pp. 148–153.

2 Curation, biography and audience encounter

Curation, biography and audience encounter

Introduction

In any discussion of how to commission, curate, interpret, label and frame the work of learning-disabled artists and their collaborators, a series of questions keep recurring. Should biography be included in the presentation of work, and how? Does this work always have to be seen to do social or political work? When might a medical/diagnostic label undermine what is being achieved through the art? How can we develop collaborative curatorial and commissioning processes? And how can work move from 'outsider', 'community' and 'education' spaces to mainstream galleries? These are just some of the questions we explore in this chapter through an introductory discussion followed by a series of conversations with key people in the field:

Jude Kelly	Artistic Director of the Southbank Centre, London
Anna Cutler	Director of Learning at Tate, London
Alice Fox	on inclusive curation of the Side by Side exhibition and symposium at the Southbank Centre
Catherine Morris	Sackler Family Curator for the Elizabeth A. Sackler Center for Feminist Art at the Brooklyn Museum, New York

Diversity, encounter and exchange in the cultural sphere

Learning-disabled artists wish to be valued as artists and individuals in their own right rather than as representative of a category of being human. However, when Inclusive Art makers display or perform their work to an audience, they intervene in a complex history of people with learning disabilities, their social exclusion and their representation. In Britain, until the late 1980s people with learning disabilities were often removed from society and hidden from view in institutions. Even today, despite care in the community polices, there is only very limited integration of people with learning disabilities and limited awareness of the contributions these people can make to the cultural sphere.

This context of social, historical and cultural exclusion means that often learning-disabled artists' work is read in singular ways as being 'representative of learning disability' (even if that is not the intention of the artists), and it can be hard for artists to get beyond this initial reaction and for audiences to respond critically when they are aware of a legacy of exclusion. These are tensions that audiences, curators, commissioners, and all artists who have historically been placed at the margins must negotiate in their work.

At times the Rocket Artists have explored these tensions and confronted the way they are viewed head-on through their performance. For example, in the Measures of Bodies performance pictured here, the Rocket Artists produced a site-specific dance performed in the Musée de la Médecine in Brussels. This performance occurred amongst displays of medical equipment and wax models of 'abnormal' body parts, and was performed to an audience of medical profes-

sionals at the opening night of the European Academy for Childhood Disability's Annual Meeting.

This type of opportunity for the Rockets is incredibly rich – the performance and the setting prompted a powerful medical audience to reconsider their perceptions of, and behaviour towards, people with learning disabilities; they had literally seen them in a new light. For example, one audience member, commenting on the 60 Jars installation situated amongst the Medical Museum samples collection, stated:

> It was so unexpected to see this in a medical museum and of course it was so fitting. The dialogue between the museum's collection and the works. Jars with hearts or other organs in formaldehyde, conversing with jars containing self-representation of the artists themselves.

For some Contemporary Artists, curators and commissioners, the most important thing remains the sheer numbers, presence and visibility of learning-disabled artists in a society that, at times, continues to ignore their existence. However, we believe solely increasing the presence of people with learning disability and their work in the cultural sphere is not enough. It is a tokenistic diversity strategy (cf. Darke 2003). Rather, greater recognition needs to be given to the particular contributions and cultures of making that people with learning disabilities can deliver in the cultural sphere, and the ways in which collaboration with people from diverse backgrounds can give work a creative edge that would not otherwise exist (a point Jude Kelly, Artistic Director of the Southbank Centre, makes here). Arts Council England refers to this as 'the creative case for diversity'.

Furthermore, where possible, people with learning disabilities should be placed at the heart of curatorial and commissioning decisions made on their work. For, like other artists labelled as 'Outsiders', the history of the representation of artwork by people with learning disabilities is predominantly a history of other people deciding how their work should be presented and curated (Jones et al. 2010). Visual artwork has tended to be viewed in Outsider exhibition spaces or community venues, with

▶ Rocket Artists
Measures of Bodies
Musée de la
Médecine, Brussels
Site-specific
performance
2010

Curation, biography and audience encounter

◄ 60 Jars
Rocket Artists, MA
Inclusive Arts Practice
staff and students
Measures of Bodies
exhibition, Musée de
la Médecine, Brussels
2010

little participant involvement in the selection, interpretation or curatorial process, and curators choosing to place an emphasis on the social or diagnostic labels of an individual or group of artists. It is hoped that presenting work in this way can help combat the stigma and oppression faced by such groups. However, as we discussed in Chapter One, labels are risky – they can end up reinforcing the very categories they seek to challenge.

The life story, diagnostic label or other 'marginalized group' label of the artists can end up obscuring other aesthetic dimensions of the artwork itself and, at worst, curatorial decisions may push the audience into a guilt-driven 'didn't they do well' response rather than a more critical reflective response to a piece of work. This relates to the broader issues of galleries targeting marginalized groups, the need to value and frame this work in the best possible light and the need for integrated community gallery spaces. Anna Cutler (Director of Learning at Tate) explores these issues in this chapter.

One option for curators of visual artwork is to retain an emphasis on the formal components of a collection. This approach avoids biographical context and tries to encourage a more uninterrupted engagement with work on a purely aesthetic level – letting the art object speak for itself to some degree. Such an approach might also involve displaying work alongside that of other Contemporary Artists who are considered more 'mainstream'. For example, there have been exhibitions that deliberately chose to display the work of so-called 'Outsider Artists' alongside that of other mainstream Contemporary Artists in order to demonstrate how all work is equally valid as art (see Jones et al. 2010). However, this approach can be successful only if the work of the so-called marginalized group is given equivalent value, space, materials, production costs, framing quality etc., otherwise the work can end up looking like a weaker equivalent.

Anyway, for many of the practitioners of work pictured in this book, the aim is not to merely 'prove equivalence'. Rather, the aim is to demonstrate some of the unique work that arises from learning-disabled social experience, culture, cogni-

tive features and embodiment, and what can be made in collaboration with these people. As Jude Kelly points out, the distinctive rhythms, gestures, temporalities, modes of moving and visualizing are what often give this work a creative edge that other mainstream work cannot offer. In fact, if the work was just the same as the so-called mainstream, it may not necessarily be worth commissioning.

We advocate inclusive commissioning and curatorial processes that enable the people whose work is exhibited to make certain aesthetic, curatorial and representational choices for themselves, in whatever way is possible. Claiming the title of artist, co-curator and commissioner, as opposed to people with learning disabilities, can often affect expectations and outputs. The conversation with Alice Fox illustrates how this is possible through a discussion of inclusive curation at the Side by Side exhibition at the Southbank. We think it is important that the complexities and tensions which exist in presenting work in this field are acknowledged and drawn out in any accompanying exhibition text or performance. Highlighting the creative challenges and opportunities involved in curating and commissioning work by learning-disabled artists can help guide the audience towards a more reflective response. Self-authored artists' statements offer another opportunity for the artist's voice to emerge, for individuals to represent themselves rather than to be, once again, observed and talked about. However, supporting a learning-disabled artist to write an artist's statement is an art in itself, and one that needs to avoid an overly simplistic, worthy, sentimental or sympathetic response. The best work in this area tends to emerge from well-established relationships.

For people with profound and multiple learning disabilities the artist's 'statement' often remains within the artifacts themselves and the primacy of the marks made. However, consenting to work being publicly displayed or performed may be beyond their capacity. Jones et al. (2010) in the book Framing Marginalised Art explore these issues in more depth with a multidisciplinary team that includes philosophers and curators. They advocate the idea that the exhibition of work without consent is justifiable if deemed in the best interests of the makers and wider society. In fact, they proceed to argue for a 'multi-dimensional ethical model' for the display of work, which asserts: 'The medical, scientific, philosophical, ethical and aesthetic dimensions of the works are all equally important in reaching a full understanding and appreciation of their significance' (Jones et al. 2010, p. 8).

However, in contrast to this approach, we think it is important that curation and commissioning respect the makers of a piece of work, aim for a collaborative curatorial process where possible, and do not focus exclusively, if at all, on the relationship between the artwork and the particular label or diagnosis of its creator/s. Furthermore, always aiming for an audience to have 'a full understanding' may be inappropriate for such work. Rather, it might be important to foster a sense of questioning and uncertainty through collaborative curatorial and performance processes, as this may encourage a more reflective disposition amongst the audience. When people are not boxed into their expected social categories, interesting and transformative things can happen. This sense of unknowing that can be fostered through work and performance is discussed in more detail in the conclusion to this chapter.

Artists' statements
Rocket Artists

.

This work is about the friends, carers and NHS professionals who helped Louella when she had a heart attack in 2009.

"Dr Rachel James, Royal Sussex Brighton, Diana, Sharon at home and NHS saved my life" Louella Forrest

Louella's NHS pouches have been meticulously worked on both sides, the fronts that you see here are for public view. The backs hold Louella's private writings to the individuals involved. She requested these remain private and face the wall. Inside the pouches are kept letters and messages, these have been removed for safekeeping by Louella. The titles help to tell her story

NHS Pouches
1 Diana – close to me
2 Sharon
3 Alice advocate10 years, she very funny
4 Jane, John
5 "Stand back and clear"
6 NHS Brighton Sussex staff
7 NHS Brighton Sussex staff
8 Heather Ellis, day centre worker
9 Natalia – NHS photos we did it together
10 X Ray men
11 Mary Anne, best NHS
12 NHS Brighton Sussex staff
13 Drivers very helpful with me, they're gorgeous

Pouches of Art
1 Day time – very good at art
2 When drivers came and got me out of the fire exit 2009
3 Pacemaker inside the skin into heart
4 Louella – be happy with my artwork, I love it with Alice, Jane. I miss it all
5 Louella – always colouring my artwork, hope I come back
6 First aid bag – when I holding it
7 First aid book with a cross
8 Doing on my own with my good arm

Research question
How can creative practices operate as artists' statements?

▲▶ **Artist statement as artworks**
 Louella Forrest
 Rocket Artists

42

**SOUTHBANK
CENTRE**

ARTS COUNCIL
ENGLAND

43

Peter Cutts
My artwork is about flying birds and strange animals. My ideas come from my head and books and my life. I use inks and screen-printing to make my work.

In The World of Flying Animals the birds are flying, the dolphins are flying and walking around and they are happy. There are beautiful flowers and trees and the birds are flying all over each other. I am proud of my work.

Peter has exhibited artworks in In The Frame, Tate Modern, London, Measures of Bodies exhibition, Musée de le Médecine, Brussels and won an Outside In award resulting in a solo show at Pallant House Gallery, UK. Recently Peter's screen-prints were exhibited at the Side by Side exhibition at the Southbank Centre, London.

▲ **Artist statement, written**
Peter Cutts
Rocket Artists

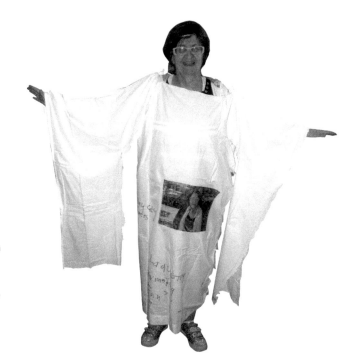

▲ **Artist statement as animation**
Peter Cutts
Rocket Artists

▶ **Artist statement as 'who am I'**
Kristen Grbec
Rocket Artists

▲ **Artist statement as self-portrait as an artist**
John Cull
Rocket Artists

Alice Fox on inclusive curation: putting on the Side by Side exhibition at the Southbank

The Side by Side: Learning Disability, Art and Collaboration exhibition, perform-ance and symposium was held at the Southbank Centre in March/April 2013. Funded by Arts Council England and directed by Alice Fox, this was the first international exhibition in the UK to feature paintings, drawings, sculptures, films, animation, music, installations and performance created and curated by learning-disabled artists working side-by-side with their non-disabled collaborators. Exhibi-tors included the Rocket Artists, Project Art Works, Action Space, Corali Dance Company, Kunstwerkplaats, Mayfield Arts, Heart n Soul, TV Glad, Inventura, Barner 16 and KCAT Inclusive Arts. Stay Up Late's jukebox featured music by over eighty international inclusive bands from around the world. Side by Side show-cased over 150 artists and thirty arts organizations from around the world. The creative activities at the Side by Side symposium included:

- Dance with Corali. Places and spaces: How can people experience inclusive practice differently?

- Dance and Decisions with Stopgap Dance Company

- Rocket Artists: Conversations with shadow and light – where is the magic in working together?

- Rocket Artists: Collaborative drawing with Rocket Artists: How can Inclu-sive Art help us understand each other?

- Music with Stay Up Late: The rules are … there are no rules.

The aim of the symposium was to redefine the notion of 'expert artist' and to devise working methods that answer the question 'How can creative, inclusive strategies be used collaboratively by learning-disabled artists and their non-disa-bled colleagues to curate a large-scale international exhibition?'

Hannah Can you tell us a bit more about the inclusive approach to curation that you took for the Side by Side exhibition?

Alice Curating can be viewed as a series of choices to be made and prob-lems to be solved. So in order to support inclusive curating with learning-disabled people, we needed to support people to tackle those choices. Visuals help support choice making and curating an exhibition in many ways is quite an easy process to make accessible because it is a series of visual decisions. It's all about 'where shall we put that object' and 'how does it look next to that other object, and what story do they tell together?'.

Hannah So how did that work in practice for the Side by Side exhibition?

Alice Well, this involved approaching organizations that we knew were lead-ers in the field of collaborative practice from across the world. Each organization/artist was invited to submit up to ten images. This meant

we received over 300 images to select from. Then we had a curation team, including learning-disabled Rocket Artist Kelvin Burke, and Tina Jenner, Jo Offer, Jane Fox, myself, Rohini Malik Okon and Paul Denton (Southbank Centre, participation team), and Kate Adams (Director, Project Art Works). We couldn't get into the Spirit Level gallery prior to the exhibition, so we had to devise strategies to support everyone to use their imagination to envisage the gallery space. Jane made a scale map of the Spirit Level gallery floor and walls. This map was huge and covered a large floor in the Phoenix Studios. Jo also made to-scale, colour images and sculpture maquettes of all the pieces of selected artwork to place on the map. So once we had conveyed the concept of maps, and the concept that these were small pictures that represent the real larger versions, we could start to position them on the map and see what looked good together and what worked in the space.

So we started with a huge pile of images, discussed each piece and sorted them into 'yes', 'no' and 'maybe' piles. Now usually, when you put on an exhibition, there are selection criteria to support decisions such as content, materials, narratives, context, etc. So we tried to agree a set of selection criteria as a group. The problem, though, was that some of the concepts behind typical selection criteria weren't accessible or meaningful; it was too heady and abstract, or totally subjective, such as 'I don't like yellow'. So instead we collected some of the images that we had all agreed we definitely wanted in the exhibition (without articulating in words exactly why), pulled out others and compared them next to the ones we had all agreed on. So then we were able to do a visual comparison keeping the standard high whilst maintaining a consistent aesthetic and narrative of similarities and rub. This largely unspoken, verbally unjustified decision-making process kept the contemplations within the visual language and enabled everyone to trust their instincts and knowledge. We also had some very funny 'disagreements' during 'discussions' of images being taken (without the group's consent) to and from the 'yes' and 'no' tables. Towards the end we reviewed the selected images to make sure organizations we admired were represented in the exhibition … to be honest, we could have filled the Southbank twice over with all the brilliant work we were sent.

I think all curation is ultimately subjective and usually the vision of a singular powerful, male 'star curator'. Our process felt good and had a validity and rigour that worked for everyone in the group.

Hannah And how much of a steer did the Southbank provide?

Alice They weren't steering at all. They were just really interested and helpful; they hadn't been part of an accessible selection process like this before. They said it was a transferable process for all collaborative curation teams and that the visuals made it all really clear. Once we had selected the work, we started to position it on the map – 'does this fit with these other pieces or not?' We all had the chance to expand our thinking and vocabulary on aesthetics of placement, space, light and sound. The other in-

teresting aspect of the curation was the gap between what organizations thought we might want to put in the show, and what we actually wanted to exhibit. For example, the Kunstwerkplaats sent us ten images that were very traditional representational art, fitting closely into a mainstream aesthetic of 'good drawing', but that sort of work wasn't in our vision for the exhibition. So we decided to visit their centre in Amsterdam, and saw so much amazing artwork that they hadn't submitted. That's when we found the 35 [ceramic] horses heads,10 Rick heads, 4 dog heads that ended up being a key exhibit. This highlighted the gap between what people thought was 'excellent' work that fitted into a normative, representational safe aesthetic expression, and the more edgy, radical, fresh, painful and soulful pieces we searched for.

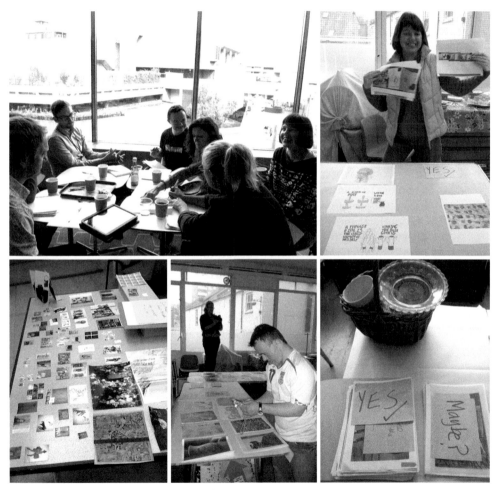

▲ **Inclusive committee curation, Side by Side**
2012–13
The Rocket Artists alongside University of Brighton academics devised practices that asked:
Research question
How can creative, inclusive strategies be used by learning-disabled artists and their collaborators to curate a large-scale international exhibition?

Curation, biography and audience encounter

Hannah Was that a consciously different approach from something like The Museum of Everything, which had a big show at Selfridges the year before?

Alice Well, The Museum of Everything situates itself as 'Outsider Art' and squarely within the 'lone genius' art market, whereas Side by Side was about collaborative practice, meeting points and conversations. But some of the organizations exhibited by The Museum of Everything were also represented in Side by Side. In our exhibition they talk about 'collaborative practice', whereas the organizations behind work at The Museum of Everything are often represented as being facilitative only, merely providing rooms and materials for excluded, talented individuals. Given that the facilitators in these organizations are largely artists themselves, there are some interesting conversations to be had there around at what point work is represented as collaborative or facilitative, and when does the balance tip?

Hannah Have you had any other experiences of inclusive curatorial practice?

Alice I supported learning-disabled artists to curate an exhibition in the early nineties. There were eight artists who were all allocated a wall each, they then positioned their work without support or curatorial knowledge ... wherever they put it, it was hung. That was interesting but really challenging, a lot of the work you couldn't really see properly, we didn't support people to learn the skills required to assemble a collection of work. In the name of self-advocacy they were just literally placing things on a wall – so we had some pictures that were really high, some pictures that were really low, and some pictures that were randomly at the side. The rhetoric of the organization I was working with was, well, 'it's their choice', but for me the choices weren't skilled or informed choice. When I'm asked to do tasks I haven't got the skills for, I feel unsafe and exposed. So through giving people that amount of autonomy, what they lost was the work being seen in the best possible light, because they simply didn't have the curation skills. So for Side by Side I didn't want to do that again. That's why the curation team was made up of experienced curators and learning-disabled artists. The exhibits were hung on the wall using a set of standard measurements that all galleries use. So the hanging team at the Southbank advised us on that, and we used the lower end of those measurements in order to make the work and videos accessible for wheelchair users.

Hannah So it is interesting the tension that you are navigating between traditional expectations of the gallery space and curation versus a more collaborative approach.

Alice Yes, the people who make the work tend to be socially undervalued, which means the work itself may be undervalued. But there are strategies for making artwork more valued, such as positioning it in a valuing gallery, for example the Tate or the Southbank, framing it in a beautiful, well-made frame – so that the frame itself says 'this is an important piece of work' – and then presenting and lighting it in a really hot,

contemporary, professional manner. This approach means the audience can see the curators have taken the work seriously and gives the work a better chance of being seen in an appropriate light.

Hannah And did you include much biography in the Side by Side exhibition?

Alice Well, all the artists could include some biography if they wanted to. So we had some biography up, we had some artist's statements up, we had some big laminate quotes up. We wanted the voice of the artist to come through, so we supported them to come up with statements about their motivations and what they were thinking about when they produced the work. Where people had more profound learning disabilities, we had statements from the collaborators they were working with. Some of the work was made specifically for the space, which worked well – Lasmin Salmon from Action Space submitted twenty beautiful cylindrical felt sculptures, and there was this big white pillar in the gallery – we thought, 'how fantastic if this pillar was just covered in Lasmin's sculptures', so then we pitched to Action Space 'does Lasmin fancy making lots more of these?', and she said yes, so that was wonderful ...

Hannah And for the opening, Rocket Artists and Corali Dance devised a collaborative performance?

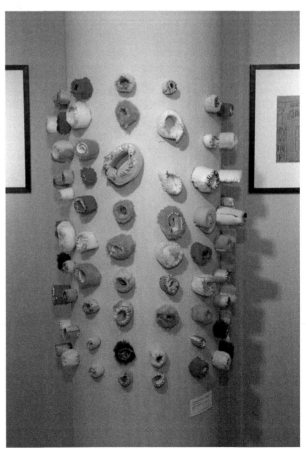

▶ Lasmin Salmon, Action Space, UK
Untitled Side by Side exhibition,
Southbank Centre, London
Fabric, plastic, foam, thread, 2013

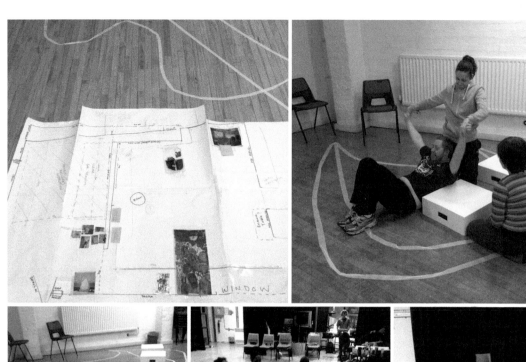

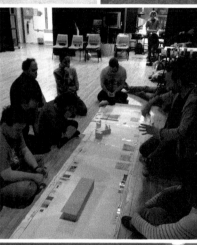

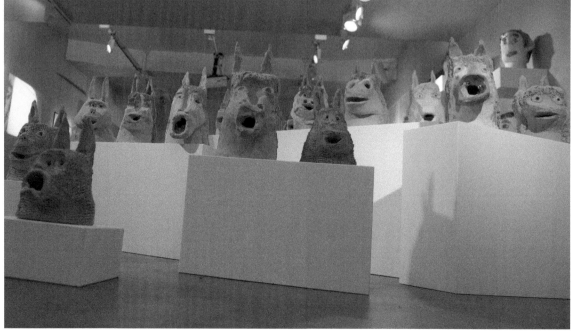

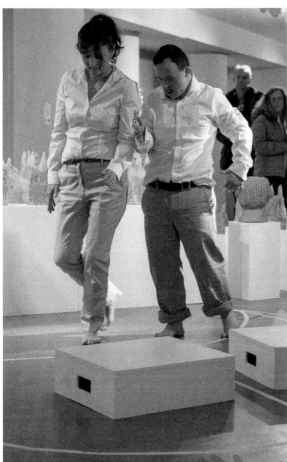

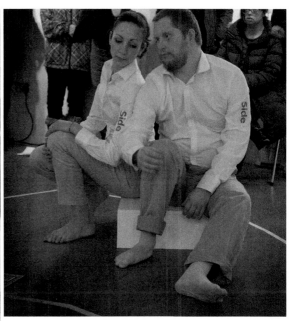

Rocket Artists and Corali
Side by Side, Spirit Level gallery, Southbank Centre, London
Site-specific performance inspired by curation map and exhibits
2013

Research question
How can inclusive choreographic strategies support a group of learning-disabled and non-disabled dancers to engage meaningfully with the Side by Side exhibition?

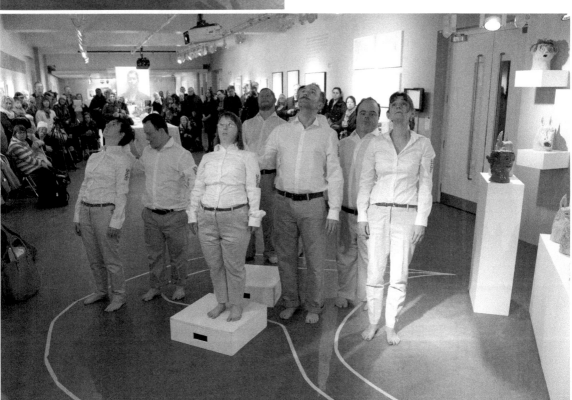

Alice Yes, for the opening we used some of the aesthetics of the curation as inspiration for the performance. So by that I mean maps, lines, crosses, measurements, masking tape, numbers, all of those things. We used all that measuring and planning as a starting point for the performance. Because the curation was a fluid, dynamic, ever-changing process really, and I think in the end we had about fifteen versions of the gallery map. This massive piece of paper that we were constantly taking pictures of and sending to each other – and we couldn't even get it onto one frame. That was the 'stuff of curation' and all of that went into the starting points for the performance. The exhibits and the space itself also fed into our performance. That process was all really exciting and brilliant because Kelvin (a learning-disabled artist on the curation team and in the performance group) could really lead and show the performers what the gallery map was about. In the final exhibition, there was the large group of ceramic sculptures, entitled 35 horses heads, 10 Rick heads, 4 dog heads by Norris Francesca, which we danced around and mirrored in the performance. Collaboratively devising the performance alongside the artworks was an incredibly rich way of experiencing, interacting, looking, touching, spending time with, effectively being in intimate audience with the exhibition artifacts.

Hannah Can you tell me about the symposium you organized to run alongside the Side by Side exhibition? You called it a 'thinking through doing' day...

Alice We wanted to devise a symposium that was structured to elicit and gather everyone's ideas and opinions. I've been to many symposiums where the communication remains within talking and writing. However, we already understand that the artwork itself speaks volumes and gives us information of a different type. Also, the people we are collaborating with often find it easier to be articulate within their creative medium. So what we wanted to do was offer people the chance to express themselves through their creative practice in a symposium format. There were 150 delegates, with and without learning disabilities, from a range of backgrounds and professional interests – artists, educationalists, performers, curators, health professionals and thinkers in the field. We had eleven creative workshops run by collaborating artists: the Rocket Artists, Action Space, Intoart, Stay Up Late, Stopgap Dance Company, Corali Dance Company and Project Volume. Each delegate had the opportunity to collaborate and communicate with others in a variety of workshops, including music composition, sculpture, drawing, dance, choreography, photography, creative writing, puppet making, shadow installations and songwriting workshops. Importantly, these workshops were held amongst the exhibition or in interesting spaces in the Southbank, serving as creative prompts for delegates to respond to.

Hannah And why did you choose to approach the symposium in that way?

Alice Well, one of the things we have noticed is that, if you only use words, you typically get people without learning disabilities or only the most verbally articulate learning-disabled people speaking. The risk here is,

unless delegates are very skilled at facilitation and listening, we may accidentally overlay one person's voice and opinions with another's, without even realizing it. It's a very uneven playing field and disempowers those who may be less comfortable articulating ideas through speaking. So we thought about the aims of the symposium and realized the most important opportunities at most symposiums were to meet people, network, communicate and learn from each other. The way we know how to meet each other, as artists, is through our creative practice; we do it all the time with the Rocket Artists, so creative media and practices were used to support communication and 'discussion', something that Peggy Phelan usefully names a 'bilingual approach using word and image'. In this case we went further – into a multilingual world including images, words, movement, shadows and sound.

Hannah　So how did the Side by Side workshops contribute to the Inclusive Arts Manifesto Draft 1?

Alice　Prior to the symposium, we met with the workshop leaders and discussed which topics were important and relevant for the symposium. Then each workshop was asked to use creative practice to explore and reflect on a chosen topic. For example, Rocket Artists were working with puppets and shadows to explore ways of working together equally. Each workshop was tasked with making a minute of film capturing their activities and opinions to show to all the delegates during the closing session.

These film clips were then edited together to make our Inclusive Arts Manifesto: (http://arts.brighton.ac.uk/projects/side-by-side).

▶ **Curation map**
Rocket Artists
Map of Spirit Level gallery, Southbank Centre, London, as used by Side by Side curation team and performance group
Design by Jane Fox

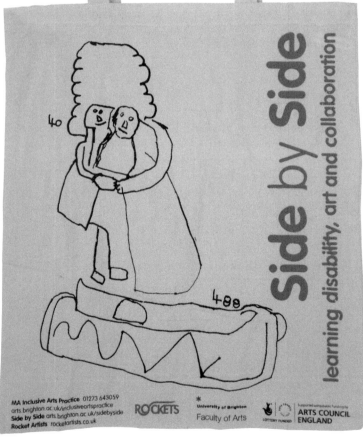

▶ Andrew Pike, KCAT, Ireland
Keynote, Side by Side symposium, Royal Festival Hall, London
2013

◀ Side by Side symposium, thinking through doing day
Delegates' bag
Used for note-taking/ drawing/thinking during the day
2013

What was successful was that we know each person who attended a workshop wasn't alone – rather, they were with someone coming together through creative exchanges, so they fully 'met' each other and shared ideas. Some of the one-minute clips that came out were very specific; for example, there was a song that addressed the right to inclusive opportunities. Others made dance duets, using the language of dance to express ways for people to 'be with' and 'know' each other.

Hannah And what did you hope would come out of that?

Alice Well, by bringing all these pioneering organizations together, what we hoped would come out of the symposium is a sense of an Inclusive Arts movement. Because while there is a lot of really good practice going on, it isn't necessarily captured, articulated or shared. The film manifesto is called 'Draft 1' because we hope people will build on the ideas in it. It's in its infancy, but it is a shared voice. It is the first group manifesto built collaboratively by artists in the field. It describes what inclusive, collaborative practice currently is.

Manifesto for Inclusive Arts Practice / Draft 1
Film stills 2013

Inclusive Arts Manifesto

Draft 1 2013

Side by Side
learning disability, art and collaboration

Make a mess

Say what you feel

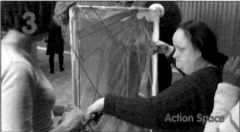

4

'Break out'

Action Space

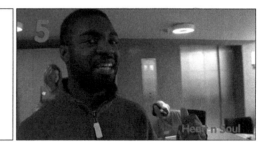

6

'Freedom to experiment'

Heart n Soul

Get it out there!

8

'Make up words'

Rocket Artists

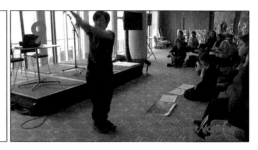

Being open to all the languages we speak and finding the bridges between those languages

10

'Equality of leadership'

Project Volume

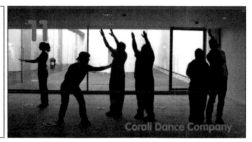

Corali Dance Company

Not being on the outside, we are there, where it's at. Being inspired by each other, working in different ways

IntoArt

We all see things in differet ways

Andy Kee

Don't take yourself too seriously

Rocket Artists

14

'Look for new experiences'

Rocket Artists

15

'Make art and jokes'

Rocket Artists

Rocket Artists

Working together we find the story.

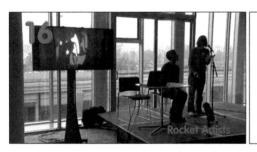

Rocket Artists

17

**'Just see what happens
- there is no correct
order'**

IntoArt

Suprising things happen when we work together.

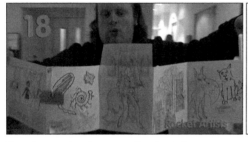

Rocket Artists

19

'Words are not enough'

Rocket Artists

Together in a head space and a physical space

20

**'Lean back to move
forward'**

StopGap Dance Company

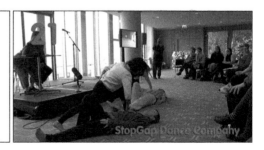

StopGap Dance Company

22

'No-one can stop us'

All delegates

To be continued...

This manifesto was created from a series of creative workshops organised by the Rocket Artists and directed by Alice Fox at the Side by Side symposium, 22 March 2013.

Side by Side
learning disability, art and collaboration

Research question
How can creative practices be used to meaningfully engage learning-disabled people and their non-disabled collaborators in the exploration of what constitutes Inclusive Arts Practice?

http://arts.brighton.ac.uk/projects/side-by-side

Art and inclusion: what is shared with other artists and curators who are placed at the margins?

When thinking about learning disability, art and collaboration, we've found it useful to understand how the work of collaborators relates to the practices of other marginalized artists and to the civil rights movement itself. For, while certain experiences of learning disability can render their collaborative art practices quite distinct, the socio-political work that is taking place in such work holds a lot in common with other artists who have been placed at the margins. For example, the work and underpinning philosophies of some feminist artists and curators offer the Inclusive Artist useful methodologies for research and practice (hence the conversation here with Catherine Morris). Expanding practitioners' horizons of interest beyond a narrowly defined 'disability arts scene' also helps the process of what Jude Kelly refers to as 'recalibrating who we think our equals are' and helps Inclusive Artists understand some of what they and their collaborators hold in common with other artists who have been placed at the margins.

Jude Kelly, Artistic Director of the Southbank Centre

Alice So, our first question is, what do you look for as a commissioner and as a big organization that puts on participatory practice, what is quality in this field?

Jude Well, our starting point would be that you have to believe that everybody's potential is unrealized, including mine, and that therefore the practice of participation is about unlocking that – the change of potential that happens, in all of us, when you're involved together, making something. This involves a surge of creativity or imagination, or the introduction of a new dynamic or approach that will come from the participant as much as it will come from the 'designated artist'. So what we're looking for first of all is a framework of profound respect and an excitement about what participation holds creatively for everyone. So the quality of the encounter between people has got to be predicated on the idea not only of respect that everybody together is likely to be able to do something – introduce an idea, change the dynamic, in a way that will surprise everybody – but that the work is really made between everybody. So different artists who might be thought of as leading a project, their work is likely to be changed and they are likely to be changed by the participants. So, I suppose the first measure of quality is the integrity of approach, and then the second measure of quality is this mixture of leadership and congregation – to be so integrated that the work could only be produced through participation in a particular way. The idea has to be strong as well, it might emerge from something quite fragile, but if they're then going to make a piece of work, you have to feel that the work has a strong idea that is central to it. So in lots of ways, the criteria for how we commission would come out of our belief that the artist, if it is an artist who brings you the idea, that they aren't doing the participatory work simply as a sort of add-on extra. It's got to be integral to the practice itself.

Alice So, in a project like the Side by Side exhibition, it was fantastic for us all to have work shown here, and to have that kind of audience and valuing that it gets from being here and not in a day centre, for example. So what is it that the Southbank gets from hosting something like Side by Side?

Jude Well, we believe in cultural rights as a profound part of human rights – everybody has the right to have the arts in their lives. But also, everybody has the right, I think, to understand other people's lives through forms of expression that often end up needing to be artistic, because they're the ones that cross barriers. The Southbank Centre in post-war Britain was a way of thinking about what a progressive future could look like, so the Festival of Britain had this phrase, 'The propaganda of the imagination', which was from the war artists, and it was very much about, if you're going to keep and maintain peace, you have to be in love with humans and you have to be in love with many different kinds of humans, not just your own tribe, not just your own people, not just within your own comfort zone of what you know and who you know. So a lot of the Festival of Britain was cultural, rather than just a pure appreciation of the arts. And certainly, since I've been here, I've been very keen that the cultural activism of this site should be its main component. In other words, you use art to explore what it is about humans that has incredible potential for good, and also how do you steer us away from malignant tendencies?

So something like Side by Side, it forces many people to reconsider who they are thinking about when they imagine a world of equals. So, like the civil rights movement that Martin Luther King led, that made people recalibrate who they imagine their equals are. That set of questions is still happening for women all over the world. Men are having to rethink and recalibrate what an equal is, and I think that is also true of people who have different learning abilities – different learning abilities in the way that we currently frame learning. But I honestly think that humans are still having to adjust all the time to understanding who makes up this world and what equality looks like. So I could say some very obvious things, of course, about the fact that once people see real skill, real talent, real conscious thought, real sets of choices, etc., then automatically humans are less dismissible. But I think it's more profound than that, because you would still have to say that what Side by Side guides you towards is saying that, for all the people who are in the exhibition who are obviously claiming an artistic space, there are plenty of other people who wouldn't be claiming artistic space, but have potential in other space. So I suppose Side by Side not only puts forward the idea that you can be an artist because of your commitment to expressiveness through a particular set of disciplines and that learning difficulty isn't a barrier to that, but it also leads the way to thinking that people with learning difficulties have desire and therefore rights in lots of other arenas as well.

Curation, biography and audience encounter

Alice Absolutely. So in terms of the quality of the work ... the art ... the actual product. What do you think would be missing in the Contemporary Art world if this work had no platform? What's the contribution?

Jude Well, I think contemporary visual arts space is still quite fraught, maybe it always will be, by a kind of schizophrenia around the market being one judge of artistic excellence versus the idea that art matters to all of us, which is another way of looking at the value of art. So, yes, the exhibition was very high quality ... they had to make it, it is their form of expression and, you know, I think we're not at the stage yet where it's validated, inevitably validated as artistic practice, I think it will still often be seen as a delight and a surprise that those people do it at all. But just as we showed with the Paralympics, and in fact the whole of the Unlimited festival that we did this year, with Deaf and Disabled artists, there comes a moment when those artists move from something where people are delighted that it's possible, through to recognizing that the work has something to teach us. But I don't think the professional arts scene is there yet.

Alice And how important would you say it is for the audience to have some kind of biography of the artist? Or is that countering this idea that we don't need a biography, the art stands alone?

Jude I believe that the whole issue of signage in galleries is difficult anyway. I think there should be a lot more signage. I think there should be a lot more biographies. I think there should be a lot more explanation, be-cause it's purist and elitist in the wrong way to ask people just to make their own way through the enormous amount of art that's created, so much of which is abstract. I think it's ridiculous, I've seen so much work that is often a reflection on other pieces of work that went before ... So I think there should be a lot of signage, and a lot of biography, and a lot of explanation. I also think this is about story, human beings love story, and so when you understand a story of a piece of work, you look at it much more attentively, you give it more respect. It doesn't make it easier, if anything it allows the audience to take time with the piece and ascribe to it proper complexity, as opposed to simply going 'oh, I don't really get it'.

Hannah And how do you know this? How do you evaluate the impact of this work on audiences? If at all?

Jude Well, there's a long-term evaluation, isn't there, which is that the lan-guage of inclusiveness would change, and that when people talk about artists they assume artists of all ability. Like, you know, still to this day in some societies 'artists' can't mean a woman, just can't mean it. Whereas in other societies you know that it means women. So, the legacy is a different attitude to human potential, going back to the beginning really about what makes good participatory work. And in a shorter timescale another legacy, certainly for the Southbank Centre, is a sense of entitle-ment by people from the disabled community or the learning difficultly community that this is a place they will expect to feel welcome in,

respected in, and they can see work by people that they know here. So a legacy for us is a greater sense that people trust us to want to include people ...

Alice And how do we create an artistic movement that values these ways of working? It's a big question.

Jude I don't know immediately. I mean, obviously what one wants is to create an artistic movement in order that, at some much later stage, you don't have to have one. I think you can only do that by doing what you were with Side by Side, which is getting people to be surprised that it's beyond their expectation and that makes people reflect that they have assumptions, or that they bring assumptions that are inappropriate. And obviously the more places like Whitechapel or Margate that will validate it through exhibition, the easier it then becomes for people to join in. You also need two or three more Brighton courses, don't you? It needs to be done in other places. Then you get a critical mass and then a tipping point, and people will start saying 'well, this is normal'. Because I think practice for Deaf and Disabled artists, I think that has reached a tipping point, I think that is a movement. But it's been quite difficult for learning-disabled people to join that actually ... because if you have a physical disability, you can talk about your opinions. But learning-disabled artists need some support around finding a voice.

Anna Cutler, Director of Learning at Tate

Alice What are the quality indicators that you're looking for when you commission participatory practice?

Anna For me, it's got to start with an ambition for artistic excellence, it's got to involve a decent human being and someone with experience and knowledge that can manage the complexity of the situation. And often the situations are complex, because practitioners are in an environment that already isn't inclusive. So I start from a position of trying to understand the environment we're in and to accept, on the whole, that many institutions, including the ones we all work in, exist on the principle of accidental exclusion, that actually they're already not suitable for everybody. So what we're navigating is how to pull back from accidental exclusions that are inherent in our practices and the processes of everyday life, in our institutions and our buildings. We have had a lot of conversation about this, and many questions. How useful is it to have a community arts team who might be seen to 'target' certain groups in terms of access? Should we be making that differentiation? I personally think we do need to do so, even if it's problematic, we need to make those invitations (to marginalized groups) visible and as explicit as we can ...

How we approach our response to this is different in each of our teams, but it is always artist-led, and the approach would consider the use of space, time, content and method. So, we would always work with an artist and begin by exploring their practice, relative to whatever

community we're working with. For us, the whole point of bringing an artist in is they can question you and rub against the organization a bit and take you forwards. It's a healthy generative process.

Hannah And then how does that work make a transition from community space to what gets seen in a Contemporary Art space, and how does that work?

Anna Most of our work does happen in the gallery environment, although there might be sessions off-site to prepare people, but often we work with the teachers first, or whoever's leading or facilitating the participants. Much of it is about time, it's about valuing time, and some quality principles are about recognizing things take time. We are looking for a set of values in people we work with that resonate with what we're trying to achieve, and with some sort of integrity. In my experience, a very good process results in a good end game of some description, whatever that end game is. So, our practice tends often not to be outcome-based necessarily – sometimes we do produce work, but there are all sorts of interesting questions about whether you want to display work or not – it can be undermining in some respects to put participants' work into a main gallery context unless you have a lot of money to value work appropriately.

 For example, we wanted a space that gave value to those outcomes, and built a bespoke gallery space that looks and feels as beautiful as any other space. But any gallery space is difficult, it's a very complex place to be; you're with lots of different publics, who all have different expectations, you've often got a set of what was once termed 'overly entitled' people who think that their way of doing things is better! So it takes a lot of resilience in an institution and with the teams to make a difference and challenge that. I think our team is quite brave, they're prepared to really push it. At the moment, our schools team is working with Touretteshero, in Tate Britain, for young kids with Tourette's and their families. They want to make it large-scale and inviting, because part of our process is making the invitation, and difference, visible.

Alice So, talking about working with that difference, how important do you think, for an audience, for the public, is some kind of biography around the people who are making the work?

Anna I think it does need some framing. That's why I said that I tend not to put work in the main gallery space, because you're measuring it up against a very different set of values and ideas and understandings. So I feel like you have to set the conditions for it to be read in the way you want it to be read, and that should offer as high quality as you can. But it's about those four things again, it's about space, time, content and method, and questions around those four things need to frame every piece we do. From the kids who make work that we've put up, to disabled artists who might have incredibly limited movement. Unless there's a context for it, or unless there's a lens through which people can read it, you're in danger of misrepresenting the work and the participants themselves. On the other hand, it's important not to over-explain and take away from the work itself ... at times it's about getting people to

speak for themselves in ways other than the art, which is difficult, because the point is often to speak through the art.

Alice Yes, we have this tension all the time in the art school: we get 'can't the work speak for itself?'. And it's like, well, it can do, but you're missing all this if it does.

Anna I think that's why my team have got increasingly keen on the journey rather than the end game. It's about the process … then how you document becomes a really serious issue, because that's part of the quality … what you don't want to be doing is speaking on other people's behalf, you know, the indignity of that is staggering. So how do you manage that? So that people are representing themselves in an effective way for everybody? This is why, I guess, film can be so great – but of course has its own issues.

Hannah And what have you seen in terms of the benefits for the institution of collaborating with people with special educational needs or learning difficulty?

Anna I think that, fundamentally, we all need to challenge our concept of normality, we need to bring in a sense of difference, we need to have a sense of humour, we need to remove the patronizing level of assumption and opinion. And it does do all of that when you work with SEN groups or those with learning difficulties. … [And] the idea that the Tate is a public space in which people can all be in the same space together – that in itself is a bit of a gem, an opportunity. It invites a different energy, and invites different sets of behaviours. For example, we had a special educational needs group here who all laid on the floor and did various activities with lots of unexpected expressions at unexpected moments, and it was completely unnoticed and totally integrated into the daily routine and culture of the building, so there's a kind of acceptance, and I hope equalizing, of different behaviour here. … And when you're participating, you're all being seen through a certain lens that is not about categorizing who you are, but rather about the quality and value of the activity going on … if art can't do that, what the hell can? Isn't art the practice that engages with difference? If we can't make that manifest, then shame on us.

Alice And do you think funding structures compound exclusion? Or what are the challenges around that here?

Anna Well, what's quite complex is how we silo things – so having a pot that is for this or that means that you're always locked in potentially to 'meeting the needs of disadvantaged people'. It works from a kind of deficit model, which may be useful for funding, but actually maintains work in a certain ideological frame.

Hannah Sometimes you go and see some sorts of socially engaged or community outreach practice and actually it seems to be just kind of poorly informed social research. So how do you avoid turning artists into weak social researchers?

Curation, biography and audience encounter

Anna It has to be about working with artists whose practice reflects the process you describe, and I suppose we try to select the kind of practices we feel can ask and respond to that question the best, including those who succeed in artistic quality. But while some socially engaged artwork takes a sort of general situation (or people or stuff),and turns it into a singularity that becomes the art (so participants become part of the artistic end game), for me learning is about taking the singularity (the art) and unwrapping it into being for the many – obviously, somewhere in there, there's a bit of a messy middle. After a talk in Australia, a member of the audience said to me 'You know, I've always thought that art education was like sex education. You know, all the bits that you didn't want to do … the not engaging stuff, the embarrassing bits you have to listen to, all the horrible details', and then he said 'But now I realize that learning is the sex.' It's the moment of making meaning, it is the interaction between the viewer and the work. We look for practitioners who have a deep understanding of how you create conditions that enable participation with ownership in creating work, or who are able to make their own meaning from the work and who can navigate that messy middle.

Hannah There's a whole feminist argument for why that sort of learning has been devalued, because it's about devalued bodies of knowledge … and experience in terms of how you interact with things and what we think of as art, knowledge and learning …

Anna Yes that's interesting, that is part of our practice here without question, we have three ageing feminists as our leadership team and we recognize that this makes for certain methods of approach that may also invite difference.

▼Rocket Artists' performed response to panel questions at Creative Minds Conference, Brighton, UK
2014

▼Ntiense Eno Amooquaye, Intoart, UK
Hera Master Come Down
The Saison Poetry Library
2014

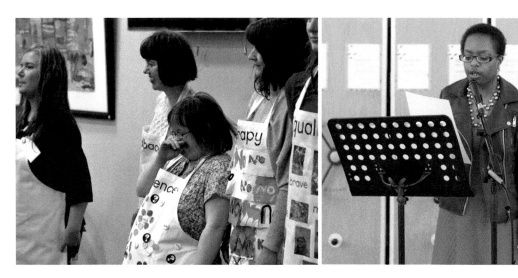

Curation, biography and audience encounter

Catherine Morris, Sackler Family Curator for the Elizabeth A. Sackler Center for Feminist Art, Brooklyn Museum, New York

Catherine Morris is engaged in contemporary curation and feminist debates. She recently curated Judith Scott—Bound and Unbound, an exhibition of Judith Scott's work, alongside Matthew Higgs. (Judith Scott is arguably the most famous artist with Down's Syndrome. She used yarn, thread, fabric and other fibres to wrap found objects.)

Alice Can you tell me a bit about the Sackler Center, your role here and your recent curation of Judith Scott's work?

Catherine The Sackler Center for Feminist Art at the Brooklyn Museum was founded seven years ago, and I've been a curator for five years. One of my primary interests in being a curator of the centre is to have a place where we show not just feminist art, but a place where we acknowledge the fact that if you are looking at art in the twenty-first century, you've been impacted by feminism ... So thinking about feminism as a methodology for curating, rather than as an identifying characteristic of any particular thing or person per se. Because I think, in order for feminism to be useful in the future, we have to keep thinking about how it is viable and engaging for a broad swathe of humanity, rather than just seeing it as a historical moment, though it certainly grows from a very important historical moment.

Alice So can you explain how you came to display Judith's work?

Catherine When I saw Judith's work, I wondered how that would fit in the context of our centre. A lot of the work I've shown at the feminist centre is not clearly, overtly feminist, so that's not the issue, and obvious to me was that the disability rights movement grows from the same impulses and the same historical moment, slightly later, than the feminist movement and the civil rights movement. So 'the political is personal', that famous feminist adage, is applicable across what we've come to know as identity politics. And while Judith's work doesn't in any way or form talk about her biography, the fact that she was able to make her work at all grows from the same civil rights struggle that feminism does. So that was the point where I started thinking it makes sense here. And then I struggled in thinking about how you present such an exhibition, and because I think the initial impulse in the sixties and seventies was comparable to the civil rights movement – the idea that you 'see the person' and get beyond disability – and now I think the idea is more about acknowledging personal reality. What the Director of Creative Growth calls the 'culture of the maker'. And Judith's culture includes everything about her, and her objects also very much reflect Contemporary Art practice ... And while many artists who would have been

69

considered 'Outsider Artists' – a problematic term obviously – do make work about their own biography, Judith doesn't, and doesn't invite that conversation. Rather, there are layers of complexity in her work that keep forcing you to put yourself in a different position, in your thinking and in relationship with the object, and in what you think, and in what your response is. That's been a fascinating part of this process of curating Judith for me, because I keep finding myself going, 'wait, oh no, so this is what I think, oh no'. And that's what makes amazing art.

Conclusions: productive difference, performative interpretation and an emphasis on unknowability

The commission, curation, display and interpretation of learning-disabled artists' work is an area of practice and debate shot through with tensions. Often, both makers of collaborative work and commissioners of work with marginalized groups are caught between wanting to label work in order to highlight the talent, culture and values of people who often go undervalued in society, and not wanting to label work that transcends those narrow socially constructed labels. The conversations here have begun to discuss these challenges in more depth, and some possible ways of approaching them, through simple acknowledgement, co-curation and performative interpretation.

Certainly, verbal interpretation of exhibited work may not be the best way of making the work accessible to a wide audience. Site-specific performative interpretation, such as that which occurred at the Side by Side exhibition, can be a more appropriate way forward, inspiring the audience to ask as many questions as it may answer. While writing itself can be performative, the temporary, fleeting nature of live performance resists objectification and can live on in the minds and bodies of audience members in unique ways that add value to this mode of interpretation (see Phelan 1993, pp. 148–149).

Thus performance can help people understand the ways in which the work of people with learning disabilities has a productive and creative force. Fears have been expressed that ring-fenced spaces and funding perpetuate divisions in the sector; however, until such work is regularly seen and valued, targeted funding is still required. Of course, despite best efforts, the work may still reinforce 'how lucky we are', 'tragedy' or 'supercrip' stereotypes in the minds of some audience members – for, in part, people see what they want to see. For feminist academic Sara Ahmed, this is a key concern in any encounter with difference:

> Encounters involve both fixation and the impossibility of fixation. So, for example, when we face others, we seek to recognize who they are, by reading the signs on their body, or by reading their body as a sign ... However, each time we are faced with an 'other' whom we cannot recognize, we seek to find other ways of achieving recognition, not only by re-reading the body of this other who is faced, but by telling the difference between this other, and other others. The encoun-

ters we might have with other others hence surprise the subject, but they also reopen the prior histories of encounter that violate and fix others in regimes of difference.

(Ahmed 2000, p. 8)

In short, any public performance or exhibition that involves a set of bodies that might be read as 'learning disabled' risks entering into oppressive and violating discourses about 'the disabled'. This violation and fixing is a concern for Disabled artist and academic Darke (2003), who states that Disabled people's dance and theatre is currently dominated by '... works that are rooted in conventional norms of society: "heroic works" that assert the potential normality of disabled people to fit in' (Darke 2003, p. 133). Such heroic representations are understood to be comfortable for spectators who class themselves as non-disabled because they 'do not challenge prevailing assumptions about normalcy too deeply' (Barton 2001, p. 184) where 'Non-disabled people love this "overcoming their disabilities" kind of performance' (Darke 2003, p. 133). However, the Inclusive work that is

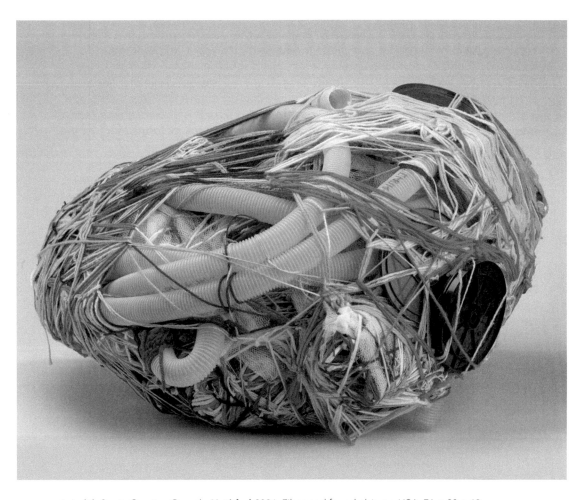

▲ Judith Scott, Creative Growth, **Untitled** 2004, Fiber and found objects, USA, 71 × 38 × 69 cm

71

represented in this book is not just reproducing an 'ableist aesthetic' (Gruson-Wood 2009) of polished, disciplined or representational work, or aiming to make something that is simply a modern take on jesters, involving 'crowd-pleasing fun'. Rather, through Inclusive Arts, so-called 'impairment' is being embraced as a locus of creativity – a positive difference rather than an absence, barrier or lack. As Catherine Morris points out, this sort of multi-layered work, that embraces the craft of the creator and that constantly repositions the spectator, is what makes good art.

Within disability studies, it has been suggested that an emphasis on the positive and productive elements of disability is best located within an 'affirmation model' of disability. Swain and French explain that this is:

> essentially a non-tragic view of disability and impairment which encompasses positive social identities, both individual and collective, for disabled people grounded in the benefits of lifestyle and life experience of being impaired and disabled.
>
> (Swain and French 2000, p. 569)

Such a 'non-tragic view of disability' embraces the positive, productive and creative aspects of having a so-called 'impairment'. However, some of the Inclusive Artwork and performance presented in this book does not involve affirmation exactly; rather, as Siebers (2010) would have it, it is 'a vision of disability made stranger, not prettier' (p. 87). It involves foregrounding difference. This makes uncomfortable viewing for some people, as it is confronting the audience with radical irreducible difference, and it is exploring that difference in all its forms (not just the 'easy',' affirmative', 'comfortable', 'positive' or 'best' bits).

Perhaps Inclusive Arts performance, curation and interpretation are best served, then, if they seek an acknowledgement of this strangeness and unknowability. A person in an unexpected place doing unexpected things can shake us from our conventional habits of thought. When we do not share, or are not accustomed to, a particular sort of body or mind in a particular place, an encounter with this difference can be dislocating and disorienting (Ahmed 2000). Such encounters can be a welcome feature of certain spaces (as Anna Cutler points out). However, we must be careful not to simply valorize such disorienting encounters or be seduced by the narcissism, reification or voyeurism that can be involved. Diversity is a highly valued and marketable feature of contemporary capitalism, and there is a risk that Inclusive Artists simply become involved in a 'repackaging' of impairment as part of a wider process involving the cultural consumption of 'others' (Braidotti 2006, p. 44), or what Ahmed (2000) has referred to as 'stranger fetishism'. The performances and productions of learning-disabled artists and their collaborators can avoid these critiques. As Bishop points out in her critical reflections on 'delegated performance':

> the better examples offer more pointed, layered, and troubling experiences, both for the performers and viewers, which problematize any straightforward Marxist criticism of these performances as reification.
>
> (Bishop 2012, p. 103)

Curation, biography and audience encounter

In our view, disorienting encounters can generate a productive form of ontological insecurity that disturbs fixed imaginings of a person's place in their world and taken-for-granted relations with others. Disability performance practices that are hard to read, and that leave audiences disoriented, full of emotion and lost for words, force people to acknowledge (rather than necessarily recognize, identify and discursively locate) the claim of others to this world. For philosopher Stanley Cavell (1979, p. 241), this acknowledgment is most important. He argues that what exceeds knowledge in human relations is what demands acknowledgement. This implies an approach to the politics of diversity that places an emphasis on unknowability and the 'receptivity of selves or communities to otherness' (Barnett 2005, p. 19). It is possible that certain forms of live Inclusive Art can help to cultivate such receptivity through enabling direct encounters with 'others'.

We keep being asked why this work doesn't reach the larger mainstream venues, and why it is often confined to community and learning spaces. The answer seems to be that there remain economic and cultural challenges for how such work can gain a wider audience. Economics means that, unless collaborative work with people with learning disabilities gathers a wider audience, it will not be seen in the larger venues such as the Hayward Gallery because it does not attract a big enough paying audience. Unfortunately this is a Catch 22 situation, because it needs to be seen in such venues in order to be valued more highly. People need to want to see the work, rather than feel they should see it. Producers need to keep aiming high – this can change.

Where do we fit into the contemporary art world?

What this part of the book is about

- Here we think about what we want the audience to know about us and our artwork

- People react to art made by and with learning-disabled artists in all sorts of ways

- It is important that artwork made by people with learning disabilities is given high-quality venues and is made to look good so it gets respect

- Learning-disabled artists' opinions about work are important. We do performances and exhibitions that show our stories to the audience

References

Ahmed, S. (2000) *Strange Encounters: Embodied Others in Post-Coloniality*, London: Routledge.

Barnett, C. (2005) 'Ways of relating: Hospitality and the acknowledgement of otherness', *Progress in Human Geography*, 29(1): 5–21.

Barton, E.L. (2001) 'Textual practices of erasure: Representations of disability and the founding of the united way', in Wilson, J. and Lewiecki-Wilson, C. (eds), *Embodied Rhetorics of Disability*, Carbondale, IL: Southern Illinois University Press, pp. 169–199.

Bishop, C. (2012) 'Delegated performance: Outsourcing authenticity', *October*, 140: 91–112.

Braidotti, R. (2006) *Transpositions*, Cambridge: Polity Press.

Cavell, S. (1979) *The Claim of Reason: Wittgenstein, Skepticism, Morality, and Tragedy*, Oxford: Clarendon Press.

Darke, P. (2003) 'Now I know why disability art is drowning in the River Lethe', in Riddell, S. and Watson, N. (eds), *Disability, Culture and Identity*, Harlow: Pearson/ Prentice Hall.

Gruson-Wood, J.F. (2009) 'Ableism kitsch: The aesthetics of disability related ethics', *Critical Disability Discourse*, 1.

Jones, K., Koh, E., Veis, N., White, A., Hurworth, R., Bell, J., Shrimpton, B. and Fitzpatrick, A. (2010) *Framing Marginalised Art*, Parkville, Victoria, Australia: Custom Book Centre/Cunningham Dax Collection. www.daxcentre.org/wp-content/ uploads/2012/02/FramingMarginalisedArt.pdf

Phelan, P. (1993) *Unmarked: The Politics of Performance*, London and New York: Routledge.

Siebers, T. (2010) *Disability Aesthetics*, Ann Arbor, MI: University of Michigan Press.

Swain, J. and French, S. (2000) 'Towards an affirmation model of disability', *Disability & Society*, 15(4): 569–582.

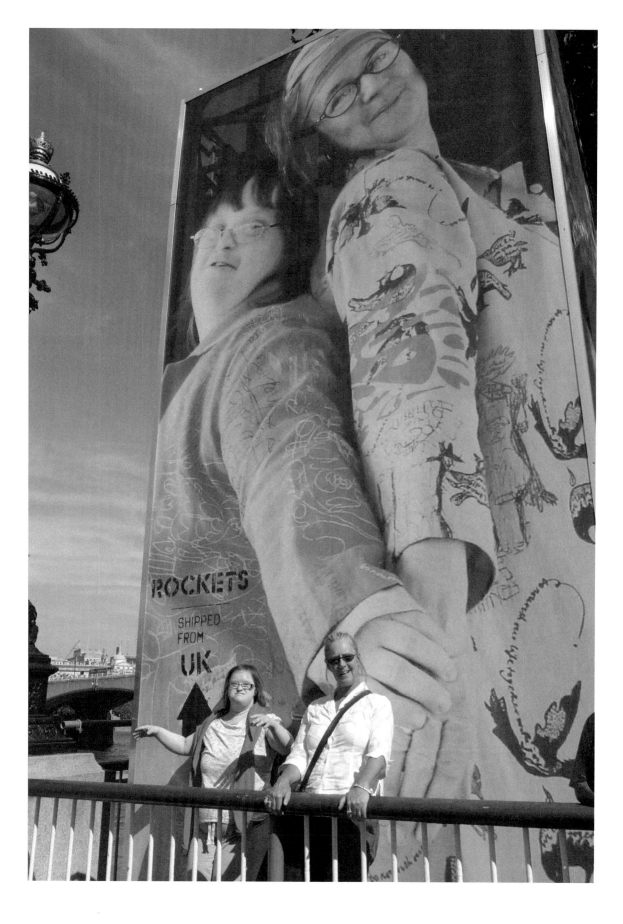

3 How do we practice Inclusive Arts?

How do we practice Inclusive Arts?

Introduction

In this chapter we identify and illustrate some common features of successful collaborative practice and introduce the idea of an 'ethics of encounter' with learning-disabled artists. This is done through a creative dialogue with the Rockets, and through a process of reflecting on the content of some of the conversations with key practitioners in the field of Inclusive Arts, including Kate Adams (Project Art Works), Mark Williams (Heart n Soul), Jane Fox (Rockets), and Charlotte Hollinshead (Action Space). These observations are relevant to anyone interested in the aesthetics of exchange, in collaboration, or in socially engaged art forms with marginalized groups. We have come up with the following list, which offers some possible starting points for being with people through creative practice, and which we examine in more detail through this chapter:

- Agree to travel together on a creative journey
- Frameworks, foundations, timetables and starting points
- Enable choice and freedom – using a non-directive, responsive approach
- Build in plenty of time, and relax
- Establish trust
- Embrace risk and uncertainty
- Be open to all forms of communication – listen in the extended sense
- Embrace an embodied ethics of encounter
- Reflect on your practice
- Remember the answers are in the room.

This is not a comprehensive model for successful Inclusive Arts Practice, rather we are sharing some common ideas that practitioners and the Rockets have described to us. These insights build on a growing literature available on the topic of how to be a good socially engaged arts practitioner and facilitator of participatory processes (see for example Helguera 2011). Some of this literature encourages practitioners to be more critically reflective in their work – where there is recognition that transparency, humility and an ability to be self-critical are crucial features of practice, and that attitudes and behaviours of all those involved in a project can be vital influences on the outcomes (Cooke and Kothari 2001). Whilst in some circles there seems to be a myth of a neutral, altruistic facilitator who simply fades into the background, as Helguera (2011) writes, 'the artist cannot disappear' (pp. 53–54), and we believe the dynamics of collaborative practice need to be explored and acknowledged.

Thus the focus of this chapter is predominantly on the 'in the moment' practice of visual and performing arts – for whilst it is possible to access general discussions of the nature of socially engaged art practice, and checklists for the practical dimensions of a project, such as the aims, resources, support arrangements, equipment, sustainability, budget and space requirements (see Mencap 2008),

understanding quality in terms of an artist's practice is much more complex and nuanced. This is illustrated by the following quote from Jane Fox, a collaborator with the Rockets, when we asked her: 'What do you think the qualities of a good Inclusive Arts collaborator are?':

> I think it's someone who can enter into a space and leave certain things outside the door. You need energy and a certain amount of vivacity. You need ideas and skills, but also it's helpful to be able to table ideas – literally as if you're putting them into a pot. You also need to be able to understand issues around ownership and control. You need to be able to negotiate and flag up things that may be becoming difficult for you, but you also need to be able to navigate that yourself. There are certain things about yourself that you need to leave outside the door – like that you've had a bad day and you're feeling fragile – things around ego and neediness. So you need to be robust and open, able to dare to step up and take the reins if they need to be taken, but also to be happy for other people to do that. So you need nerves of steel, because I think there's a huge amount of uncertainty. And I think you need to be able to just be quiet, because actually what I've noticed with a lot of the collaborations I've done, is that too much talking digs a hole under the process. So you need to have confidence in your choices around materials and processes ... You need to trust the people you're working with, even if initially you're thinking 'um ... I'm not sure about that direction'. Also, you need to be vigilant; in a way you don't want someone else to run off with the control, so you might need to have troubleshooting skills between you. In a way, you need to support each other to be able to do all of those things.
>
> (Jane Fox, Inclusive Artist, 2014)

An agreement to travel together creatively to an unknown destination

Interestingly, all the artists we spoke to seemed to have a genuine interest in where a collaborative creative journey could take them, and a recognition that, in order for the best quality work to be produced, the final product cannot be over-determined. For example, Mark Williams explains that the ethos of Heart n Soul involves an 'agreement to travel together':

How do we practice Inclusive Arts?

> *the essence of the culture and how we work is not about a very finite, definite end point that is agreed before the start of a project. It is more the agreement to travel together. To a destination that may be a little shady ... but you're comfortable when you get there, whatever it's like.*
>
> (Mark Williams, Heart n Soul, 2014)

This 'shady destination' often requires facilitators to be open to an array of possible art forms and media. As Charlotte from Action Space explains:

> *I'm working on a project at the moment in Camden – people with challenging behaviour and complex needs, and we are pretty much covering every single art form and in many different ways ... because whatever happens in that moment is a creation between those people and that's all productive.*
>
> (Charlotte Hollinshead, Action Space, 2014)

It also requires practitioners to adopt what Kate Adams from Project Art Works refers to as a 'responsive approach'. As she explained when Hannah asked 'What do you think the particular considerations are when you are setting up a collaborative activity?':

> *Well, first of all non-directive, a responsive approach ... we don't overly direct people, and we try to maintain a kind of purity in the agency of the mark. So, allowing self-direction; high-quality materials; an open and non-hierarchical environment; and a high artist-to-individual collaborative ratio, usually one-to-one.*
>
> (Kate Adams, Project Art Works, 2014)

Frameworks, foundations, timetables and starting points

Practitioners recognized the need to journey together creatively and a need to be open to a variety of possible pathways. However, they also identified that a clear framework from which the creative process could begin was crucial to the success of a project and helped people to begin their creative journeys in a safe and supported manner. Clear planning and illustrated timetables, to help people understand the format and duration of each session and the whole programme, are of use here. This, combined with a framework that recognizes that too much or too little choice can be restrictive, is important. This is part of laying the foundations for something good to happen. Charlotte from Action Space states:

How do we practice Inclusive Arts?

One of the things that I'm hopefully quite good at, is laying down the foundations of something in order for something to happen. And giving people the freedom to let rip with it. Starting them off and then stepping back a bit ... For example, last year we got a donation of 500 tennis balls and we just thought 'brilliant what can we do with that?' I love that as a starting point.

(Charlotte Hollinshead , Action Space, 2014)

While interviewees spoke about the need to be open to a diversity of ideas and approaches, at the outset of a programme or session it is also important to have a degree of structure so that participants feel safe and can embark on their own creative journey.

Choice and freedom

Choice and freedom are particularly important when understood within the context of the lives of people with learning disabilities. For those people who live in institutions or who are in receipt of care, their lives often tend to involve a high degree of compliance with others' goals and agendas, and the potential to exercise only a limited degree of choice. Arts activities offer a degree of freedom from some of the restrictions they face elsewhere in their lives. However, in order for this to be achieved, arts facilitators need to give up thinking of themselves as leaders or teachers, and instead consider themselves as collaborators and as someone who puts a framework in place that enables everyone in the room to take part and make choices in their own individual way. This requires careful listening and a high degree of reflective observation. However, your collaborators may try to reposition the you as 'teacher' (in the traditional sense) – this means there is a skill in supporting them whilst challenging their expectations of you.

So, if you currently facilitate arts activities with people with learning disabilities, you might want to step back from your work and ask yourself – who has the power in the room? Who is making choices? Who is exercising control? Who is coming up with the ideas? If the answer to all those questions is 'me', you are doing something wrong and perpetuating the social position that people with learning disabilities often find themselves in. Keep challenging people's expectations of you and the expectations you hold of yourself.

Clearly, some practices require a greater degree of taught skills than others – for example, in order to take photographs you need to be taught a few basics, but after that point the creative process should be allowed to evolve. Maybe the pictures will be terrible when judged by the standards of classical technique, but if

How do we practice Inclusive Arts?

we see each artist as developing their own standards and values for the work, this can be very liberating for all involved. In fact it might just be more beautiful than anything we could possibly have imagined at the outset. This is the difference between a contemporary arts approach to collaborating with learning-disabled artists and a more traditional, normative 'teaching skills'-led approach.

Time

The very highest quality work is often the outcome of established collaborative partnerships – achieved over decades. For example, Dean Rodney and Mark Williams of Heart n Soul have worked together for over ten years. They know each other well, and that aids the process of working together. Equally, Alice Fox and the Rockets have also worked with each other for over twelve years. As Helguera (2011, p. 19) identifies, 'Many problems in community projects are due to unrealistic goals in relation to the expected time investment.'

Time is also required to establish the trust of funders and to build up audiences for work. Furthermore, extended periods of time together can help collaborators recognize repetition, fear and significant absences in people's work. For just like spoken language, artworks can be full of cliché and 'safety drawings' that limit personal expression, as Alice explains:

> When Shirley is feeling a bit anxious about an activity we have offered she will often draw an owl. It is a cartoon owl and it is her default visual. If it was a conversation it would be a clichéd response – what she has to do first before she feels confident enough to give something new. This is what I have called the 'safety drawing'. I know if Shirley draws her owl there is a problem, but if you don't know her and haven't spent time with her you wouldn't realize that ... it took Shirley a year to draw something other than owls with us. You need time together to recognize things like that.

(Alice Fox, the Rockets, 2014)

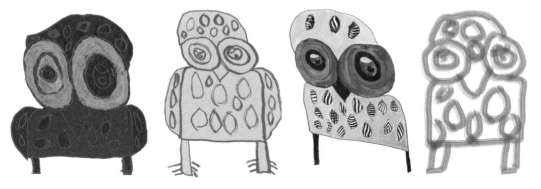

▲ Shirley Hart Rocket Artists **Owls** 2003-14

84

It takes time to recognize that someone is doing their safety drawings. Alice encourages people to move on from these set positions through cultivating a non-judgemental atmosphere in the studio, keeping work safe, putting it away if people don't want others to look at it, and starting with something they know about in order to prompt people to express themselves visually. So, for example, with Shirley you might give her some other birds to draw, to create links to what she feels comfortable with. Such practices require a form of slow, artful hospitality that exists in contrast with many of the key drives of the neoliberal subject (Couldry 2010). A hasty temporality can undermine the voice of people with learning disabilities and result in cliché and repetition. Once knowledgeable partnerships are established, other criteria for success such as risk-taking can be embraced.

Trust

Unhurried time together helps the establishment of trusting two-way relationships. Such relationships have been recognized as a crucial feature of creative arts environments (Nicholson 2002). Facilitators need to trust that their collaborators will come up with ideas, and trust that the process itself is a feature of the artwork that can itself be valued as good (even if the outcome fails on some level).

> *You can't rush relationships with people – if you do, you are not giving listening (in the expanded sense) the time it needs. You can't rush people's creative process – if you do, you aren't supporting meaningful creative self-expression.*
>
> (Alice Fox, the Rockets, 2014)

> *It's a basic confidence in the strength and the purity of the ideas and that people will see them through. It is also being very comfortable with things not always working, or with things being quite different from how you thought they might be at the beginning. Being very open to that and not being restricted by genres and categories or overly-thought plans ...*
>
> (Mark Williams, Heart n Soul, 2014)

Risk and uncertainty

It seems evident that placing trust in artists' ideas also involves taking risks. This involves allowing creative ideas to evolve to a point where they no longer work, as well as to points where they do. As Matarasso writes, 'One of art's most important lessons is that failure is normal and survivable: it is what makes not failing so special' (Matarasso 2013, p. 10). This requires the practitioner to have the guts to not know what is going to happen next, and a capacity to work with

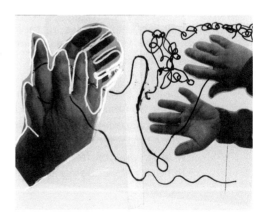

How do we practice Inclusive Arts?

problems, boredom, taboo, conflict and antagonism. It also requires everyone involved in the creative process to see, hear and accept what other people are giving you, and turn it into something more through the collaboration. For example, in a life drawing class somebody might draw the floor rather than the model, this is a challenge to traditionally conceived notions of what the artist is there to do, but it is possible to work with that. This requires respect, openness and delight about what comes your way.

An openness to all the languages we communicate in

Inclusive Art practitioners need to have the ability to attend to 'total communication' (between people – embodied, gestural, visual; and between people and materials). This requires learning-disabled artists and their collaborators to listen to each other through the artistic medium – solving problems through making, doing and moving rather than listening and talking. As Kate Adams, who works alongside people with profound and multiple learning disabilities, explains: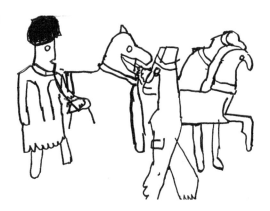

> ... what we do is intensive interaction using total communication, which is to do with monitoring and being receptive to behaviour, gesture, sound, facial expression. It's acute and sensitive and empathic observation. So, that's how we create the right environment to understand and receive [non-verbal] communication that's given to us through people in a working process.
>
> (Kate Adams, Project Art Works, 2014)

The facilitator needs to be able to recognize some of these diverse modes of communication. This might involve sitting quietly with a person, speaking very little but choosing particular materials that help the person speak or feel through an artwork. Materials might be selected for a range of reasons, including their malleability and ease of use, or their ability to evoke memories in participants and audiences. For Jane Fox, speaking too much can 'actually dig a hole under the process'. She states:

> ... voice can come through the handling of materials and marks on paper. So I think this thing around being, basically giving space – if you give space, and allow someone to explore and work, voice can come through material onto the surface of whatever it is that you're working on. So often voice isn't about being able to translate something, it's about being able to look at it on the page.
>
> (Jane Fox, Rocket Artist, 2014)

While for Alice, this also involves selecting materials that listen:

> *For a material to support someone to express something it needs to be fluid, it needs to be changeable and moveable so you can play with it and apply it. For example, a material like clay is quite fluid and you can literally impress upon it, this means you can articulate and re-articulate something. Other materials which listen well are things like charcoal, chalk and pastel – things which are malleable and which can be moved around the page, rubbed on, rubbed off and worked on top of. Print making also really works because it enables image repeats, in effect the opportunity to state and re-state ideas, making a message louder and persistent. Mono-printing works really well because you can work into the plate and change things, take things on and off.*
>
> (Alice Fox, 2014)

And for Tony Gammidge (MA Inclusive Arts tutor), this can also involve choosing materials for their olfactory qualities. As he states:

> *Some materials have smells that transport us back to past moments, for example the association of plasticine and childhood. This can speak to both the artist and the audience.*
>
> (Tony Gammidge, artist, 2014)

Being open to all the languages we communicate in and choosing materials and processes that 'listen well' is an important skill – it involves a recognition of the materiality as well as the discursive sociality of the inclusion process. Where inclusion is understood in its broadest sense as encompassing processes that occur between people, between people and materials, and between people and the physical spaces they find themselves in (Barrett and Bolt 2013).

The artwork itself tends to embody, manifest and represent the working relationship, therefore if the collaborative process is working, the artwork is likely to display those features. Furthermore, materials themselves can play a role in making aesthetic decisions and can be relied upon when words aren't working. Incomplete or unsuccessful (as defined by the group) artistic outputs can be a result of collaboration dysfunction. When Alice visited the Tim Rollins and KOS (Kids of Survival) Studio in New York, she discussed these issues in relationship to decision making in the studio, where one of the artists explained:

> *It's a meritocracy. The work decides what direction we're going to go in. We have our core values, what we care about, including each other and the work, and that dictates the direction we're going to go in. That's the code.*
>
> (Rick Savinon, KOS artist, 2014)

In some contexts, the 'work' (in terms of the art materials and their inclinations) makes the decisions. In other cases, the relationship that is established through the

How do we practice Inclusive Arts?

materials is the artwork, and the challenge might be to communicate that to a wider audience. At times, the facilitator may need to be prepared to 'dissolve' partially into the artwork and think of themselves as developing new forms of collective understanding that would not have been possible without the group. This requires an acceptance of our incompleteness as practitioners and a capacity to un-learn as well as learn from each other. The 'non-disabled' artist is not the expert in this relationship, rather they are an artist who is literally coming into being collaboratively.

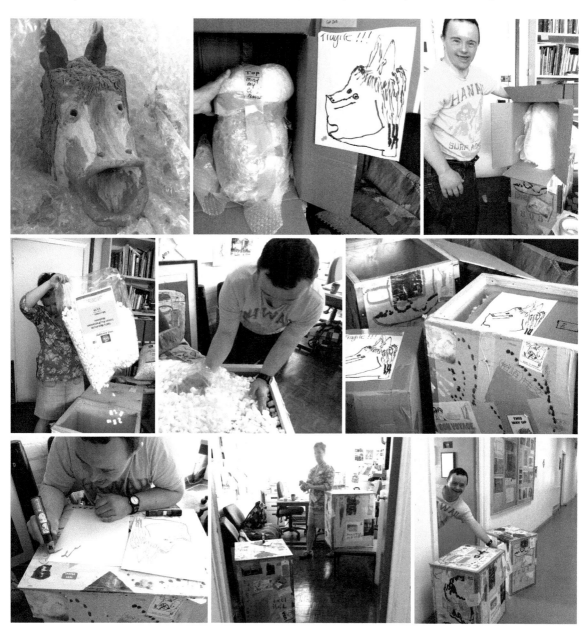

▲ Kelvin Burke, Jo Offer, Rocket Artists, **Going Places continued...**
Tea chests are packed with ceramic horses' heads ready to go to Crawford gallery, Cork

An embodied ethic of encounter

The capacities of artists to agree to travel together on a creative journey, lay down flexible foundations, facilitate choice and freedom, allow time, establish trust, embrace risk and chaos, listen and be open to all forms of communication can be understood to stem from an 'embodied ethic of encounter'. This ethic of encounter involves what feminist geographer Simondsen has referred to as a 'sensitivity to the bodily imperatives that issue from different bodies ... [Which is] able to respond to (even "strange") bodily imperatives of the other without reconstructing him/her as "the Other"' (Simondsen 2010, p. 217). Such an encounter does not fix a person with a learning disability within the category but rather, through arts practice, enables the possibility of transformation and the possibility for each person in the room to learn and un-learn from each other. It is a responsive habitual sensibility – where the practitioner, through their actions, anticipates a potential for facing something or somebody different – the not yet and the elsewhere. This sensibility has parallels with the practice of love in the sense of Love conveyed by the philosopher Erik Fromm (1956) in his book The Art of Loving, where he identifies four elements necessary for love: care, responsibility, respect and knowledge.

Travel

Choice + Freedom

Time

Trust

Risk

Open

Think

Through combining these elements, it is possible to facilitate an encounter that neither reifies nor incorporates the learning-disabled person, rather it allows a space for them to retain their otherness and a space for the practitioner to be transformed by their encounter. Thus an 'ethic of encounter' is not just a minor detail of practice, but is about a whole mode of being in the world and letting others be in the world. It is extremely important because it helps to guard against continuing harm to vulnerable people. Thus it is a form of embodied micro-politics (Mann 1994). Whilst some people have suggested to us that artists cannot learn this sort of attunement, we think it can be learnt and with repetition can become a habitual sensibility. Of course, adopting this sensibility cannot guarantee a quality outcome; however, it can mean you fail competently within good practices.

In Chapter Five we discuss in more detail procedural ethics and the forms you may need to fill out in order to practice alongside, and conduct research with, people with learning disabilities. This sort of ethics involves pre-empting 'ethical issues' and is somewhat different from the 'ethic of encounter' identified here which is about in-the-moment best practice.

How do we practice Inclusive Arts?

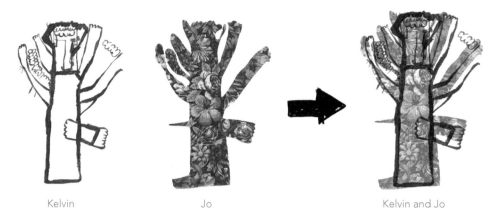

Kelvin Jo Kelvin and Jo

▲ Kelvin Burke, Jo Offer, Rocket Artists
Research question What practices and strategies need to be in place to support a learning-disabled artist to engage with the design industries?
2010

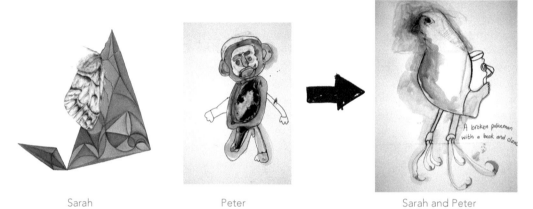

Sarah Peter Sarah and Peter

▲ Sarah Gladden, MA Inclusive Arts Practice student, and Peter Cutts, Rocket Artists
Collaborative drawing
2010

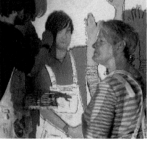

Mike Jeanette Mike and Jeanette

▲ Jeanette East, Mike Everett, Rocket Artists
Overalls project
Collaborative self-portraits
2006

90

Becoming a self-aware practitioner

In order to cultivate high-quality encounters, reflecting on your practice can be very helpful to understand what working alongside people labelled as having learning disabilities does for you (creatively, emotionally and personally) and the possible sources of impulses that you act on in order to shape the outputs of your collaborations. You might consider what draws you to this work and ask yourself questions such as:

- At what points do you intervene in practice? Why?
- In what ways do you need to feel needed? Could you let go of that need in order to embody a better practice?
- In what ways are the artists you are working alongside including you in their worlds?
- How can you encourage this sort of generous hospitality? How are you and your creative practice transformed through that relationship?
- What sorts of understandings of society and politics are evolving through your work?

Understanding yourself as an artist who is coming into being 'in becoming' with your collaborators is an important part of reflecting on your learning and un-learning and ensuring a more equitable relationship. The practitioners interviewed in this book do not think of the people they work alongside as primarily 'in need of help' or as 'outsiders', rather they consider the unique creative contribution that each person can make, and when they are working in a group context they are able to respond moment by moment to what is occurring in the room. This sustains an embodied ethic of encounter that helps support learning-disabled artists to produce fantastic work. Here every moment should be seen as having creative potential (cf. Mansell and Beadle-Brown 2012).

It is also important that you develop a social and political awareness to your practice. As we argued in Chapter One, you cannot ignore the wider socio-political context of people with learning disabilities' lives, and although your artwork may not address social issues in any direct or explicit way, knowing the sorts of socio-political work it can do – from promoting social justice (see Chapter Six) to generating advocacy or antagonism – is important. Suzanne Lacy states:

> It seems to me that what is important is to politicize yourself as a person and then learn to integrate those politics into everything that you do. As my projects take shape they are informed by a political as well as an aesthetic evaluation.
>
> (Lacy 2010, p. 152)

How do we practice Inclusive Arts?

However, it is important to tread very carefully here, particularly when working alongside vulnerable people, otherwise there is a risk of collaborators becoming bound up in your statements rather than their own. Allowing your socio-political viewpoint to evolve alongside your collaborators' (rather than bringing a pre-determined position into the room) and inhabiting the sort of embodied ethic of encounter we describe in this book helps to guard against this risk and the sort of ego-centrism that can accompany it. We are not suggesting you disappear from the work, but we are suggesting your politics and beliefs don't dominate in a way that undermines the process.

 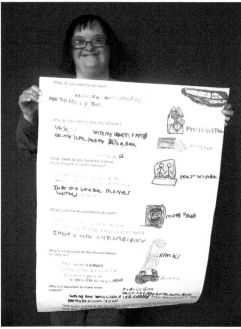

▲Rocket Artists
Evaluating the Rockets in Residency
project for Arts Council England
2004

▼**Visual tools**
Calendars, diaries, project maps,
diagrams and named photographs for knowing who's
here and remembering those who are not.

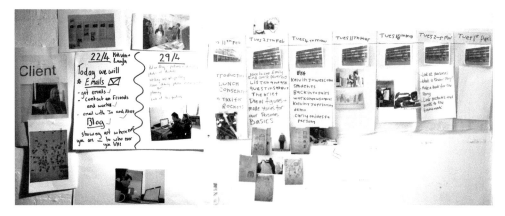

The answers are in the room

Thus, finally, we think it is important to focus on the assets in the room. That is, the people, skills, experience, knowledge, interests, ambitions and space that you have together. Use these as your starting points for creative endeavours and problem-solving (this in itself is a micro-political move). It requires you to adopt what Alice refers to as an 'attitude of assets' rather than deficits. So think 'we have what it takes'; 'we know a way forward that together can support exciting ideas to emerge'. This approach will help you to develop an understanding of the freedom that any supposed 'constraints' can provide.

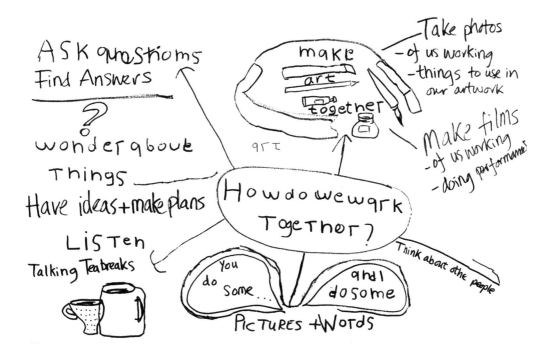

▲ Kelvin Burke, Jo Offer, Rocket Artists **How do we work together?** Ink on paper, 2014

How do we practice Inclusive Arts?

Rocket Artists in conversation

We carried out a number of conversations for this book and have tried to represent in text the voices of the Rockets and other artists. Below we include some sections of the conversations conducted with the Rockets. There is so much in these transcripts and the accompanying images that they are worth reading over more than once. What they illustrate is the tensions, contradictions and differing interpretations of collaborators in the Rockets. The gaps, misunderstandings, failed questions and laughter in the transcripts are as important as what is said, illustrating some of the difficulties and the joys of collaborative partnerships. Their failure to meet what might traditionally be understood as a 'publishable interview transcript' also makes the case for Inclusive Arts more evident; at times their voices (more broadly conceived) can be heard more strongly through the artwork than through their words.

A conversation about the Wedding Cloaks.
Jane Fox, Louella Forrest and Alice Fox

Jane	So Louella, let's do a bit more talking. Let's talk about the Wedding Cloaks. Could you tell us what the wedding project was about?
Louella	Getting married.
Jane	What did we do?
Louella	She's the bridesmaid and I'm the bride.
Jane	What did you make? You screenprinted?
Louella	Yeah. She's got my heart and I've got her bird! ... I've still got it.
Jane	Do you still wear it?
Louella	Yeah for occasions.
Jane	What kind of occasions?
Louella	New Year's Eve.
Jane	We worked in the same space together didn't we? We had lots of conversations ... How did they come to be wedding cloaks? ...
Louella	We looked like we were getting married. My dream wedding. She's the bridesmaid I'm the bride.
Alice	Who's idea was it to do wedding cloaks? You're pointing to yourself and to Jane. Jane why did you want a wedding cloak?
Jane	I was excited by the idea because I wanted to make cloaks that were sort of magical and special for us, and that made us feel good about ourselves ... that got made even more powerful when we went to see that massive picture on Southbank ...
Alice	What did it feel like going to see that? ...

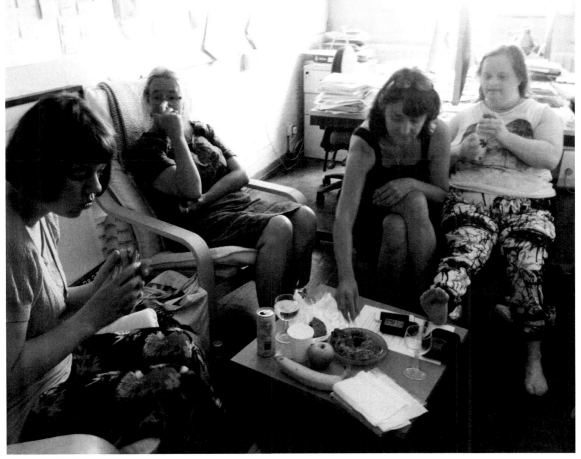

▲ Conversations with
Rocket Artists
2014

How do we practice Inclusive Arts?

Louella Enormous!

Alice So why do you think they put a really big picture of you and Jane in your cloaks up in London in front of the Royal Festival Hall?

Louella They love it.

Alice Why did they love it? It's obviously good, but what's good about it?

Louella We looked like a happy couple.

Jane We were a happy couple!

Alice What makes it good?

Louella She's taller than me, I'm short and she's tall … little and large.

Jane What were you celebrating with your designs? What was the cloak about?

Louella Dreams.

Jane Dreams of what?

Louella About your heart.

Jane It felt like a good project, because it was from the heart, for both of us wasn't it? What were we saying about ourselves?

Louella Celine Dion and Titanic.

Alice So the cloaks are good, you're both looking good, everyone agrees they're good, which is why they're thirty or forty foot tall outside the Royal Festival Hall in London on the Thames for everyone to see.

Louella Oh my God!

Jane I've got a question for you. When we did the wedding cloaks what was good about doing it together?

Louella Easy.

Jane It's easy? Because I was doing the printing? I was doing the washing down while you were doing your nail varnish! I won't forget that in a hurry!

A conversation about being a Rocket Artist.
Tina Jenner, Alice Fox and Louella Forrest

Alice What was it like before you were a Rocket?

Louella People used to treat me like a baby, like a kid.

Alice How did that make you feel?

Louella Awful.

Alice You had two pieces of work up in the Tate Modern in London didn't you. How did that make you feel?

Louella Amazing, like an artist.

Alice What other things have we done together?

Tina We've been on the plane [to Cork] ... We've been to Brussels in Belgium.

Alice We did a performance and worked in the museum and you did the music, didn't you Tina?

Tina That's right. Done the music to a performance. We've done loads of pictures ... worked with students.

Alice How long have we been together in the Rockets Louella?

Louella Twelve years.

Alice What things have you and I done together?

Louella A lot. Too many!

Tina Don't forget we were doing the conferences too, and the museum ...

Alice So, why do we do performances together? Because ... we're good at dancing?

Louella In our hearts. [Does Heart Dance movement] You go too slowly.

Alice I go too slowly?

Louella They keep looking at you, and they keep looking at you when you're doing it. Doing it like this, doing it like this ... [More movements]

Alice And you're saying I'm doing it wrong?

Louella Yeah. [All laughing]

Alice What were you thinking when you were looking at me, that I was doing it too slowly? Why didn't you tell me? You could've helped! You do tell me if I'm doing it wrong don't you? ...

Louella Every time I move you keep looking at me! ... You look so funny!

Alice I think when you're dancing with someone it's best to know where they are and what they're doing.

Louella You look so strange!

Alice [All laughing] Well, thanks for the feedback. Shall we give up talking and dance instead?

All Yeh.

How do we practice Inclusive Arts?

Conclusions

A recent Arts Council review of adult participatory arts pointed towards the need for more 'connected intelligence' in this field, commenting that the knowledge base of successful adult participatory arts organizations is 'fragmented, dispersed and often inaccessible' (Dix and Gregory 2010). However, it is not only 'connected intelligence' that is required in this field, it is 'connected practice', where everyone can learn from each other through sharing the making and doing of Inclusive Artwork. As Wenger-Trayner et al. state:

> the 'body' of knowledge of a profession is not just contained in a set of books. As important as the books undoubtedly are, they are only part of the story. They are too dead to constitute the full body of a living practice. From a social perspective we see the real 'body of knowledge' as a community of people who contribute to the continued vitality, application, and evolution of the practice.
>
> (Wenger-Trayner et al. 2015, p. 13)

For us, this 'body of knowledge' that we have heard about from some key practitioners in the field is associated with quality of the encounter, an ability to understand all the languages we communicate in and the materiality of inclusion (how particular materials, spaces and practices aid interaction). This work is not attempting to be the same as something a supposedly 'standard minded' person could produce. Rather, it values and critically engages with a diversity of ways of being and knowing. Some of these ways of being and knowing stem from having a so-called 'impairment', from living within a system that attempts to support you in particular ways as a person with learning disabilities (and at times fails to support you), and from living with the label and the socio-cultural experience of 'learning disability'. In positively engaging with the productive potential of such experience, Inclusive Artists can help to redefine what good art is and where it can come from, helping to transform lives in the process.

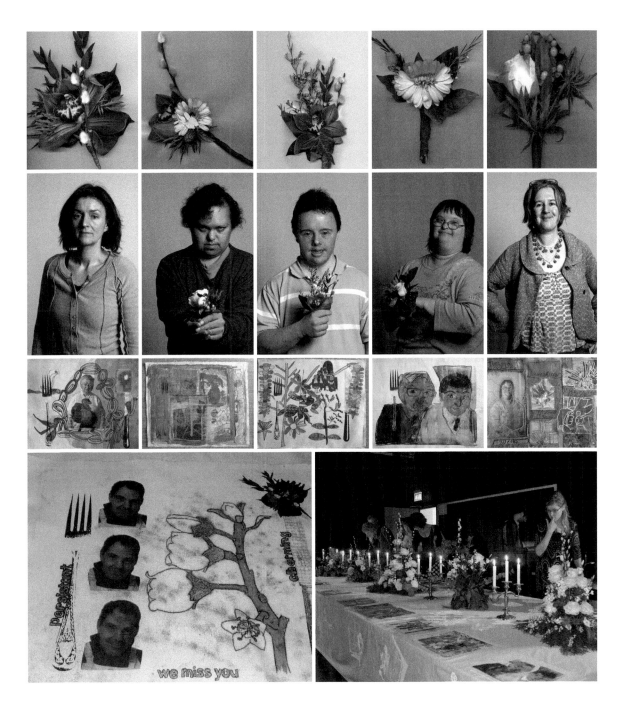

▲ Rocket Artists, University of Brighton
students and staff
Remembrance project
2009

The framework was for each artist to create a table mat and
flower sculpture remembering someone they don't see any
more. Made in response to the death of the much loved,
inspirational Rocket Artist Andrew Apicella.

What this part of the book is about

- This shows what skills and experience you might need to be good at running art workshops

- It says time, trust, skills and choice are important parts of Inclusive Art making

- It also has conversations with the Rocket Artists

- They talk about how they work together, and what they do and don't like

How
do
we

work together?

How do we practice Inclusive Arts?

References

Barrett, E. and Bolt, B. (2013) *Carnal Knowledge: Towards a 'New Materialism' Through the Arts*, London: I.B. Tauris.

Cooke, B. and Kothari, U. (eds) (2001) *Participation: The New Tyranny?* New York: Zed Books.

Couldry, N. (2010) *Why Voice Matters: Culture and Politics after Neoliberalism*, London: Sage.

Dix, A. and Gregory, T. (2010) 'Adult Participatory Arts – Thinking it Through'. London: 509 Arts/Arts Council England. www.artscouncil.org.uk/media/uploads/adult_participatory_arts_09_04.pdf

Fromm, E. (1956) *The Art of Loving*, New York: Harper & Row.

Helguera, P. (2011) *Education for Socially Engaged Art: A Materials and Techniques Handbook*, New York: Jorge Pinto Books.

Lacy, S. (2010) *Leaving Art: Writings on Performance, Politics, and Publics, 1974–2007*, Durham, NC: Duke University Press.

Mann, P. (1994) *Micro-Politics: Agency in a Postfeminist Era*, Minneapolis, MN: University of Minnesota Press.

Mansell, J. and Beadle-Brown, J. (2012) *Active Support: Enabling and Empowering People with Intellectual Disabilities*, London: Jessica Kingsley.

Matarasso, F. (2013) 'Creative progression – Reflections on quality in participatory arts', Unesco Observatory, Multidisciplinary Journal of the Arts, 3(3): 1–14.

Mencap (2008) 'The arts and people with profound and multiple learning disabilities (PMLD)', London: Mencap (accessed 18 July 2014). www.mencap.org.uk/sites/default/files/documents/2009-12/2008.292%20The%20arts%20and%20people%20with%20profound%20and%20multiple%20learning%20disabilities.pdf

Nicholson, H. (2002) 'Drama education and the politics of trust', *Research in Drama Education*, 7(1): 81–93.

Simondsen, K. (2010) 'Encountering O/other bodies: Practice, emotion and ethics', in Anderson, B. and Harrison, P. (eds), *Taking Place: Non-Representational Theories and Geography*, Farnham: Ashgate, pp. 201–220.

Wenger-Trayner, E., Fenton-O'Creevy, M., Hutchinsin, S., Kubiak, C. and Wenger-Trayner, B. (2015) *Learning in Landscapes of Practice*, New York: Routledge.

Conversations with artists

Conversations with artists

Dean Rodney and Mark Williams, Heart n Soul

Declan Kennedy and Andrew Pike, Kilkenny Collective for Arts Talent (KCAT)

Kate Adams, Project Art Works Charlotte Hollinshead, Action Space

 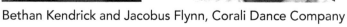

Bethan Kendrick and Jacobus Flynn, Corali Dance Company

Heart n Soul, London
Dean Rodney and Mark Williams

Dean Rodney was fourteen when he first started working with Mark. Now twenty-five, in 2012 he co-directed the Dean Rodney Singers involving a global band of seventy-two disabled and non-disabled musicians and dancers as part of the London 2012 cultural Olympiad. Dean has a very distinctive way of seeing the world which is informed by his autism. Dean is also the rapper, co-songwriter and frontman of The Fish Police. Combining upbeat surreal pop imagery and a punk aesthetic, they've created a unique sound with an urban edge. His tastes are eclectic: he cites Will Smith, Kraftwerk and Daft Punk as key musical influences. The environment of Heart n Soul was crucial to Dean's development as an artist. Dean describes this and other features of his work in his conversation with Alice and Mark.

Mark Williams is artistic director, CEO and co-founder of Heart n Soul – an internationally respected creative arts organization with learning disability culture at its core. Mark was awarded an MBE for services to Disability Arts in the New Years Honours list in 2010. As well as overseeing a diverse range of creative programmes, he has helped develop the multi-media club night 'The Beautiful Octopus Club', which features live performances, DJs & VJs and interactive zones.

Dean ... when I was at school I kept thinking about video games and films and I kept mumbling to myself about all those things and my teacher kept looking at me, and thinking 'urgh! What is he on about? This guy, he's always talking about all these things!'

Mark And what was the difference when you came to Heart n Soul?

Dean The different part is that at Heart n Soul I always talk about the stuff I like. I always talk about films and video games.

Alice What happens when you talk about those things here?

Dean Everyone gets very interested.

Alice That's fantastic! So what I'm hearing is, that you come here, you have ideas and you get listened to.

Dean Yes. That's right.

Alice And all the music that's out there now. There's nothing quite like The Fish Police, so you bring something new. I'm wondering what it is. Why do people like it?

Dean Well during the performance, I was talking to the audience, I was talking about the album, I was saying it's like a dream, and one of the audience said 'it's real' and I said 'yeah exactly, it is real', and that was my reaction from the audience. Also they really liked the suit that I was wearing.

Conversations with artists

Mark feels that part of the success of Heart n Soul can be attributed to creating the right environment where people feel safe, creative, free and really able to express themselves. He and his team at Heart n Soul also benefit creatively and imaginatively themselves from working alongside artists like Dean who have diverse ways of seeing the world, as he explains to Alice.

Alice What do you get from working alongside Dean?

Mark So if we were talking specifically about The Fish Police and Dean, then obviously what we've got is somebody who's very talented, who has a lot of ideas, who has a fantastic imagination. And who is very generous, in terms of allowing people to come to see what's inside his head. So, Dean's often talking about seeing the world in terms of cartoons, movies and films. And some of the way that world is described comes out in the music. So I guess what's been really exciting is to put a great team around The Fish Police so that Dean, Matt and Charles are able to work with really high quality collaborators ... Also what I love about working with Dean is that he is very unafraid to be very, very ambitious. So for example in the Dean Rodney Singers project I was thinking, yeah, that sounds an amazing project, really getting inside the way Dean thinks creatively with seventy-two people we don't know from seven countries in this one song. But he said 'no, no, twenty-three new songs' ... and that ambition and being unafraid to be very adventurous was really exciting.

▲ Dean Rodney Singers
Heart n Soul, UK
2012

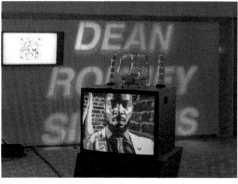

◀ Heart n Soul, UK
Dean Rodney Singers installation
2012

Alice	So what we've got, then, is an incredibly ambitious, successful, interesting, high quality, exciting thing that happened where you're each inspiring each other and each listening to each other, and because of that doing great things that you couldn't do individually.
Mark	Yes, and when we travelled to all the seven countries.
Dean	We started in the UK first, and then Germany second, South Africa, then Brazil, Croatia, Japan and China.
Mark	And in all of these places we were meeting people who we'd never met before ... we only had two or three days in each country working with these people, but because Dean had such a clear framework of an idea it gave each country a creative framework within which then to add and mix and play, so we were able to share videos and little snatches of music with each country, digitally, you know, through YouTube and on iPads. It was really amazing.
Alice	We talk about building a framework within which things can happen. What's fantastic Dean is that you've created the framework ... I think that's a great way to collaborate.
Mark	And again, this is maybe a little bit unique to Dean, but I think generally from my experience of working with learning-disabled artists, people aren't limited by traditional boundaries. The artists don't over-think things, think too much about the problems, they just have a pure idea about the concept and that's very liberating once everyone knows they have permission to really explore what that idea might be like.
Alice	So one of the strengths of Heart n Soul is that you have the ability to see the potential and not be terrified by your massive ideas Dean – a two-way bravery.
Mark	And that bravery for me is important, I've always been really interested in improvising and not being scared of not knowing exactly what you're going to do ... So, as a musician I'm very happy to stand on the stage not knowing what I'm going to do, with other musicians not knowing what they're going to do and allow what happens to evolve. In a sense that's what I try to do in the role of the artistic director at Heart n Soul, create those conditions where people feel safe to not necessarily know what we're going to do next. So there is a framework which allows people to be safe, but there's always at least a quarter of our programme that we don't know what it's going to be at the beginning of the year.
Alice	So would it be fair to say that something about the creative process of working with people with learning disabilities has actually influenced the structure and the running of Heart n Soul?
Mark	Absolutely. It's a basic confidence in the strength and the purity of the ideas and that people will see them through. It is also being very comfortable with things not always working, or with things being quite different from how you thought they might be at the beginning. People being very open to that and not being restricted by genres and catego-

ries or overly thought plans, but generally being creative and liberated by being in the moment, that's what I think sometimes gets forgotten with arts organizations. We're supposed to be about creativity, and creativity normally means you don't know exactly what you're going to be doing. Otherwise you can't be creative because you're going to know what you're going to be doing all of the time. And I think for me that's one of the things I've really enjoyed, is that freedom, to not know what's going to happen next.

Alice It can kind of get you up in the morning, can't it?

Mark Yeah! And it's great. And I think there's great power in being able to be like that, and that's why we say at Heart n Soul we believe in the power and talents of people with learning disabilities, because that's what makes the whole organization work, without that we'd be nothing really. It's that kind of liberation.

Alice I think that's great. If someone's just started up ... what you've just said Mark is absolute gold-dust advice about how to operate, how to be.

Mark Yes, and that way of thinking is also now being articulated within the Arts Council as the 'creative case for diversity'. In the sense that the permission to explore things in different ways is a genuinely creative opportunity for everybody – everybody's given permission to do things they don't normally do ... One of the things that all of the Heart n Soul artists bring to that is that they're all very real. They're not pretending to be anything other than themselves. It struck me right at the beginning that people weren't faking anything. They weren't pretending. It's authentic. It's not manufactured. For me, when I hear you Dean, or Lizzie [Emeh] or Kali [Perkins] or Pino [Frumiento] or Tilley [Hughes], I'm hearing really honest, true voices who are not trying to be anything other than who they are, and that's very refreshing ... you're the opposite of [X Factor] because you're really authentic and real.

Alice You've hit on something there – I work with the Rocket Artists, and we're visual artists and performers, and there's an integrity and a sincerity to the work. It's very brave ...

Mark And I think just being that much more out there, and people being more conscious and aware of these artists and these possibilities to collaborate, it's freeing other artists to also share how you work, and that's great for everybody ... so if we're looking at why this work is important, it can open up areas of discovery or new ways of doing stuff that you hadn't thought about. If you're relaxed enough to go within, that's the key ... And I think part of the culture of Heart n Soul is that in a sense, there's no such thing as a mistake. I'm not the first person to have said that, but the worst thing that happens if something goes wrong is that you learn something ... It relaxes people – once you realize that no-one's going to shout at you if you get something wrong, you just move on. From an organizational perspective, it's really important if you genuinely want to be a creative organization that you do give people

permission to get things wrong ... Musically, many of the most interesting things happen because you weren't expecting them to happen, it's a mistake, but it actually sounds really interesting.

Alice And do you have disagreements or conflicts in your collaborations?

Mark I don't know if there's conflict, but what I encounter again and again in collaborations is where the person who doesn't have the learning disability creates their own boundaries, and they'll ask me 'am I allowed to do that? Is it okay if I do that?', and it's not something that the person with the learning disability has imposed in any way ... the other area where potentially there can be difficulties is where egos get too inflated! But the essence of the culture and how we work is not about a very finite, definite end point that is agreed before the start of a project. It's more the agreement to travel together ...

Alice Is there a question that I haven't asked that you were hoping I would ask?

Dean About the songs by The Fish Police? Well Sabrin is a song about this girl that I liked at school and every time I went to school I always kept talking about her and I always tried to say hello to her and get her attention … Then after, when I left school I was wondering 'what will Sabrin do if I'm not at school?' …

Alice So do we know if Sabrin has heard your song? Because that was a while ago, when you bumped into her. Do you know if she's heard it?

Dean Yeah, she has heard it.

Alice And what did she think?

Dean She liked it …

Mark The launch of the album was actually scheduled to coincide around Sabrin's birthday.

Kilkenny Collective for Arts Talent (KCAT), Ireland
Declan Kennedy and Andrew Pike

KCAT aims to create an environment in which artists and students from different backgrounds and abilities can make work together. The KCAT Inclusive Art and Study Centre is an open-access Arts and Life Long Learning initiative. Founded in 1999, KCAT delivers visual art and theatre courses, and is home to the KCAT Studio and the Equinox Theatre Company. KCAT combine learning-disabled artists with other professional and amateur artists. The centre has developed interactive international and local partnerships that challenge the 'Insider/Outsider Arts' debate.

Conversations with artists

Andrew Pike studied art for two years in Ormonde College, Kilkenny before becoming one of the first learning-disabled artists to join the KCAT Studio. Though best known for his painting, Andrew also has award-winning animations to his credit. Andrew delivered the keynote speach on inclusion at the Side by Side symposium, 2013.

Declan Kennedy has an MA in Fine Arts and spent ten years practising as an artist before joining the KCAT Studio group as a facilitator in 2002. In 2008 he became the Studio Co-ordinator. Declan has also created and developed the visual arts strand of Arts Ability at CUMAS, New Ross, Co. Wexford. He is project co-ordinator and facilitator at Arts Ability as part of Wexford County Council Arts Ability Project since 2003.

Alice What do you think you've gained from working with Andrew, creatively?

Declan Well, I think Andrew is really inspiring in his work. He has a beautiful line in his drawing and it's just incredible what he can do ... I had done a few workshops in animation and he really bought into this medium and loved it and started working in it, and then it was just trying to keep up with him after that. He has no limitations of ideas and he doesn't let go of an idea, that's been great.

Alice So, same question to you Andrew, what do you get from working with Declan?

Andrew Well, sometimes he says, 'I don't like that', and I just stick to it, and he says, 'okay, that's your choice', and I think that's the best thing, he's just a facilitator or a mentor, but we call him a tormentor sometimes. [Laughs] We have to have fun.

Alice You build up a friendship and you work together as a team.

Declan But the big thing for me is the trust. I know how good he is, and so I can trust every call that he will make, and I love his storylines.

Alice So the trust comes from where? How many years have you worked together?

Both About fifteen years.

Andrew Like they say, Rome wasn't built in a day. I had a good teacher before I came to KCAT, I was in a third level education, my mum was horrified, she said, 'Huh! That's university!' ... But the teacher, she taught us how to draw big and get the right perspective in the middle ... She taught me for two years ...

Alice Your collaboration obviously works well, you only have to look at the work you do to see that, but what happens when things go wrong?

Declan Oh, it does, but I think we use time an awful lot ... so there's less pressure. As I said earlier on, take time! Say okay, I've got a story and I want

to animate it, but make sure you've got the storyline, and you have put it on a storyboard ...

Andrew Well, I remember once I was hassled over and over and over again, and the pressure because I was in another place and I wasn't feeling right ...

Declan It's quite tiring too. But I think that process is so important because it helps the ideas come out without trying to interfere, like you're not going to stop something magic that's about to happen in there. He's holding it all, he knows it, he has it, but to get it down is sometimes a slow process, that coming out of the ideas.

Alice And all that time you're in an uncertain place?

Andrew Searching. Not quite limbo, but in controlled chaos, but then you control it yourself and it's like a jigsaw puzzle that doesn't fit very well, you're pushing but you can't get it in, but then you get the right piece and it fits and then it's so smooth.

Declan When he's making a character as well, the character is mentally forming, is taking on its form as he's making it. So an awful lot of the decision is made there, and that sends him off with the idea of what's going to happen ... he doesn't let go of the idea. What he's working on is with him all the time, so he looks at every object as a potential piece of animation. You don't know what he'll pull up next and put together to make something ... It's brilliant. That's the magic of it.

Andrew Yeah, it's like painting a picture. I have to look at something and then I say 'yeah' and that's it. And the way it goes, it feeds the mind ... So I had my eye on a horse and cart and I saw some straws with the bend, and use that as the shoulder blades, and put the hands there like that, and sort of ... So whatever I find lying around I just pick it up and – piece of art!

Alice Fantastic ... So what's your definition of Inclusive Arts?

Andrew It's a different way of working. At KCAT we offer places for everybody, not just for people who have got learning disabilities, but for others without. It just works, we learn from them and they learn from us and that's how our practice works. We see other people struggling and we say, 'Why don't you try this?' We started off very small, about twelve people and that really grew, and as we worked we got bigger and bigger and then we were doing BTech awards and things like that.

Alice What advice would you give someone who said, 'I'm about to start an Inclusive Art centre, what shall I do?'

Declan I suppose it has changed a lot. Sixteen years ago, when we started, the term didn't really exist in Ireland anyway, and I think in the other groups that we had looked at around Europe, they were still separated. The first ten years of this idea of an inclusive classroom where everybody had something to offer, that was amazing ... people would just leave the place on a high, going 'I got much more than I bargained for there!'

113

Conversations with artists

Andrew I would advise to start small, just say 'okay, this is what we're going to do, and this is what we want'. And if you have a council member in Brighton or wherever on board, then he or she will say, 'This place is a good thing. And we need to support it and get local business people to support it', and gradually ...

Declan There needs to be a support system in place to make it work. But KCAT began with very little money, in an old run-down baking factory that was leaking and it was cold and damp ... and it slowly grew. The most important thing is the artists! They're the core, they're the jewel. And this studio is so strong because no matter what goes on, what politics, at the end of the day, you just look at the art and go, 'Wow! Of course we have to support it.' It will always come down to that. At the end of the day, that's your bottom line, your core. That people are actually making the work that they really want and need to make. That's enough.

Alice Do you see yourselves as activists? Is there a social change you want to make?

Declan I think it's a by-product of what we do. It's not the most important thing – levelling the pitch is the most important thing, with quality materials and professional presentation, so you're dealing with professional galleries. Something I've found is that the more established the gallery, the more supportive they are. Smaller galleries aren't so sure of themselves, don't have the confidence – whereas the bigger galleries are saying 'this is where the button is, we should be there'.

Alice Okay, so I've got one final question. If you had a wish for the future, what's the future for Inclusive Arts?

Andrew Collaboration, working together, working with other groups internationally, sharing practice. We're also very conscious of supporting smaller groups nationally, so we had a gathering here of all the groups we could gather in Ireland and invited them all just to come and spend a day working with us ...

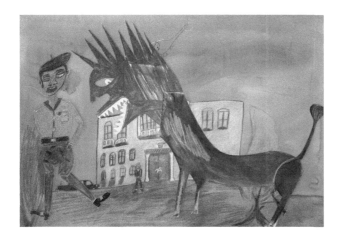

◀ Andrew Pike
KCAT, Ireland
Animation still
2009–10

Project Art Works, East Sussex
Kate Adams

Project Art Works, established in 1997, conducts a wide range of visual art-based collaborative projects with people who have profound intellectual disability and multiple impairments (complex needs). Its work is both local and national in scope, and its programmes embrace and address the social, cultural and political forces that both enable and disable individuals affected by neurological impairment. It plays a leading role in driving forward inclusive collaborative practice, initiating exploratory approaches to diversity and excellence in mainstream visual arts. From their experimental research base in East Sussex, its artists have been developing and evolving projects and methodologies over the past sixteen years. Their practice embraces the different and complex relationships – families, carers, communities and the state – that surround people who have intellectual impairment.

Uniting knowledge of the social care sector and the primary issues facing people who have profound impairments, with high conceptual and artistic standards to produce work that attempts to disrupt perceptions, they establish the conditions for meaningful collaboration through non-hierarchical, deep and open connections between people – participants, audiences, organizations and artists. The artists use film, paint, construction, drawing, print, digital media, and environments of light and sound as a means of prompting shared, creative investigation.

Kate Adams is an artist, co-founder and director of Project Art Works. In 2012 she was awarded an MBE for services to art and disability.

Hannah First of all, I'd like to ask you about the term Inclusive Arts, because it can be a problematic term. Some people don't like it ... is there another term?

Kate Well, we don't use the term Inclusive Arts, we use the words 'inclusion' and 'integration', but simply about making art, and we talk more about collaboration than inclusion.

Hannah And what do you think are the qualities of a good collaborative studio environment that works for everyone?

Kate I think the environment is key, actually. The environment is the first stage of the creative engagement. So, we affect environments, we

change them, through ensuring that there's freedom of space; that different areas are differentiated within a single environment; that the light quality is changeable; and that there's a sense of freedom and no hierarchy. So both the physical and attitudinal environment is key. There is no hierarchy within the space ... they are non-hierarchical environments.

Hannah What do you think the particular considerations are when you are setting up the collaborative activity? Because one of your specialisms is people with complex needs ...

Kate A number of perceptual, experiential, cognitive, communication impairments combine to produce complex needs. Collaborative activity should be non-directive and responsive. We're very particular about ideas around intervention. So we don't overly direct people, and we try to maintain a kind of purity in the agency of the mark. Allowing self-direction; high-quality materials; an open and non-hierarchical environment; and a high artist-to-individual collaborative ratio, usually one-to-one. We also work with support teams that people come with, so that the learning of that individual isn't static and doesn't stay within the studio, but goes outwards into their lives.

Hannah And in terms of particular techniques of listening that you might use in the studio space as collaborators – can you talk about those at all?

Kate Well, we don't use that term 'listening', but I know what you mean. What we do is intensive interaction using total communication, which is to do with monitoring behaviour, sound, facial expression. It's acute and sensitive and empathetic observation. So that's how we create the right environment to understand and receive communication by people in a working process.

Hannah And how would you define quality in that process? In terms of both process and outputs?

Kate I think a sort of truth. If the encounter is enabled in a way that allows freedom and non-direction, then an individual can make work that is surprising and authentic. It doesn't necessarily mean it's a great piece of art. We have a lot of debate about this in our organization (and analysis of events that happen in the studio because they're quite often extraordinary). The actual moment-by-moment process is quite often where the art is.

Occasionally an artwork will be made, like a painting for example, that is in our view stunning, because it has an authenticity and beauty and aesthetic that accidentally happens to be extraordinary. I'm talking about works that come out of encounters with people with very complex needs. We also work regularly with one or two artist/participants who we've had long associations with, who do consciously and with intent make very interesting, and sometimes beautiful artworks – so that's a different process, because the art is the object ... but with many of our collaborators the art is as much in the process as it is in the object.

Hannah What mistakes have you made as a collaborator, and what have you learnt from them? Is there anything particular that stands out as a story recently?

Kate Well, I'm not sure. We don't think of right or wrong in terms of moves. I think that we try to improve our practice all the time through communication, total communication, but also embracing the relationships around an individual, and I think we've got some way to go, we've still got to refine how we do that. We work very closely with families. One of our projects embraces families who have a child with severe disability. We offer workshops over all the [special] school holidays. And the whole family – parents or a guardian, and sometimes whole sort of extended families, you know, siblings, cousins, aunts and uncles, they all come for a day and we work together, and that's very successful, but it's more difficult, I think, to work with support teams from agencies in a way that helps them to step back from their duty of care, but also to respond to what takes place. That's always a difficult area of negotiation. Support workers who come with participants with complex support needs have a duty of care, and may find some aspects of the studio dynamic or content challenging themselves. Therefore we work closely with support workers and care agencies to ensure that people come on time and stay for whole sessions. We also ask for and provide feedback, so that we achieve greater understanding and a strong working partnership between care environments and projects.

Hannah And moving on to the public face of this work, what do you think the role of biography is in this work? So, for example, if you display it, is it important that there is a biography, or is it better that the public see this work and can value it on its own ... just for its aesthetic?

Kate Well, in exhibition contexts we don't overly explain disability in artists' statements. We may describe a person's approach to their work, and how long they've been working, and what projects they've been involved in, but we don't say this person has Down's syndrome or severe cognitive impairment, for example. We never mention specific disability terms unless it's a very significant part of an artwork. Which it rarely is. We use biography, but in a way that is in itself an education to public audiences. We use exhibiting opportunities in order to change attitudes as much as anything.

Hannah So what do you think these practices can do for a broader politics of inclusion?

Kate Well, by showing and revealing something about people, first of all; through what they make. Their abilities. We're not a care agency, so if people come to us, they come with support, and because we work with people with very complex needs, we have a broad impact on ways of thinking about especially profound disability. And also challenging behavioural needs, which is a sort of area of complex needs that is poorly addressed in society broadly, and in art projects generally. You know there are people with behaviours that challenge who tend to be kept out of inclusive programmes, because they are experienced by others as challenging. They can be very marginalized, so I think the way in which our programmes address behaviours that challenge helps to reduce fear

117

and show good practice. And by being as truthful as we can to the individual, whilst not overly describing their disability, their essential nature and value as human beings is very clearly exposed, and that's an important message that members of the public really attend to.

Hannah And how do you evidence that sort of impact?

Kate Well, we collate exhibition feedback forms. We evaluate all our projects, and produce evaluation reports. We work with local Challenging Needs Services, for example, and in partnership with social care organizations, statutory services, social workers, psychologists, support teams, and all kinds of different services; we don't overly scientifically evaluate what we do. We are an arts organization, and much of our work around evaluation is empirical, emotive and based on case studies. We think that's important because that is actually the context and space for, I suppose, subjective evaluation of art and creative process.

Hannah Yeah, it must be very hard to capture that, sort of trickle-down, in terms of the wider communities of any individual who comes here, and how that affects them?

Kate Well, families come to exhibitions, they come to open days, and wider families, friends. Public audiences are incredibly receptive as a rule. A major strand of our work is film and recordings of people working creatively, and we often include sensitively edited filmic works in exhibitions alongside works of art. Another strand of work we've been developing over many years involves exploring the impact of built space on people with complex needs, because they are very aware, and built space can be both exciting and problematic for them. We do a lot of film work where we may have an installation within a gallery and just show people exploring space. And that can be challenging for audiences because many people don't take responsibility for the experiences and feelings they have when seeing/witnessing profound disability. It's an area of human response, fear and experience that I think is primal and, as yet, unevolved. So, we often have, what's the word, quite contrary reactions from members of the public.

Hannah And how do you see what you're doing here relating to the contemporary art field?

Kate Well, I suppose it relates in the quality of conversation or interaction that we have with contemporary art themes, and curatorial concerns. We have conversations with curators, we work a lot with mainstream galleries. In the last few years we've worked with Milton Keynes Gallery and the Foundation for Art and Creative Technology in Liverpool, Camden Arts Centre, De La Warr Pavilion and others. We try to engage and have good quality conversations with curators. Because we're all visual artists, and we all have strong personal practices ourselves, so only part of what we do is our practice here. We don't necessarily use what we do here in our own practice, apart from the learning about letting go of overly directed outcomes, for example.

Hannah And you're not finding yourself in Outsider Art spaces?

Kate We don't see what we do as Outsider Art. Although a couple of people we've worked with have sat much more clearly within Outsider Art in terms of them having very, very strong, and very particular, and a very extraordinary personal, almost compulsive, visual language. But I think where our work sits is much more within visual art performance, happenings and installation.

Hannah And what role do you think there is for risk taking, in this sort of work?

Kate Well, I think it's up there, quite high. Just in terms of navigating inexperienced responses from the public. I think that working in a studio with six people with behaviours that challenge and severe cognitive impairments is also quite risky, on many levels. Also, as an organization we raise all our own funding to conduct what we do, so just existing is quite risky. We're not part of an institution of any kind, and there are no safeguards around us other than the quality of what we are able to produce and the needs of the people we work with – which will never go away.

Hannah And can you see yourself kind of pushing at the limits of this practice, in terms of any work that you can think of that touches on taboo or difficult topics?

Kate All our work does that. I mean everything that we do, I think, is challenging and pushes at the edges of what's possible and desirable. And also in terms of the wider advocacy work that comes out of what we do. Especially now and at the moment, when social care budgets are under such threat and the quality of people's lives is really compromised ... we have a holistic approach to the work we do because so many of the people we work with depend on the state, and what the state is and what the state can offer them, and their lives and the quality of their lives are largely dependent upon the political colour and ethos of the state. So, I think we push at the boundaries of our role a lot. And we are political in a subversive, artistic way in that we support people to self-advocate through art.

Hannah Would you see yourself as an artist activist, then?

Kate I see myself as a parent activist because of the way in which I came to this work through my son ... And I would see myself as a political artist, but it's not absolutely obvious. The organization is also political in subtle ways, we don't come out of traditional disability politics. We work with people who are unable to advocate for themselves in what may be seen as acceptable ways. The effectiveness of what we do is hugely dependent on the quality of our relationships with people ... and we hold that and value it above many other things, and that in itself is political. So we do push the boundaries, but in ways that are multi-faceted, I think, artistically, socially and politically.

Hannah Yeah, I totally get the importance of that kind of micro-scale politics and how important that is to individual lives. But I'm going to ask you a question about policy anyway. Have you seen changes as a result? Can you kind of trace anything that's happened either to an individual or more policy wise.

Kate Well, I think that with people who are non-verbal, the quality of advocacy is key to the quality of their lives, and if they have strong advocates around them, like family members or individual support workers (who can be incredibly good advocates for individuals, and we've encountered much of that actually, which is really encouraging), then the outcomes for them are better. So advocacy is key, and I think across the UK there's been a reduction in good quality advocacy for people who don't have a voice. So we're doing a lot of questioning about our practice, and whether we need to be very much more clear about our advocacy role for individuals, or how to do that.

Hannah Yeah.

Kate But I think there has been a policy change within the Arts Council over the life of our organization.

Hannah A creative case for diversity.

Kate Yes. But I also think there has been a change in social care policy; it's just that, at the moment, much of the progress of the last decade is being eroded and undermined by the current government, its action on reducing national debt, and the impact on local authorities and their approach to the apportionment of cuts. Because social care budgets are so huge in all local authorities, and because there's been a cap on council tax, many local authorities are disproportionately raiding social care budgets and cutting vital care services and provisions in order to meet targets.

Hannah Are you suggesting that maybe your organization is feeling like you have an increasing role to give voice to the impacts of those cuts, to facilitate that in some way?

Kate Well, we provide a lot of advice, because within the organization and within our network of long-term relationships with individuals and quite articulate families, we are able to pool and share knowledge about how to negotiate with social services or providers, and that's really important for people. I mean, people come to us to ask for advice. But I don't think all arts organizations can do that because they don't have the same level of engagement with social policy or expertise in negotiating with social care services. However, I do think if you are going to make change through art, the work has to be holistic and not separate to the reality of how people live their lives.

Hannah What do you see as the future of your organization? We started to talk about that in terms of advocacy ...

Kate Well, the approach we take in the studio, which is responsive and collaborative, we also apply to strategic planning within the organization, and we're just going through quite a large planning exercise at the moment. We do them every three or so years. And our emphasis remains on exhibiting, and actually the process is going from extremely high-quality, impactful, relevant, creative interactions with people with complex needs, to high-quality and impactful exhibitions in mainstream galleries, to creative interventions in public spaces and with the individuals in the studio. Basically, the work happens between these two polarities, between the magic of the immediate and intimate connection through art in the studio to the iteration of that in a contemporary artistic output.

Hannah Yeah. Is there a tension at times between process and output?

Kate No, no. There's a good balance. It's just that those are the two polarities, and in between them there is a world of ongoing actions, events, projects, encounters, etc. There are so many ways in which we work, but those two essential activities (exhibition/production and one-to-one connection with people) are the bookends of the organization.

Hannah And in exhibiting work, how would you avoid things like cliché or voyeurism sort of cropping up?

Kate Well, I'm not entirely sure what you mean? But cliché is easy to avoid because if you're a good artist, you can spot it a mile off. So that's something that I don't think is particularly problematic. You can't avoid the reaction of public audiences and their own personal interpretation of what you are doing, but you can be aware of the possibility of it, and that's all we can do.

Hannah And in terms of audience encounters with working with gallery spaces, what do you hope audiences might come away with?

Kate I suppose we always hope that people are touched, that they gain a greater empathic understanding of the spirit and quality of people's engagement with the world and what they can learn from people who live in the world with difference. Because they're contributors to our broader humanity in a way that actually, largely, people are very receptive to.

Hannah If you had a wish for the future for your organization and its reception, what would that be?

Kate I don't know. I don't normally operate on the basis of wishes! I like probabilities and potentials. I suppose just to continue to reach people in a way that enhances their lives, and also to continue to be able to stand by people.

Action Space, London
Charlotte Hollinshead

Action Space aims to support the creative and professional development of learning-disabled artists and to create projects that provide London's learning-disabled community with opportunities to engage with the visual arts. Launched in the 1960s and established as an independent charity in 1984, it now has two dedicated art studios and runs a programme of weekly studio projects where beginning, emerging and established learning-disabled artists are able to develop their practices using professional facilities. Exhibitions and events provide studio artists with opportunities to showcase and sell their work. They also work with partners across London to deliver projects, and aim to be a conduit between the learning disability community and contemporary arts world. They have recently worked with prestigious contemporary arts organizations such as the Royal Academy, Camden Arts Centre, The Museum of Everything and the award-winning Outside In arts agency.

Charlotte Hollinshead began working with Action Space in 1996. She currently runs two South London Studio Projects: 'Connections' in Camden and 'Pursuing Independent Paths' in Westminster. Charlotte specializes in developing interactive arts projects, with a focus on film, photography and installation art. She has a BA Hons Fine Art from Central St Martins College of Art and Design.

Alice First of all, can you tell me about your approach to working with people with profound intellectual disability and multiple impairments?

Charlotte That's a difficult question ... there needs to be a broad range of approaches for different settings. I currently work on two types of projects with people with complex needs. The studio project, where learning-disabled artists develop their own individual arts practice; and group-based collaborative projects often specifically for people with more complex needs. I'm currently working on a collaborative project in Camden for people with challenging behaviours, we pretty much cover every single art form, with a focus on installation and spontaneous happenings – whatever happens in that moment is a creation between those people, and that's all allowable. There is no right or wrong. Film-making and photography are a massive part of what I do. I use it constantly, I document every single thing, and the documentation becomes a creation in its own right ... [it] validates what you're doing, giving it another level of value and an opportunity for another shared experience.

There is a lot of humour in this line of work, there's a lot of fun to be had with just playing with materials and bodies and seeing what we can all do together. I'm very playful in my working approach, but actually the work is very serious and it needs to be sophisticated and essentially look good ...

Alice So, what skills of yours do you pull upon when you're doing that?

Charlotte I've got a broad range of art skills that I can draw on quickly, which is important when you are working in the moment and responding to what's happening. But it isn't just about the practical skills you can apply to a situation; it's people skills that are vital, and a confidence to play and experiment in the moment. I can see if something isn't going in the right direction, or if someone's struggling, then bring in something else, either a material or a way of interacting that they can then make their own and take on another path. I frequently lay down the foundations of a happening and give people the freedom to let rip with it. So starting them off, and then sort of stepping back ...

Alice So, you've talked about using lots of different approaches and materials. How do you select material?

Charlotte I go through big phases of work, of being interested in particular types of materials, and use them as a starting point before introducing further materials or ways of working. So the starting point initially extends from me actually, rather than from the individuals. If you're working with a group of twenty people who've got complex needs, it takes a long time to get to know that individual, and what their particular likes and dislikes are, but you can quickly gain a rough idea if you just plunge them into a scenario. For a while now, I have been using plastic and tape as the core starting points in group projects. It's amazing how many variations you can create with limited resources. Once a group is more established, I expand the materials and ways of working in response to their needs, interests, etc. I also love it when things just sort of come your way. I did a project last year where we got a donation of 500 tennis balls and just thought 'brilliant, what can we do with these?' ... people get very stuck with the idea of what art is and what they can make ... so I get a real kick out of seeing how many different ways we can get people engaged ...

Alice So, are there some qualities of materials that sort of support people's creative voice, would you say?

Charlotte In a collaborative setting it's all about being involved in a moment where we could create anything with anything. I don't think I would say there are some qualities of materials which work better for expressing yourself, it's more to do with approach. Many people I work with need an immediate experience and aren't as interested in a lengthy process to express themselves, with a nice tight end product. It's really all about the process of creating and making. When people are given a real freedom to explore materials, amazing things can happen which are true to them and can express a magnitude of things.

Alice Some people would say there is a tension between the outcome looking good and the process of making it. What would you say about that?

Charlotte There is a tension, but it's my job to balance those things, for the process of making to be at the heart of what's happening, but to provide a framework which allows it to be seen in the best possible light. Many of the

▲ Action Space, UK
Tennis Balls
Experimental film; film still

▼ Pardip Kapil
Action Space, UK
Tennis Balls installation
Film still

learning-disabled artists I work with in the studio setting create artworks which can have rough and raw feeling to them, but generally this actually enhances their beauty, and when exhibited or presented in the right setting they look stunning.

On group-based projects, I sometimes create clear backdrops to create a neutral setting to film within, but I've grown to prefer the films that were created spontaneously, they can have a rough quality but weren't set and weren't staged. They feel more true and right because it's just what had happened, rather than pretending it was something else. Still, I always edit out a lot of stuff to really get the best out of things – that's my job, to provide something really interesting and progressive for people to experience. You want people with disabilities' work to be presented in the best possible light, to be shown that they're equally capable of achieving amazing, interesting things that are visually very sophisticated.

Alice One of the things that interests me is that some organizations suggest they are just facilitators rather than collaborators ... how do you see yourself?

Charlotte In settings such as the studio projects I am generally a facilitator, supporting artists who make work independently, but there are moments in the studio when some of the artists have a need to collaborate and bounce ideas around. When working with people with complex needs in a group project, my role is as a collaborator first, which can then shift into being a facilitator. It's a constantly changing role really, it's never a set thing, and there are evolving discussions about how we present the role which can then affect how the artwork and the process is described. It's frustrating when people with disabilities are presented in a way which isn't relevant to them. When I first came into this field, people were titling people's work for them in order to give it a bit of 'high-art' value, with its 'important title'. But most of the people I work with are non-verbal, we're having to work on a purely visual basis and on the experience of making it. And what words do you use to describe that? I mean, it's an ongoing thing ... Each person is different and you have to really feel that you're supporting them in the correct way to create the work that they need and want to make, and you're presenting it in a way that you hope that they are happy with – it can be really difficult.

Alice You have to be quite artistically brave, actually ...

Charlotte Yeah, you do. We often get asked about how our learning-disabled artists are involved in the decision making of their artistic careers, especially the artists who are non-verbal and not necessarily able to express themselves. We have to tread carefully and ensure we are making the right decisions, and that the creative opportunities are perfectly suited to that individual, presenting them in the right way and enabling their work to be seen in the most sophisticated light. Not everyone who I work with does want a public platform for their work ... You can only ever hope you're doing the right thing, and that you're doing the participants or artists on your project justice. It can be difficult.

125

Conversations with artists

Alice So, what do you think about labelling the work 'Inclusive Arts'?

Charlotte It is a word that I use when I'm describing certain ways of working, not all ways of working. I would use the term 'inclusive' more in the collaborative setting.

Alice And in the collaborative settings, what skills do you use as a practitioner?

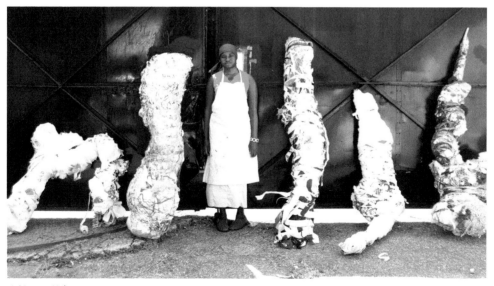

Charlotte I've been working in this field for a long time, early on I used to plan every detail of the workshop so I was driving every moment of it. There was little spontaneity. But over the years I've loosened up my approach, many of the learning-disabled artists made me free up, because I've had to. On collaborative projects, I generally don't plan it very much, I start off with a few core things, and I have to respond then and there. Not many people can work like that, purely because it's quite nerve-racking. But I find it the most thrilling, because you never know what's going to happen. Sometimes it doesn't work, but for people who have got the capacity to have a leap of faith and really embrace the fact that they're experimenting, and that they don't know the final outcome, it's a lot more fun ... I'm confident enough to make mistakes, I suppose.

Alice And how do you think working with people with learning disabilities impacts, if at all, on your own creative practice as an artist?

Charlotte Oh, massively. It has such a huge impact, with everything I do, all my projects feed into my own practice, all of it. One of the reasons I love working with people with learning disabilities specifically is that there is a lot of freedom, there's a lot of the unexpected, and a lot of looking at the world in another way. There's also humour and humanity. I really love all those qualities jumbled together to make something lovely and rich, it feels right.

▲ Nnena Kalu
Action Space, UK
Wrapped sculptures
2012

126

Corali Dance Company, London
Bethan Kendrick and Jacobus Flynn

Corali is a committed group of dancer-performers who have learning disabilities and artist collaborators, from a variety of artistic backgrounds. Corali has developed a cross-art aesthetic that makes use of video, film, animation and live sound/music alongside movement, dance and spoken word. Performances are devised collaboratively using methodologies that creatively empower the dancer-performers and stimulate rich artistic processes. Corali promotes new approaches and contexts to present work and has developed partnerships with high-profile London venues such as Tate Modern and the Southbank Centre.

 Bethan Kendrick joined Corali in 2003 as a dancer-performer and has been in all its performances since that time, including Shed Show tour 2004, Refrain 2006, How Happy We Would Be 2011 and Empty Theatre Dream 2014. She has also created a solo film, At Last. Bethan is also Corali's regular office volunteer. Bethan has performed in Sum of Parts 2011 and Compass 2012 – two collaborative works performed on the main stage of Sadler's Wells. In 2014 Bethan graduated from the inaugural diploma in devised performance at Central School of Speech and Drama, the first course of its kind in the country. Prior to Corali, Bethan was a member of Larondina Dance Company and Alessendre Dance School Company.

 Jacobus Flynn studied Drama at Hull University, has a Masters in Performance Art from Middlesex University, and spent two postgraduate years researching choreography and composition at The Amsterdam School for New Dance Development (SNDO) in the Netherlands. Jacobus has worked with Corali since 2003 as a dramaturg and choreographer, and has been a core member of the devising team since then. He has facilitated performances in special schools, as well as teaching integrated performance at university. He also works independently as a director, writer and occasional performer, collaborating with various artists and performance makers, mostly in Denmark, the Netherlands and the UK.

Alice So what kind of performance do you do?

Bethan We do live art performance, mostly movement and dance.

Alice And what do you get out of your collaboration, if anything?

Jacobus It's just a really exciting environment in which to create work – to work with artists who can really push and change and challenge some of the ideas that I had. When I started making work, I felt I had more control over making it from start to finish, and sometimes it could be a masterpiece, but sometimes you'd end up thinking 'it's not quite right, but it's alright'. Whereas now, when I collaborate with members of Corali, I reach a point where I have to let go – and suddenly the work goes

somewhere that I hadn't visualized at all, and for a moment it feels like it's out of control, and then it's just really exciting and goes somewhere much more interesting.

Alice That's something Mark and Dean from Heart n Soul were saying as well – that the excitement comes out of not knowing where this work will end up?

Jacobus Yes. And trying to facilitate and draw out the best in people's different skills is also really exciting. This mix creates something special and you don't yet know quite where it's going, but we've got enough trust in each other that it's going to work itself out.

Alice Do you think it takes a certain kind of personal skill to sit with that uncertainty in the creative process?

Jacobus Well, it's not like you just come in with total chaos and risk. You go in with a strong idea and a strong concept, and that allows you to get far enough down the line to be able to just explode it for a while and see where it'll go ... the idea that holds it all together is really important. It's not just merging all our ideas into a gloop, because that doesn't work. So working in collaboration is not just everyone with the same input on all levels, but working out how things can fit together to make the best jigsaw with everyone's skills.

Alice So who has the first ideas? How do you plan the concepts?

Jacobus Well, for example, the starting point for our performance Refrain was inspired by Bethan watching an invited rehearsal of the Michael Clark Company at Laban, carefully watching what she saw, and making notes ...

Bethan So I've been writing down what movements I saw in that show and then after that, then we put it all together. And then they [the dancers] have to respond to the words that I was saying and the movements that I wrote down.

Alice Sounds very interesting. Do you find that a good way of working?

Bethan I found that a good way ... I like people responding to the words with their movements.

Alice I'm going to ask you both the same question now: if Corali had to close (not that it's going to), what would you miss?

Bethan Doing the professional development classes ... We do that every Wednesday morning in Brixton. We do a lot of hard work.

Alice Do you like hard work, Bethan?

Bethan Yes ... I've been looking at anatomy. Anatomy. And how parts of your body, like spine and shoulder girdle work ... And we've been doing some floor work.

Alice Floor dance work?

Bethan Yes, that's a bit difficult.

Jacobus And that's the great thing about the professional development classes. It's also weekly, so it's a great opportunity to work together regularly on creative and physical ideas – not necessarily working towards a performance – it's a chance to really develop as artists and try out different things. And work hard and push areas that are difficult, and that we might not actually put in a performance because we're finding it too difficult – but it's a great safe area to explore and train.

Alice And what does it feel like, Bethan, to be working alongside and dancing with other people?

Bethan You can get to know them better.

Jacobus Everyone's personality really comes out in the way that they move, I think. In the class you can get an idea of who people are through their movement. We rarely go for big unison choreography where everyone's doing the same thing, because I don't think that is working best with the exciting performers that we have. Instead, I think when you're doing a movement that you've made yourself and you really own that movement, that's when it really works. So the viewer gets an instant, instinctive kind of response. If you watch a performance and it looks like they have just put the movement onto people, then that usually doesn't work. In Corali, the meeting point between audience and individual performer is the key exciting strength we have. I think we've come to realize more and more that to really show why we're special, our work often better achieves this connection in a more intimate performance. Performing in smaller places, working with smaller details, so the audience feels more connected with the performers.

Alice I can't help thinking that you must be, whether you mean to be or not, ambassadors of quality work by people with and without learning disabilities?

Jacobus For me personally, whilst making the work, I haven't really got an eye on that. It's about the work and I think that's how you can successfully change people's opinions, by concentrating first on the work. Making the work good. And that's what was satisfying about Side By Side as well – the work is of high quality, and its placing in a high-profile, mainstream space gives the right message and reaches out to a wider audience.

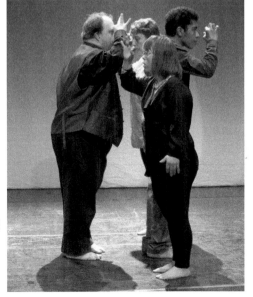

▶ Corali, UK, Empty Theatre Dream
Brighton Dome, 2014

129

What this part of the book is about

- This is a set of conversations with artists who make work together

- The artists think it is important to work together in an equal way

- They talk about the friendships that can be made through working together on artistic projects

- They talk about how the studio space and funding are important for this work

- They talk about taking their work around the world to lots of different countries

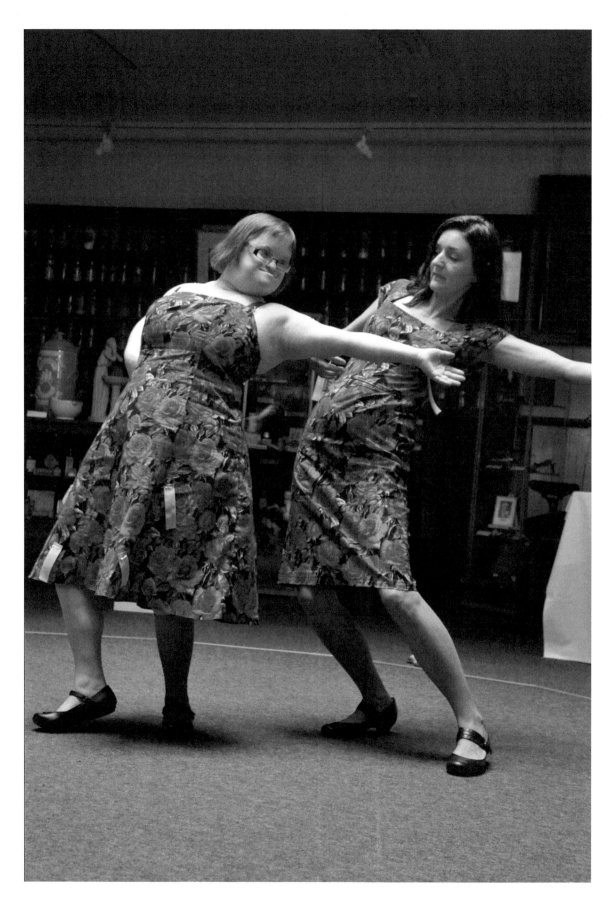

5 Inclusive Arts Research

Introduction

In this chapter we outline key dimensions of Inclusive Arts Research and what practitioners and artists need to know before they get involved in any form of research-based practice. Inclusive Art methods are particularly useful for researchers who want to foster genuine dialogue with people with learning disabilities. This is because arts activities aid communication and help to foster a non-confrontational atmosphere. Such approaches are important because they communicate something which is often distinct from traditional forms of social research about people with learning disabilities. In so doing, such approaches can begin to challenge the ultimate authority traditionally placed in the fields of medicine and psychology to direct policy outcomes for people with learning disabilities.

People with learning disabilities and their collaborators or co-researchers may become involved in research for a number of reasons: they may want to evaluate the success of their project or organization; add credibility to the claims they make about the value of art activities; see what new meanings can be made as a group; give voice to participants; or explore the properties of a material, mode of practice or place. There is no single way to undertake Inclusive Arts Research. Rather, Inclusive Arts researchers are likely to select from the 'buffet' of arts-based and social research-based methods on offer. The selection will depend on the appropriateness of the method for the group they are working with and the research questions they, their group or funders wish to answer. It will also depend on their understanding of what constitutes knowledge (their epistemology) and being (their understanding of what it is to be human).

Thus ambitions for what Inclusive Arts Research can achieve should not be limited to a narrow window of disability politics – such as matters of access or advocacy within social services, or issues of 'social impact' conceived in the term set down by the public sector. Rather, we think the insights of collaborative forms of Inclusive Art inquiry can also be applied to a whole range of socio-cultural issues. For the experiences of people with learning disabilities, like those of other disabled people, can involve forms of productive difference that challenge standardized narratives of the world and how we should exist in it (Hansen and Philo 2007; Macpherson 2015).

In this chapter we make a distinction between Inclusive Arts Practice as a form of research (which actively makes meaning/knowledge through art and explores the material, performative, ephemeral, habitual and non-conceptual aspects of what it is to be human) and research on Inclusive Arts (which tends to use interpretive methods from social science and humanities to illustrate or evaluate the impact of Inclusive Arts on people's lives, often looking beyond the intervention itself). Of course, a combination of approaches may be used in order to explore the properties and success of a project, and in order to speak to a range of audiences (artists, visiting members of the public, funders, academics, carers, care institutions and participants). Furthermore, some of these methods may be conducted collaboratively (with the research questions and direction of research defined primarily by a group), or some might be conducted primarily by individual researchers. Questions of appropriateness, intended outcomes and informed con-

sent will guide the choices made. For further general guidance on co-inquiry and other forms of action or participatory research, see Reason and Bradbury (2008); for specific discussion around research with people with learning disabilities, see Stalker (1998); Thomas and Wood (2003); Walmsley (2004); Abell et al. (2007); Aldridge (2007).

Inclusive Arts Practice as a form of research: making meaning through artistic forms of inquiry

Research is understood here to be an original, detailed and systematic study of a subject in order to enhance knowledge or understanding. Inclusive Arts Practice as a form of research involves the conduct of Inclusive Arts Practices (outlined in Chapter One) wearing a 'research hat'. This requires that the intent of the work is to go beyond personal artistic development and attempt to shift the frontiers of the discipline by 'developing cutting edge practices, products or insights' (Borgdorff 2011, p. 54) that are likely to impact upon people's lives, practices, policies or organizations. To be research, the work should not have previously been carried out by others (it needs to be original), and what is achieved through the process needs to be documented and disseminated. The inquiry must be purposeful and systematic, and the researcher must have a capacity to reflect on their practice and their influence as a practitioner, and to consider what has been achieved and how it might develop.

This approach to research involves making meaning through artistic forms of inquiry and/or exploring the properties and possibilities of an artistic material, group or individual through an arts intervention. It exists in contrast to scientific or medical models of research that tend to advocate distance, neutrality and objectivity (standing outside the research process) in order to produce unbiased truths, so it will go against many preconceived notions of what research is. Research is not necessarily tick-box questionnaires, interviews or numbers-based evaluation. Research on Inclusive Arts might involve an element of this (see the following section). However, like other arts-based and qualitative forms of research, Inclusive Arts Research advocates and actively values the immersed, situated, subjective, relational nature of the researcher and the research process. As Leavy writes in Method Meets Art:

> Traditional conceptions of validity and reliability, which developed out of positivism, are inappropriate for evaluating artistic inquiry. Unlike positivist approaches to social inquiry, arts-based practices produce partial, situated and contextual truths … The aim of these approaches is resonance, understanding, multiple meanings, dimensionality and collaboration.
>
> (Leavy 2009, p. 16)

Inclusive Arts Practice as a form of research can be understood as a way of employing arts practice as a useful method for exploring, discovering, creating and communicating new meaning and new forms of knowledge. As Leavy (2009) points out, arts practice research can generate partial truths and multiple mean-

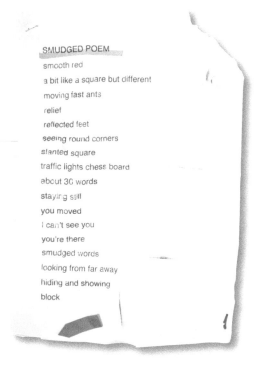

SMUDGED POEM

smooth red

a bit like a square but different

moving fast ants

relief

reflected feet

seeing round corners

slanted square

traffic lights chess board

about 30 words

staying still

you moved

I can't see you

you're there

smudged words

looking from far away

hiding and showing

block

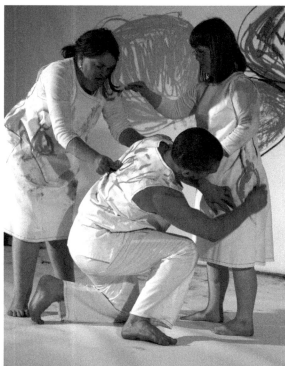

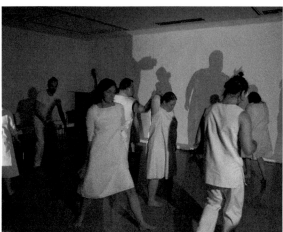

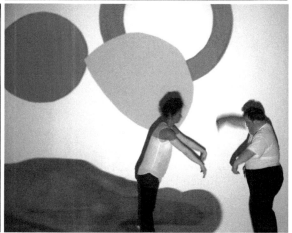

ings. This shouldn't be seen as a disappointing research outcome – but should be embraced, for it is more likely to reflect the complexity of the social world (partial answers might not be what research commissioners and funders seek, but perhaps we can help them expand their expectations of what arts-based research can produce).

Inclusive Arts can also be used to give voice to participants who are often unseen and unheard. For example, this might include a performance or exhibition that shows the audience something about (the often unseen) lives of participants, or that reveals some aspects of their humanity. This approach builds on an established mode of arts-based research as 'giving voice' to subjugated and oppressed forms of knowledge (Finley 2008). This style of arts-based research is particularly important because:

136

By connecting people on emotional and visceral levels artistic forms of representation facilitate empathy, which is a necessary pre-condition for challenging harmful stereotypes and building coalitions/community across differences ...

(Leavy 2009, p. 14)

This is a useful starting point for reflecting on what Inclusive Arts Research might achieve. However, the necessity of empathy for challenging stereotypes could be questioned here – other emotions, such as awe, wonder and fear, could also have a role to play. Furthermore, assuming people with learning disabilities have a voice that should be uncovered, or that people with learning disabilities need to be 'given voice' because they occupy an oppressed social position, can be an oppressive and limiting approach in itself – replicating their position rather than facilitating dialogue and fostering genuine collaboration. How a collaborative practice constructs new meaning, how participants establish who they are through their practice (and through the intimacy and integrity of the marks they are making), or how a practice elucidates otherwise hidden aspects of an environment or art material, might be just as important aims for research. Such approaches could help to illustrate the scope and talent of learning-disabled artists, rather than simply re-present them in a singular or clichéd manner as a socially oppressed group who need to be heard. Here, research is involved in forms of 'world-making' rather than just re-presenting the world as it already exists (Gibson and Graham 2008).

▶ Louella Forrest, Rocket Artist and researcher
NHS Pouches
Fabric, transfers, ink
2012
Research enquiry
Using purses to remember and talk about the NHS people who saved my life.

◀ Rocket Artists, Corali
Smudged
Tate Modern, London
Working methods and final performance
2008
Research question
How can creating a site-specific multi-media performance in the Tate Modern galleries support learning-disabled dancers and their non-disabled collaborators to look at and further understand/comment on the artworks?

Inclusive Arts Research

Research terminology

In order to conduct research using Inclusive Arts Practice, it is helpful to understand artistic processes in a systematic and clear manner using some research terminology. For within academia, 'research' is often understood to be an original detailed study of a subject in order to enhance knowledge or understanding, where traditionally research is understood to have the following components:

- a 'subject' (the object of study)

- a 'literature review or review of practice' (an investigation into what other people have already done that is similar and a set of reflections on how this research can build on or improve this in some way)

- 'methods' (the tools or practices used to reveal something about the object of study)

- 'modes of analysis' (the ways in which what is revealed is explored further and reflected on)

- a set of 'findings' or 'research creations' (these can include objects, performances, documentation, film, photos, images, cutting edge practices or insights that are likely to impact upon lives, practice, thinking, policies or organizations).

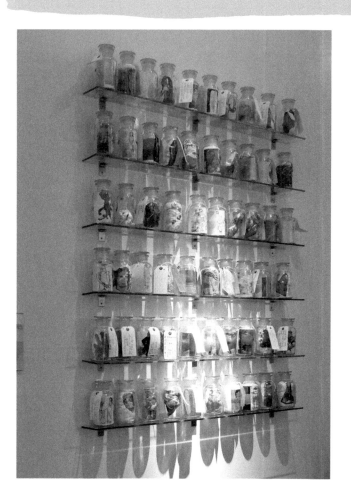

◀ **60 Jars**
Measures of Bodies exhibition, Musée de la Médecine, Brussels 2010
Research question
In what ways does autobiographical text and body sculpture placed in sample jars next to other sample jars in the Musée de la Médecine rework senses of learning-disabled identity? By positioning the work within the collection, value is placed on preserving the knowledge of people with learning disabilities as experts of themselves.

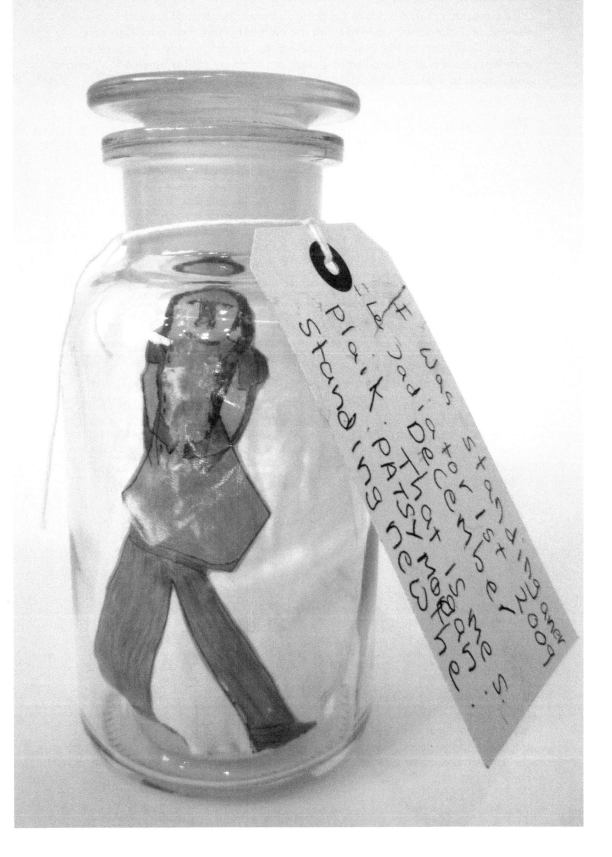

Inclusive Arts Research

Few research practitioners move through these elements of research in a linear manner, and often they move through the elements more than once (see Kelvin and Jo's illustration of The Research Cycle here). In fact, Inclusive Artists are in an excellent position to unsettle what is understood to constitute 'knowledge', who is understood to 'make knowledge', and what is understood to be 'research'.

The Research Cycle

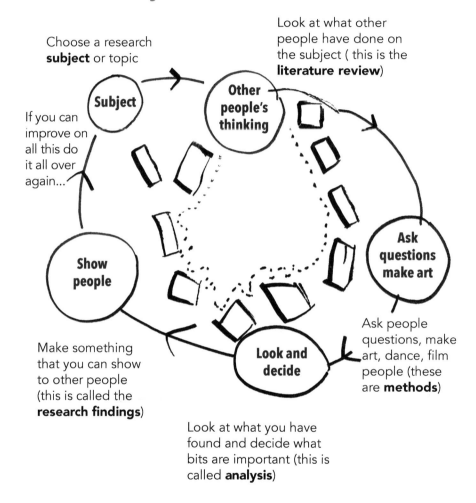

Choose a research **subject** or topic

Look at what other people have done on the subject (this is the **literature review**)

If you can improve on all this do it all over again...

Ask people questions, make art, dance, film people (these are **methods**)

Make something that you can show to other people (this is called the **research findings**)

Look at what you have found and decide what bits are important (this is called **analysis**)

Who or what is the subject of Inclusive Arts Research?

The primary subject of Inclusive Arts Research might be the group dynamics, the non-disabled collaborators, individual people with learning disabilities, or the qualities of an artistic material, mode of practice or place that emerge in conjunction with the group or individual involved. The subject of the research might change as the process evolves, and new movements, materials or individuals may

become significant. So Inclusive Arts researchers need to be brave and confident in uncertainty. However, the individual researcher or group practising collaborative research must choose the subject they are interested in, and then ask one or two questions about the subject to help guide the research at the outset. For example:

- What qualities or uses of paint emerge through a collaboration?

- What properties of the studio space emerge through an inclusive dance?

- How can clay be used to help give voice to people with severe learning disabilities?

- How can visual arts be used to represent the stories of people with learning disabilities to wider audiences?

Note that these are just starting points, which are likely to evolve through the creative and collaborative process. As Borgdorff writes:

> *Formulating a question implies delimiting the space in which a possible answer maybe found. Yet research (and not only artistic research) often resembles an uncertain quest in which the questions or topics only materialize during the journey, and may often change as well. Besides not knowing exactly what one does not know, one also does not know how to delimit the space where potential answers are located. As a rule, artistic research is not hypothesis-led, but discovery-led (Rubidge 2005: 8), whereby the artist undertakes a search on the basis of intuition, guesses and hunches, and possibly stumbles across some unexpected issues or surprising questions on the way.*
>
> (Borgdorff 2011, p. 56)

Thus a researcher needs a flexible structure within which to re-formulate research questions and evaluate in an ongoing manner how the research is progressing. Keeping a diary is helpful here. If you want your work to speak to other people working in the field of learning disability or social research who are not from an arts background, it is worth recording some basic contextual information from the outset. For example:

- be clear as to how the research was designed (who was involved, what prior work was consulted, who the funders were and if there were any specified outcomes)

- how many people were involved and their age, gender, socio-economic background, etc.

- the duration and timescale of the programme (timing of workshops, number of weeks, how many drop-outs there were)

- the research methods used and how this was conducted (for example, this might be purely a piece of 'arts-based research' or it might include other appropriate qualitative methods discussed later in this chapter, such as participant observation, ethnography, interviews, focus groups or video methods)

- a self-reflective section on the researcher's 'positionality' (how they think they might have influenced the research in terms of their relationships, roles and positions in the process)
- a findings section which discusses what forms of knowledge or modes of being are utlized or summoned into existence through the artistic research process (for example, did you use or develop new forms of embodied knowledge, habitual behaviour, brush strokes or imagery?).

What constitutes a literature review in Inclusive Arts Research?

A literature review or review of practice is an investigation into what other people have already done that is similar, and a set of reflections on how to build on or improve this in some way. This is necessary in order to learn from others' mistakes and in order to know if this work is original. Knowing how other people have tackled something similar is always worthwhile, not necessarily to replicate what has been done previously, but rather to know how to build on or depart from that prior work and thinking. Consider both the practical expertise needed to proceed with the project, and the conceptual forms of knowledge needed in order to explain the research. Good starting points for a research perspective on arts-based forms of knowledge and inquiry are academic journals such as Performance Research and Visual Studies.

What are the methods of Inclusive Arts Research?

The methods of Inclusive Arts Practice are the methods of Inclusive Arts Research. They are the methods of collaboration, line, brush movement, performance, gesture and facilitating opportunity. However, these embodied and practical artistic skills also need to be practiced with a critical and reflective 'research hat' on. This is a challenge because it requires researchers to simultaneously be a participant and also (metaphorically at least) 'stand outside' the process and ask, 'What is being achieved here, for whom? What responses or connections are being evoked? What resonances are occurring? What are the most successful processes or lines of inquiry?'

This process of standing outside the activity and critically reflecting on what is happening relates to the skills needed to develop as an Inclusive Artist (whether or not you are choosing to do research). So making use of the self-reflective methods we advocate in Chapter Three will be of use here. Other methods will depend on the research questions – this means the methods are likely to evolve in conjunction with the group and what is and isn't working. The extent to which this is the case will also depend on whether the research is being designed as a collaborative project of co-inquiry from the outset, or whether there is a single designated lead researcher.

Multiple methods can be useful in order to collate a range of viewpoints; for example, combining collaborative drawing activities with interviews about those

activities (Macpherson et al. 2015). In fact, some social research textbooks advocate 'triangulation' – this is where two or more methods are used in a study to check the results (Rothbauer 2008). However, triangulation is a concept borrowed from land surveying techniques that determine a single point in space through the convergence of measurements taken from two other points. As such, it is not necessarily a concept that maps well onto the social world. Two methods might lead to the same set of findings, but they might equally lead to two different findings. So don't get hung up on this concept (and see Blaikie 1991 for a full discussion of the issues associated with triangulation). Contradiction, confusion and absences could all form part of the research 'findings'.

Unlike some forms of research, which advocate designing research at the outset and then 'applying' that research design to a group, when working with people with learning disabilities in arts settings it is essential to be flexible and open to change. For example, if a participant decides the only way they can participate in a group is by standing outside the door and looking through the window, the work will have to be designed to accommodate this. So the practicalities and pragmatics of working with a diverse group of participants inevitably have a major influence on the choice of research methods and arts-based research processes used, and thus the shape and content of the knowledge generated. What is important when writing up research or presenting it is to make transparent those circumstances that framed the choices made as an individual researcher or as a group. Honesty and openness about the process are worth more than adhering to some preconceived idea of what research should look like.

Being a reflexive (self-aware) research practitioner

It is important to be able to reflect on practice, and the process, throughout an Inclusive Arts Research project. This involves engaging with an internal dialogue about the work, and the emotional, political and intellectual responses to what is being achieved. This might take the form of a visual, video or written diary in order to trace the development of the project and the findings. It is essential to be attentive to emotions during this process for, as Leavy states, 'emotions play an important role in artistic expression and they can also serve as important signals in the practice of arts-based methods' (Leavy 2009, p.19). Questions researchers may want to ask themselves during a diary-making process include:

- How am I negotiating the balance between immersion in the process and reflection on the process (as a facilitator or co-researcher) in the studio?

- How do I manage any shifts from facilitator to collaborator to co-researcher?

- What combination of practicalities, pragmatics, situations and resources is structuring the choices made with this group/individual?

- What occurrences, silences, disruptions or contradictions have structured the development of the creative research activity?

- What role does the artistic medium or practice play in the collaborative decision making?

Inclusive Arts Research

What are the possible findings of Inclusive Arts Research?

Traditionally, research has been divided into quantitative (numbers) and qualitative (text-based) findings. However, arts-based research recognizes a greater diversity of ways in which we can make and convey meaning. We can add to a list of possible findings properties such as gestures, habits, images and sounds. In this way, arts-based research calls into question what might traditionally be conceived as a research finding or output, where presenting arts-based research findings doesn't mean turning people into clichéd one-dimensional narratives. For example, in research the 'knowledge' that is produced might be processual, embodied and habitual rather than a material output. Film becomes a useful method of recording some of this because it supports your co-researchers to remember and understand what is taking place and can reveal to audiences the significance of the 'in the moment' practice.

The important thing is to be confident that Inclusive Arts Research has something to communicate that is of value, and that is often distinct from traditional forms of social research about people with learning disabilities. The artwork itself is of value, for the work produced is a form of human expression where knowledge is created and meaning is made. The products may be used as an important form of advocacy within social service settings (something that Kate Adams does using film at Project Art Works). However, in contemporary arts settings such work may have a different role where, rather than providing comforting illumination for an audience, it may leave them bewildered or confused. This raises issues about who the intended audience is for a work and the parameters of quality; discussions that are beyond the scope of this chapter. However, it is important that a research inquiry is aware of its intended audience and the purpose of the work, and begins to document work in a detailed and systematic way – through visual, verbal, textual methods of recording, a reflective diary, a literature review and review of prior work in the field.

Rocket Artists and University of Brighton art students Introduction to Inclusive Art and Design Practice led by Jo Offer (University of Brighton), Adam Thorpe (Central St Martins, Socially Responsive Design and Innovation), Kelvin Burke (Rocket Artist)

Research questions
Jo What inclusive methods can we use to support Rocket Artists and art students to engage with design practices?

Kelvin Find out how to do projects. Different people, not the same all the time.

Adam What can collaborative design (particularly in the context of design for social innovation) and Inclusive Arts Practice learn from each other about the co-creation of inclusive processes in which everyone (affected by an issue) can contribute to its address?

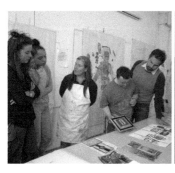

▲ Kelvin Burke, Jo Offer
How can we illustrate 'Learning'?
Drawing on acetate with monoprint
2014

Research on Inclusive Arts: interpretation, definition and classification

In this section we explore how we might conduct research on Inclusive Arts. Research on Inclusive Arts will tend to require the researcher to use interpretive methods in order to evaluate the intermediary and longer-term impacts of a project or consider whether a project met its intended outcomes. This means arts-based methods might be complemented with other methods borrowed from the social sciences such as interviews, focus groups, participant observation or ethnography. These methods can help to generate evidence for the wider impact of a project on participants or their communities (Macpherson et al. 2014). Some may shudder or sigh at the idea of evaluating social impact or applying other instrumental criteria to measuring the outcomes of arts projects. They would not be alone: for example, Sullivan argues that:

> To continue to borrow research methods from other fields denies the intellectual maturity of art practice as a plausible basis for raising significant life questions and as a viable site for exploring important cultural and educational ideas.
>
> (Sullivan 2010, p. 95)

Certainly, arts practice as a form of research is valuable in exploring the material, performative, embodied, ephemeral, habitual and non-conceptual aspects of what it is to be human. It is also useful for actively making forms of meaning and knowledge through art. However, some research questions may not be answerable through purely arts-based research methods. Furthermore, as an Inclusive Artist there are clearly opportunities here to develop and build upon existing social research methods to make them more accessible to people with learning disabilities. Visual diaries, video methods, imagery and reflective practice are all existing forms of creative interpretive social research methods that might be appropriate to use and develop. Therefore it is worth consulting recent social research and evaluation projects in the field of creativity, performance, visual arts and learning disability to get a sense of this diverse field of research practice (Anon. 1998; Brookes et al. 2012).

Evaluating the success of a project

An Inclusive Artist might be required to evaluate the 'success' of their project. This could be because of a need to meet the criteria for past or future funding, or it might be because as an organization they want to evaluate 'what works' when delivering Inclusive Arts. I have put 'success' and 'what works' in quotes because clearly these are complex areas of debate. If you are trying to evaluate success, what is important is to think about what success would look like for your particular project (so state your intended outcomes). This evaluation needs to be embedded in a project from the outset, through clear intended outcomes and ongoing forms of documentation and evidence gathering. Beware – how you evaluate a project can end up determining what it becomes in ways that work against an open artistic process.

Evaluation cannot be done just after a programme of work has finished. For example, co-researchers may have difficulty recalling activities by the following week. This is where the regular visual diary-making illustrated here can be of use to ensure everyone knows where they are in the process and can reflect on the activities in each session.

Session Plan for Tuesday 4th March 2014
Introduction to Inclusive Arts Practice project
Blue Room and White Room Phoenix Arts Centre

10am	Rockets and Students arrive Blue Room	
10am	Welcome Who's here /not here? Timetable Aim for today / Planning Look at framework Take photos	
10.20 am	Kelvin and Jo demonstrate printmaking and collage	
10.30 am	Amy and Peter / Kelvin and Alex Perspex drawings and show artwork example.	
10.40 am	All continue personas. Amy and Peter draw a new persona. Kelvin and Alex - work on the persona started last week with Amy.	

▲ Accessible session plan devised by Jo Offer to support Kelvin Burke in the co-delivery of undergraduate teaching on 'Introduction to Inclusive Arts' research. 2014

Inclusive Arts Research

One problem with most research in this area is a desire to 'celebrate the success' and downplay any negative outcomes. Evaluation needs to be open to negatives as well as positives, and have the capacity to consider both intended outcomes and any unforeseen effects. Precisely how the research is conducted will depend on intended outcomes, the timescale of the work and the methodology proposed.

While some reviews of 'cultural services' advocate standardized frameworks for evaluation (Coalter 2001), there is no one-model-fits-all for evaluating the impacts or value of arts interventions (Reeves 2002). As a starting point, some common headings under which participatory arts programmes could be evaluated include:

- quality of purpose
- quality of engagement
- quality of communication
- quality of practice and process
- quality of artistic products
- sustainability of outcomes.

(Adapted from Bartlett 2009)

These headings are intended as a guide; clearly they are subjective. Quality and sustainability have to be clearly defined in the context of the lives of people with learning disabilities in order to be meaningful. Working with participants from the outset to identify what is wanted from a project and what success might look like is useful when conducting an evaluation. This is a form of so-called 'action-research methodology' which values collaboration and participant empowerment. Even if funding is contingent on achieving certain externally defined outcomes, forms of collaborative research can still be used to try and define what particular outcomes might look like for people with learning disabilities.

Conducting collaborative research with people from the outset takes time. Meaningful (rather than tokenistic) research with people with learning disabilities requires appropriate support in order for them to gain the skills and confidence needed to give genuine opinions (rather than just be grateful and tell you what you want to hear). There is a risk that the cheerful or deferent disposition that is sometimes adopted by people in dependent subject positions will form a prohibitive barrier to more meaningful dialogue (see Macpherson 2008). Furthermore, the in-the-moment enjoyment of a project can sometimes stop participants or audiences from giving more critical feedback (Bishop 2012).

Often the time-limited nature of research can also mean that truly significant dialogue is not generated. There tends to be a scarcity of evidence about longer-term social impact or cultural value beyond the lifetime of a particular project. Inclusive Arts researchers can attempt to overcome some of these research challenges through their sustained practice, through meaningful engagement and through considering how to evaluate or just understand projects over longer timescales.

148

Thinking about social impact and cultural value

You may be an artist who dislikes the term 'impact'; however, increasingly funders and academic institutions want evidence of the impact or value of work beyond the artistic project itself. Prior to the 1980s in Britain, the arts sector relied primarily on aesthetic rationales and argument which emphasized the intrinsic value of artwork (Reeves 2002). However, changing public policy priorities and dwindling public funds have meant the arts have increasingly been placed in competition with basic services such as social care, education and policing. Often the arts are now required to justify themselves in terms of 'social impact' or 'cultural value'. This doesn't mean that art projects need to be reduced to a 'tool' to achieve social, community or health-related outcomes. They can still embrace an open artistic process which values risk taking and openness to unintended outcomes (Knell and Taylor 2011). However, unless funding is not an issue, or is supplied without requiring any form of evaluation or justification, any researcher in this area will need to be familiar with common research terminology and criteria for measuring social impact and cultural value.

Social impact refers to those effects that are sustained beyond the art intervention or encounter itself, and that resonate within the wider life activities or outlook of individuals (see Reeves 2002, p. 29). The table below outlines some of the possible social impacts of a project (adapted from Matarasso 1997). However, we emphasize again here that projects should not simply set out with such social outcomes in mind. In fact to do so would be to detract from the benefits of an open artistic process (cf. Belfoire 2002).

Care should be taken in utilizing any ideas from the table. As researchers, if we look for something hard enough we are likely to find evidence of it. In fact Merli (2004) is rather critical of the original research upon which this table is based. He points out that there is a need to give clear definitions and be clear about what theories are underpinning research. For example, in order to declare that a programme has improved 'the quality of life of participants', you must know how the participants define quality of life. This returns us to the need for appropriate forms of collaborative research to be employed from the outset as part of any research and evaluation process.

One alternative to this table of social impacts has been developed by Brown (2006) in 'An architecture of value', where he attempts to develop a new language for the benefits of the arts that avoids limiting perceived benefits to solely social impacts, and sidesteps the somewhat unuseful division between 'intrinsic' and 'instrumental' value. Instead, he identifies five clusters of benefits that spread from the individual to the interpersonal to the community. An advantage of this visualization of the value, benefits and impacts of arts engagement is that it gives recognition to the way such value occurs over time rather than just at a single point in time.

Matarasso (1997) – list of 50 social impacts identified through Comedia's study of participative arts programmes

1. Increase people's confidence and sense of self-worth
2. Extend involvement in social activity
3. Give people influence over how they are seen by others
4. Stimulate interest and confidence in the arts
5. Provide a forum to explore personal rights and responsibilities
6. Contribute to the educational development of children
7. Encourage adults to take up education and training opportunities
8. Help build new skills and work experience
9. Contribute to people's employability
10. Help people take up or develop careers in the arts
11. Reduce isolation by helping people to make friends
12. Develop community networks and sociability
13. Promote tolerance and contribute to conflict resolution
14. Facilitate the development of partnership
15. Build support for community projects
16. Strengthen community cooperation and networking
17. Develop pride in local traditions and cultures
18. Help people feel a sense of belonging and involvement
19. Create community traditions in new towns or neighbourhoods
20. Involve residents in environmental improvements
21. Provide reasons for people to develop community activities
22. Improve perceptions of marginalised groups
23. Help transform the image of public bodies
24. Make people feel better about where they live
25. Help people develop their creativity

26. Erode the distinction between consumer and creator

27. Allow people to explore their feelings

28. Provide a forum for intercultural understanding and friendship

29. Help validate the contribution of a whole community

30. Promote intercultural contact and cooperation

31. Develop contact between the generations

32. Help offenders and victims address issues of crime

33. Provide a route to rehabilitation and integration for offenders

34. Build community organizational capacity

35. Encourage local self-reliance and project management

36. Help people extend control over their lives

37. Be a means of gaining insight into political and social ideas

38. Facilitate effective public consultation and participation

39. Help involve local people in the regeneration process

40. Enrich the practice of professionals in the public and voluntary sectors

41. Transform the responsiveness of public service organisations

42. Encourage people to accept risk positively

43. Help community groups raise their vision beyond the immediate

44. Challenge conventional service delivery

45. Raise expectations about what is possible and desirable

46. Have a positive impact on how people feel

47. Be an effective means of health education

48. Contribute to a more relaxed atmosphere in health centres

49. Help improve the quality of life of people with poor health

50. Provide a unique and deep source of enjoyment

Personal Development
Self-Actualisation
Improved Social Skills
Creative Competency
Ability to Think Critically
Character Development
Emotional Maturity
Health and Wellness

**Economic &
Social Benefits**
Tolerance
Civic Pride
Social Capital
Creative Workforce
Economic Impact
Harm Avoidance
Community Engagement
Stewardship

Human Interaction
Expanded Capacity for Empathy
Larger Social Network
More Satisfying Relationships
Family Cohesion
Teamwork Skills

**Imprint of the
Arts Experience**
Health and Wellness
Social Bonding
Aesthetic Growth
Intellectual Stimulation
Spiritual Value
Emotional Resonance
Captivation or 'Flow'

Communal Meaning
Community Engagement
Stewardship
Sustain Cultural Heritage
Political Dialogue
Create Shared Memory
Communal Meaning
Transfer Values and Ideals
Social Contact
Sense of Belonging

Cumulative

Before/After

During

Individual ▶ Interpersonal ▶ Community

◀ Five Value
Clusters
©WolfBrown
2006

For more detailed reviews of the relative merits of recent approaches to measuring impact and cultural value, see the Arts Council publication Understanding the Value and Impacts of Cultural Experiences (Carnwath and Brown 2014).

In sum, making claims about what research has 'found out' is tricky. Each outcome that a researcher may claim a project has achieved needs to be clearly defined, either through a collaborative process or by utilizing established definitions in the appropriate literature. The problem with the latter approach is these definitions may not be entirely meaningful to people with learning disabilities. Thus one task of Inclusive Arts Research would be to make these ideas more appropriate and meaningful to this diverse group of the population.

Evaluation needs to be embedded from the outset and ongoing

When conducting research on Inclusive Arts with people with learning disabilities, it is important to be open to the possibility that events may not be recalled in the longer term. This means that ongoing, day-by-day documentation and monitoring is crucial. This will help to capture key moments and collate evidence in a way that is appropriate and meaningful to people with learning disabilities. Equally important is the ability to phrase questions in a way that helps participants express

themselves and their preferences without fear of offending you. For example, you might ask, 'What did you enjoy doing in this session?', and in each of the four corners of the room is something to symbolize the activity that has been done. Participants can move to the corner of the room they prefer. This is more likely to elicit a meaningful response than asking for a verbal answer.

There are all sorts of other ways of measuring and evaluating the impact of a project that we are unable to touch on here in any depth. For example, a technique called contingent valuation uses an opinion poll to discover what people would be prepared to pay for a particular good or service if it weren't provided free, in order to value in economic terms what contribution an 'arts service' has made to the economy. Other researchers have attempted to compile other sorts of statistical evidence for the social and economic impact of the arts (Reeves 2002). However, the risk is that arts organizations become bogged down in measurement and tick-boxes, rather than focusing on the art process itself (Mirza 2006; Raw et al. 2012). Therefore we advocate some creative starting points for research which keep the questions and the answers predominantly within the practice of Inclusive Arts. As Sullivan (2010, p. 89) writes, 'to find out what is important about the visual arts there is a need to start with the art'.

A few starting points for Inclusive Arts Research

Here we have come up with a few ideas for how to begin to conduct research on and through Inclusive Arts.

- Shadow a participant before, during and after an intervention and help them tell their story. This approach could use participant observation and ethnographic techniques combined with image-making, photography and/or film-making.

- Follow a particular material or compare a number of art materials or methods. Think about what they achieve, the agency of the materials and the 'social work' that art materials and practices can do.

- Video an intervention and try to identify key 'turning points' or 'periods of success' during the work. Ask what produced these moments? (What combinations of materials, actions, inactions, silences and movements?) This requires an understanding of participants' lives and what might constitute a turning point or 'everyday epic' moment. Think about how such film footage could be put to work in different contexts (from a personal social advocacy perspective to a gallery setting).

Research project ethics

Artists or artist-researchers working with people with learning disabilities must ensure that the work that they do with them is ethical. In short, this means that the work done together should have the informed consent of participants, should avoid exploitation, treat people as an end in themselves (rather than a means to an end), be dignified, respect privacy, avoid harm, and ideally contribute positively

to participants' lives in some way. Research will need to be 'safe' and thus navigate some potentially difficult terrain around understandings of 'risk' (Wolpert 1980). A lot of ethical conduct occurs 'in the moment' as the researcher interacts with integrity with co-workers (keeping a reflective diary in order to explore this element of practice can be useful). However, for a project to receive the go-ahead as a piece of research, a written ethics proposal must be produced in advance that is reviewed by a research ethics committee at university and/or National Health Service level, and/or any ethical procedures must be followed which are required by the organization within which the research is taking place, for example within hospital arts settings, hospices and schools. The content of ethics forms need to anticipate and provide evidence that the researchers have prepared for any ethical issues that may be encountered through the work. It is worth remembering that health and safety risk assessments also need to be carried out in advance of submitting ethics proposals; if something is deemed too 'high risk' the project may not be considered by ethics committees.

In the rest of this section we discuss the context of such ethics forms and some of the content. The guidance here offers an overview and starting point for producing an arts-based research project with people with learning disabilities that adheres to crucial ethical procedures. However, project-specific guidance and exemplary forms should also be sought from people who work in your area of interest. There is also a wealth of online resources available to help produce accessible information about your project. For example, in the United Kingdom the organization 'Change' has picture banks and exemplary accessible research reports (www.changepeople.org).

Context

In order to keep those you work alongside safe, gain their trust and ensure you are accepted as a co-worker who acts with integrity, it is important to be aware of the potential vulnerability of some of the people you work alongside, and the negative historical connotations that the term 'research' may have for them. In the first half of the twentieth century, statistical diagnostic procedures derived from medical and psychological research produced the category 'learning disability' and 'mentally deficient', and were utilized as evidence for the need to institutionalize people away from free society (Radford 1994). Furthermore, there is clear historical evidence of the abuse and exploitation of people with learning disabilities in early academic research (Carlson 2010). In fact, it was not until the 1980s that any room was made for learning-disabled peoples' perspectives within research and evaluations of the services they received (Kiernan 1999).

Due to the historically negative connotations of the word 'research' for people with learning disabilities and their ongoing vulnerabilities and dependencies, the potential remains for exploitation within contemporary research projects. While most people with learning disabilities in the UK now live in community settings rather than in institutions, they remain among the most disadvantaged in our society. They may have had bad experiences of educational establishments or previous experiences of abuse of their human rights (JCHR 2008). This means

people with learning disabilities who participate in research may be reluctant to express their genuine views or opinions for fear of repercussions. Therefore the establishment of trusting relationships and the elicitation of genuine responses may be crucial ethical goals for your work – goals that Inclusive Arts are well suited to enabling.

Establishing such relationships also brings with it certain responsibilities. Learning-disabled people may lack social networks, and often where these do exist they are made up more of professionals than friends (Pockney 2006). As Nind writes:

> Entering into a research relationship can potentially extend a person's social network and researchers need to consider what this means and feels like from the perspective of research participants with learning difficulties.

> (Nind 2008, p. 9)

Most importantly, people are people first – who lead full, three-dimensional, creative lives that transcend social definitions and expectations of so-called 'learning disability'. It is essential to respect their lives and be clear from the outset about the intended timescale of commitment. Furthermore, research should also contribute in a positive way to the lives of those who are its subject. Ideally, this would be at the time of participation as well as informing any societal or policy changes. If a form of co-inquiry or collaborative action research is planned, then the large amount of time required to fully involve people should be taken into account in order to avoid tokenism.

Informed consent

A key consideration for any project involving human participants will be how to go about gaining the informed consent of participants. Many people with learning disabilities are capable of understanding verbal or written information about research and deciding for themselves whether or not they wish to participate. Others may have difficulty understanding some of the words used in verbal explanations, or may be unable to read or write. In these situations, it will be necessary to produce accessible consent and participant information sheets or videos explaining the research, that people can take away and review before deciding whether to participate. Pictures should be used to make documents more accessible.

In Britain, those who do not have capacity to consent to participate in research themselves will need to gain a 'best interest' decision from a consultee whose responsibility it is 'to advise the researcher about the person who lacks capacity's wishes and feelings in relation to the project' (DH 2008, p. 3). You will also need to go through a National Health Service research ethics approval process if that person is categorized as a 'Tier 4' patient. At the time of writing, this approval process involves a lengthy and time-consuming set of documents which are not well adapted to art-based forms of research and other forms of collaborative research inquiry. We hope to see this change in the future.

Rocket Artists
Measures of Bodies
Musée de la Médecine,
Brussels
Site-specific performance
with guests Jacobus Flynn
and Graham Evans
2010

Research Questions How
can a collective dance piece
support learning-disabled
performers and their non-
disabled collaborators to
explore and comment on
the medical artefacts at the
Musee de la Médecine,
Brussels?

How can a collaborative
dance piece support learning-
disabled performers and their
non-disabled collaborators to
explore ideas of heart as both
pump and emotional centre?

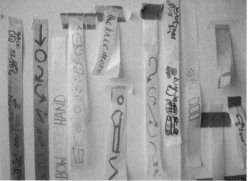
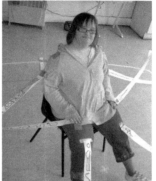

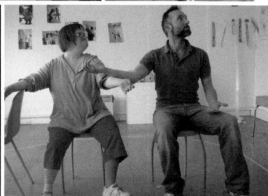

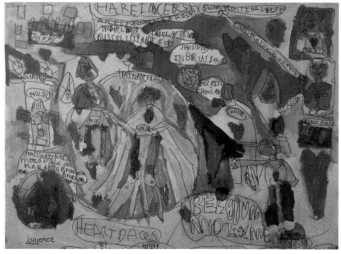

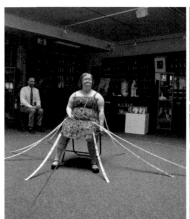
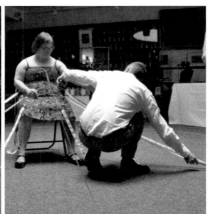
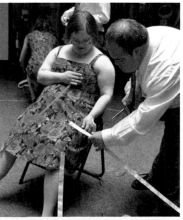
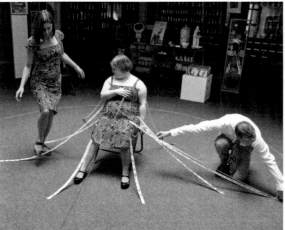
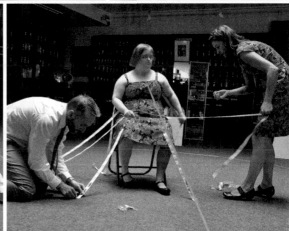
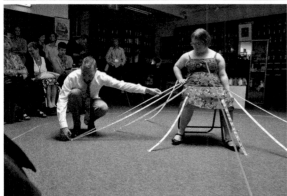
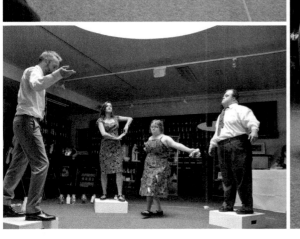
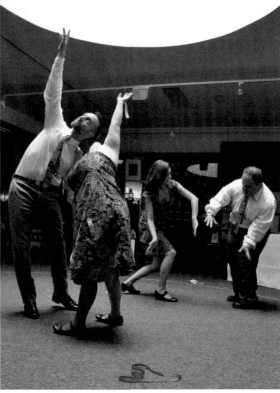

Inclusive Arts Research

As Kate Adams, Director of Project Art Works, stated in our conversation with her:

> I think the ethics of working with people who may lack the mental capacity to make informed consent is an area of understanding that requires a lot more research and debate. I think ethics has to be understood within the framework of people's lives and the way in which people live, because theories about what is acceptable intervention, for example, and what isn't are immensely variable depending on how or what a person is able to communicate about their experience. I think theory, practice and experience with people who have complex needs have to be assigned equal value. So, ethically, the context of people's lives and what they experience has to be addressed as moment by moment, observational and responsive methodology.
>
> (Kate Adams, Project Art Works, 2014)

Ethics committees are used to check that vulnerable participants are being treated ethically and an appropriate standard of safety and structure is set up in a proposed research project. Criteria for approval will include evidence of informed consent (using appropriately formatted information about the project), that recruitment is free from coercion, that confidentiality is ensured where appropriate, that images of people and their artwork are stored appropriately, and that the arts-based research is contributing positively to the lives of those involved.

The way in which ethical consent forms have to be written – the language that is used and the way in which the psychological and medical sciences categorize people with learning disabilities into different grades of impairment, from mild to moderate, severe and profound – may be somewhat at odds with the process of engaging with people through arts-based approaches. Our approach has been to use the non-medicalized language most appropriate to Inclusive Arts Research and provide explanations if necessary. For example, referring to people as having 'complex communication needs' rather than necessarily using the categories given to us by social services. Furthermore, whilst ethics committees (informed by a scientific vision of the research process as linear) tend to see consent as a 'one-off event' and research projects as having a 'predetermined research structure', in reality in Inclusive Arts Research consent and research design involve ongoing, iterative processes. A fact we hope ethics committees begin to catch up with.

Free from coercion

The power dynamics between people with learning disabilities and non-disabled people can be uneven, and people with learning disabilities may be keen to please those they see as occupying positions of authority and power. This needs to be borne in mind when carrying out procedures for informed consent and ensuring participants are not 'coerced' into doing research. For example, one issue to be aware of, particularly where recruitment to the research project takes place in a service setting such as a day centre, is that people might be confused about whether or not researchers are service providers. It is imperative for the position of an independent researcher to be made clear. Furthermore, it is important to state that, if they consent to participate but later wish to withdraw from the research project, they will not be subject to 'penalties' for withdrawing or loss of the services they currently receive.

158

Research 'outputs' and intended audiences

Due to the nature of the creative process, Inclusive Arts Research may be unpredictable and flexible in its material and ephemeral effects. This is hard to write into a standard ethics form, which tends to require a degree of certainty about what the research outputs will be. So researchers should ensure that they consider the intended audiences for research outputs and their capacity to communicate in a range of ways: Is this work intended for funders, academics, policy-makers or other people with learning disabilities? What is produced will be contingent on this. How might the research be communicated in a format which is accessible to people with learning disabilities? How might visual methods be used to communicate the process and outputs of the research to other people with learning disabilities? Be mindful of making complementary aesthetic choices that underpin and magnify the content of the work for a range of viewers – an exhibition or performance can effectively communicate research through the language of the exploratory practice.

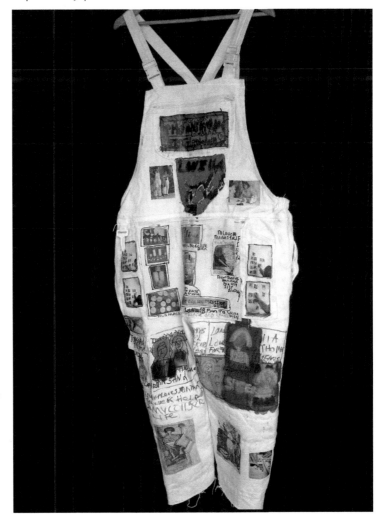

▶ Rocket Artists
Overalls
2006
Research question In what ways can using artists' overalls as a canvas support and capture the creative ideas of learning-disabled artists and non-disabled art students in Inclusive Arts workshops?

What this part of the book is about

- Inclusive Art making can be a way of finding out about the world

- Inclusive Art making can also be important for people's lives

- When audiences see Inclusive Art, they can feel differently about the people whose work they see and they can feel differently about themselves

- We discuss how it is possible to show all those things through research – asking questions and giving answers through art

References

Abell, S., Ashmore, J., Beart, S., Brownley, P., Butcher, A., Clarke, Z., Combes, H., Francis, E., Hayes, S., Hemmingham, I., Hicks, K., Ibraham, A., Kenyon, E., Lee, D., McClimens, A., Collins, M., Newton, J. and Wilson, D. (2007) 'Including everyone in research: The Burton Street Group', *British Journal of Learning Disabilities*, 35(2): 121–124.

Aldridge, J. (2007) 'Picture this: The use of participatory photographic research methods with people with learning disabilities', *Disability & Society*, 22(1): 1–17.

Anon. (1998) 'People with learning difficulties share views on their involvement in a performing arts group', *Community, Work and Family*, 1(3): 329–334.

Bartlett, K. (2009) 'A work force for the future? New methodological approaches for evaluating community dance', *Animated – the community dance magazine*, Spring.

Belfiore E. (2002) 'Art as a means towards alleviating social exclusion: Does it really work? – A critique of instrumental cultural policies and social impact studies in the UK', *International Journal of Cultural Policy*, 8(1).

Bishop, C. (2012) *Artificial Hells: Participatory Art and the Politics of Spectatorship*, London: Verso.

Blaikie, N.W.H. (1991) 'A critique of the use of triangulation in social research', *Quality and Quantity*, 25: 115–136.

Borgdorff, H. (2011) 'The production of knowledge in artistic research', in Biggs, M. and Karlsson, H. (eds) *The Routledge Companion to Research in the Arts*, Abingdon: Routledge.

Brookes, I., Archibald, S., McInnes, K., Cross, B., Daniel, B. and Johnson, F. (2012) 'Finding the words to work together: Developing a research design to explore risk and adult protection in co-produced research', *British Journal of Learning Disabilities*, 40(2): 143–151.

Brown, A. (2006) 'An architecture of value', Grantmakers in the Arts Reader, Winter: 18–25 (accessed 6 May 2014). http://wolfbrown.com/images/articles_essays/documents/AnArchitectureofValueGIAReaderWinter2006.pdf

Carlson, L. (2010) *The Faces of Intellectual Disability: Philosophical Reflections*, Bloomington, IN: Indiana University Press.

Carnwath, J.D. and Brown, A.S. (2014) *Understanding the Value and Impacts of Cultural Experiences*, London: Arts Council England. www.artscouncil.org.uk/advice-and-guidance/browse-advice-and-guidance/understanding-value-and-impacts-cultural-experiences

Coalter, F. (2001) *Realising the Value of Cultural Services*, London: Local Government Association.

DH (2008) 'Guidance on nominating a consultee for research involving adults who lack capacity to consent', issued by the Secretary of State and the Welsh Ministers in accordance with section 32(3) of the Mental Capacity Act 2005, London: Department of Health.

Finley, S. (2008) 'Arts-based research', in Knowles, G. and Cole, A. (eds) *Handbook of the Arts in Qualitative Research*, London: Sage, pp. 71–82.

Gibson, K. and Graham, J. (2008), 'Diverse economies: Performative practices for "other worlds"', *Progress in Human Geography*, 32(5): 1–20.

Hansen, N. and Philo, C. (2007) 'The normality of doing things differently: Bodies, spaces and disability geography', *Tijdschrift voor Economische en Sociale Geografie*, 493–506.

JCHR (2008) 'A Life Like Any Other? Human Rights of Adults with Learning Disabilities', Seventh Report of Session 2007–08, HL Paper 40-I/HC 73-I, House of Lords/House of Commons Joint Committee on Human Rights, London: The Stationery Office (accessed 4 February 2014). www.publications.parliament.uk/pa/jt200708/jtselect/jtrights/40/40i.pdf

Kiernan, C. (1999) 'Participation in research by people with learning difficulties: Origins and issues', *British Journal of Learning Disabilities*, 27(2): 43–47.

Knell, J. and Taylor, M. (2011) Arts Funding, Austerity and the Big Society: Remaking the Case for the Arts, RSA Essay 4, London: Royal Society for the Encouragement of Arts, Manufactures and Commerce (accessed 1 August 2014). www.thersa.org/__data/assets/pdf_file/0011/384482/RSA-Pamphlets-Arts_Funding_Austerity_BigSociety.pdf

Leavy, P. (2009) *Method Meets Art: Arts-Based Research Practice*, New York: Guilford Press.

Macpherson, H.M. (2008) 'The workings of humour and laughter in research with members of visually impaired walking groups', *Environment and Planning D: Society and Space*, 26(6): 1080–1095.

Macpherson, H.M. (2015) 'Biostratigraphy and disability art: An introduction to the work of Jon Adams', in Hawkins, H. and Straughan, L. (eds), *Geographical Aesthetics: Imagining Space, Staging Encounters*, Farnham: Ashgate (Geography Series).

Macpherson, H.M., Hart, A. and Heaver, B. (2014) 'Impacts between academic researchers and community partners: Some critical reflections on impact agendas in a "visual arts for resilience" research project', *ACME: An International E-Journal for Critical Geographies*, 13(1): 27–32.

Macpherson, H.M., Hart, A. and Heaver, B. (2015). 'Building resilience through group visual arts activities: Findings from a scoping study with young people who experience mental health complexities and/or learning difficulties', *Journal of Social Work*, in press.

Matarasso, F. (1997) *Use or Ornament? The Social Impact of Participation in the Arts*, London: Comedia/Arts Council.

Merli, P. (2004) 'Evaluating the social impact of participation in arts activities. A critical review of François Matarasso's Use or Ornament?', *Variant* 19 (accessed 11 September 2014). www.variant.org.uk/19texts/socinc19.html

Mirza, M. (ed.) (2006) 'Culture vultures: Is UK arts policy damaging the arts?', Policy Exchange, 19 January 2006 (accessed 11 September 2014). www.policyexchange.org.uk/publications/category/item/culture-vultures-is-uk-arts-policy-damaging-the-arts?category_id=24

Nind, M. (2008) 'Conducting Qualitative Research with People with Learning, Communication and other Disabilities: Methodological Challenges', Review Paper, Southampton: ESRC National Centre for Research Methods.

Pockney, R. (2006) 'Friendship or facilitation: People with learning disabilities and their paid carers', *Sociological Research Online*, 11(3) (accessed 11 September 2014). www.socresonline.org.uk/11/3/pockney.html

Radford, J. (1994) 'Intellectual disability and the heritage of modernity', in Rioux, M. and Bach, M. (eds), *Disability is Not Measles: New Research Paradigms in Disability*, North York, Ontario: Roeher Institute.

Raw, A., Lewis, S., Russell, A. and Macnaughton, R.J. (2012) 'A hole in the heart: Confronting the drive for evidence-based impact research in arts and health', *Arts and Health*, 4(2): 97–108.

Reason, P. and Bradbury, H. (eds) (2008) *Sage Handbook of Action Research: Participative Inquiry and Practice*, 2nd edn, London: Sage.

Reeves, M. (2002) 'Measuring the Economic and Social Impact of the Arts: A Review', London: Arts Council England (accessed 11 September 2014). www.artscouncil.org.uk/media/uploads/documents/publications/340.pdf

Rothbauer, P. (2008) 'Triangulation', in Given, L. (ed.), *The SAGE Encyclopedia of Qualitative Research Methods*, Thousand Oaks, CA: Sage, pp. 893–895.

Stalker, K. (1998) 'Some ethical and methodological issues in research with people with learning difficulties', *Disability & Society*, 13(1): 5–19.

Sullivan, G. (2010) *Art Practice as Research: Inquiry in Visual Arts*, London: Sage.

Thomas, D. and Wood, H. (2003) *Working with People with Learning Disabilities: Theory and Practice*, London: Jessica Kingsley.

Walmsley, J. (2004) 'Inclusive learning disability research: The (nondisabled) researcher's role', *British Journal of Learning Disabilities*, 32(2): 65–71.

Wolpert, J. (1980). 'The dignity of risk', *Transactions of the Institute of British Geographers*, 5: 391–410.

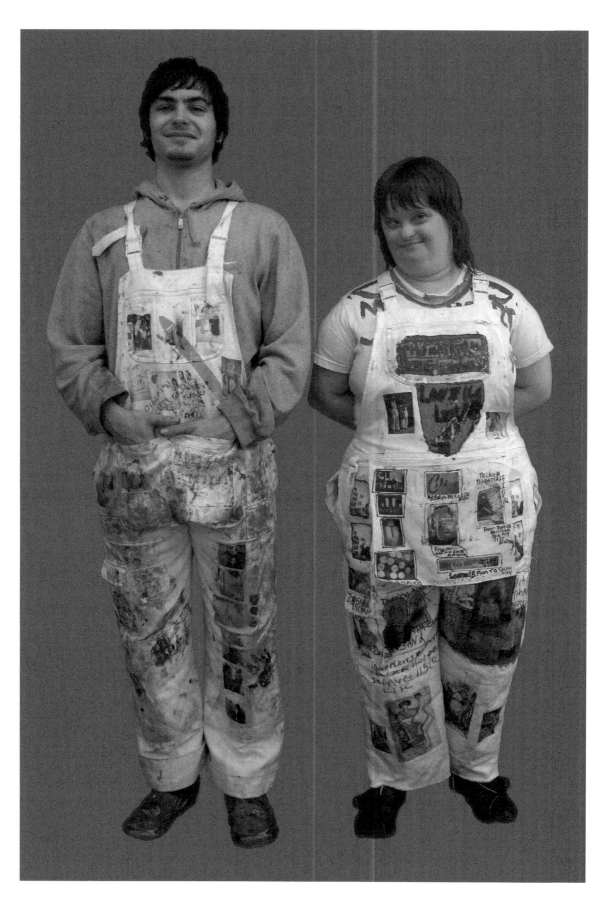

6 The future of Inclusive Arts: building a global movement

◀ Rocket Artists
Overalls
2006

The future of Inclusive Arts

Introduction

Represented here are the ideas and aspirations for the future of Inclusive Arts of over thirty well-known artists, national and international companies, academics and other cultural commentators. All agree that while barriers to practice need to be addressed, the future is rich with creative potential. We have been unable to include everybody's comments in full here; however, we hope this chapter is representative of the diversity of ideas we were given for the future of Inclusive Arts. Many identified to us that part of the value of Inclusive Arts lies in the collaborative process itself, the companionship of a creative journey and the richness of human experience that it can produce. However, one of the challenges is to articulate this value to a diverse array of funders and audiences (Timothy Franklin, Friction Arts; Dr Anni Raw, Centre for Medical Humanities).

Some take issue with the term 'Inclusive Arts' or with what the term 'inclusion' obscures (Tim Wheeler, Mind the Gap; Mayfield Arts). Some are interested in advocating the specific qualities, cultures and unique features of learning-disabled arts practice (First Movement) or the promotion of individual artists as professionals (Sarah Watson, Chair of Carousel; Intoart; Mind the Gap). Others emphasize the creative and educational benefits for everyone of collaboration, and the potential of art as a way of achieving social justice (Nick Hughes, Restless Dance Theatre; Dave Richmond, Arts in Development Ltd). Others express a hope for a greater focus on the quality of the art itself, rather than any therapeutic or social benefits (Lawnmowers; Ich bin O.K.; Corali Dance).

Intoart emphasizes the need for directors and curators to participate in inclusive networks so that learning-disabled artists can take the lead in developing their own programmes. Others hope to continue to tour internationally (Lawnmowers; Heart n Soul). There is a recognition that, just as in any other field of arts practice, establishing really good working partnerships takes time (for example, Sarah Pickthall of Cusp Inc and Andy Kee have worked together intermittently for over twenty years).

In order to build a global movement, attention is drawn to the need for integrated approaches to education (Jude Kelly, London Southbank) as well as access to Inclusive Arts opportunities from a young age and higher education art courses, while many groups also draw attention to the need to develop audiences. For example, Paul Richards from the band Heavy Load suggests there is a need to help the public engage through getting to know personalities and what influences and drives them as artists. Others hope forms of visual and performance artwork will speak for themselves, without a heavy emphasis on biography or labels (Mayfield Arts). Artists also draw attention to the need for larger amounts of time and quality spaces in which to rehearse and make work (Chris Pavia, Stopgap).

Many agree that ideally 'Inclusive Arts' will dissolve as a term as the world and the contemporary arts scene become inclusive by their very nature (Mayfield Arts; Sarah Archdeacon, Director of Corali Dance). Although it was also identified that, paradoxically, the removal of the label might mean we cease to acknowledge the difference and diversity that enriches the arts for everyone (Professor Sarah Whatley) and it also ignores

the specific challenges involved in getting this work accepted and funded. Certainly, for some it is important that the distinct contributions of people with learning disabilities to the creative process are recognized on their own terms rather than becoming entirely integrated into a set of 'mainstream' norms (First Movement). The following section presents a selection of these comments. We then proceed to discuss employment and the validation and accreditation of work in this field; the ethics of display; consent and the need for support worker 'buy-in'; and the future for work in this field that may be seen as 'taboo', from issues of sex and sexuality to the practice of life drawing.

What would you hope for the future of Inclusive Arts?

▲ Performance Group,
Arty Party UK
A Woodside Home
2013

For Inclusive Arts to help build a creative future where it can thrive; Where nothing has to be planned; Where each new project is seen as an adventure by everyone involved; Where there is trust in the process of artistic collaboration; Where the unknown is greeted like a long-lost friend; Where a story can always unfold; Where a dream is listened to more then a policy; Where the complete beginner can lead the 'expert'; Where people have more time to stop, to be open, and to listen to the art all around them; Where play is an intrinsic and valued part of life; Where the richness, depth, artistry and companionship of a creative journey is acknowledged as being more important then any amount of stats and clever words.
Ray Jacobs, The Performance Group Live

In an Inclusive arts future we can recognize that good art need not be judged by the dizzying whirr and beauty of its conceptual complexity. Rather, curiosity, play, embracing the risk of discovering we know and understand nothing, and expressing through connection to another individual's world that fresh excitement at being alive, can also produce insight, beauty, creative fission.
Dr Anni Raw, Researcher at the centre for Medical Humanities (CMH), Durham University

The future of Inclusive Arts

From left to right
Sarah Watson
Carousel, UK
Wild Things 3
Jukebox
Side by Side
exhibition, London

John Mullins, Trisha
Donnelly,
Creative Growth Art
Center, USA
Untitled
Mixed media on
screen print, Unique

Station 17, Germany

Stopgap Dance
Company, UK
The Awakening
2014

What's missing at the moment is learning-disabled artists being recognized as artists in their own right – I'd like to see that happen in the future. Then artists, performers and film-makers with learning disabilities can be equal artists.
Sarah Watson, Chair of Carousel, learning-disabled film-maker and artist

Clearly there are structures and prejudices we need to dismantle that block our understanding of who an artist can be. These obstacles often come from viewers, collectors, and the 'art world,' but occasionally from artists too. I hope that the future brings not just inclusion, but leadership. Essentially, I see our artists as leaders of contemporary culture.
Tom di Maria, Director, Creative Growth Art Center, Oakland, California, USA

Well before you get to exhibition stage, this is about how people with a learning difficulty are integrated into all sorts of areas of personal and professional development. So are art colleges going to become inclusive? Are schools going to become inclusive to a greater degree, and where does art fit into school life nowadays? For this work to expand, the number of opportunities for disabled people to be part of practice needs to expand. So it has to be acknowledged as being important, artistically, not just therapeutically.
Jude Kelly, Artistic Director of the Southbank Centre

We want to make sure that we bring in and train the next generation of Lawnmowers ... We would like to expand our work ... have late-night gigs and be part of mainstream festivals. We hope to secure our building to fulfil all of our plans ... In the future we would like to be so inclusive that no-one sees a label around our work, they just see us all as great artists ...
Lawnmowers, Newcastle, group reply

Graeae is fuelled by a passion to create artistically accessible theatre for artists and audiences alike … through meaningful, equal collaborations we can ensure that theatre does not become any more male, pale and stale than it already is. Inclusive arts need a wider platform and to be seen as an asset. If it is deemed as a risk (because financial cuts may force creative industry to play safe), then it is a risk worth taking.
Jenny Sealey, MBE, Artistic Director, Graeae Theatre Company

Once we recognize that the arts build social justice, we might spend less time and money on justifying the arts and more on realizing our potential.
Dave Richmond, Arts in Development Ltd

It is necessary that artistic groups focus on all dimensions of their behaviour and constantly question how the conditions for in- and exclusion are shaped and who they prove to be useful for.
Peter Tiedeken, Barner 16 (record label for the Band Station 17), Hamburg, Germany

I think there needs to be more opportunities and time given to make and rehearse works. It took Stopgap a long time to make and rehearse our latest show Artificial Things, and they gave me a lot of time to make and rehearse my dance show The Awakening …
Chris Pavia, Stopgap Dance Company

Through its work in Cambodia, Epic Arts has seen first-hand that Inclusive Arts have a transformative power for change within society. I hope that in the future, Inclusive Arts will affect society as a whole by discussing the attitudes we must cultivate in order to create a truly inclusive world in which we can all live. I hope to see Inclusive Arts become the blueprint for all arts communities, not a just specialized area, but the way that all arts 'just is'; a sector that is inspiring, accepting, adaptable and a true celebration and expression of individual creativity in all its forms
Laura Evans, Arts Advisor and Senior Manager, Epic Arts, Cambodia

The future of Inclusive Arts

 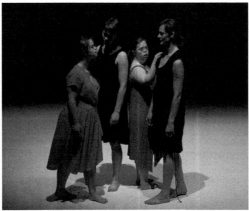 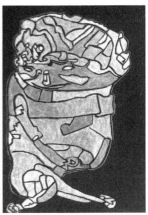

From left to right
Graeae Theatre
Company
UK
Bent
2004

Ich bin O.K, Austria

Ailbhe Barrett,
Mayfield Arts, Ireland
An Old Man
White chinagraph
on paper
42 × 59 cm
2013

Angela Burchill,
Mayfield Arts, Ireland
Lynda's Angel
Pastel pencil on paper
20 × 29 cm
2013

Zach Frith, activating
Solid Space ball cube
First Movement, UK

Clifton Wright, Intoart
UK
Family Photo Album
Pencil crayon on paper
2012

I wish to see Inclusive Arts expand and flourish so everyone has the chance to participate and be visible, where disabled and non-disabled people learn, create and thrive through the arts together, where a philosophy of inclusion is embedded and there is a level playing field in terms of funding for Inclusive Arts.
Professor Sarah Whatley, Director of the Centre for Dance Research

For us, Inclusive Arts should not be seen as something special or a social project, it should be an integral part of the professional art scene … The emphasis should be on the arts and not the disability of the artists. This is our philosophy and what we work for on a daily basis … Everybody should have the chance to experience art, to express the pure joy of performing art and to show what he/she can do.
Hana Zanin, Teacher and Choreographer, Ich bin O.K., Vienna

I hope for my own gallery, my own pictures at home and here in CÚIG.
Ailbhe Barrett, Artist, Mayfield Arts, Cork, Ireland

I hope for more exhibitions and to go around the country and abroad with my art.
Angela Burchill, Artist, Mayfield Arts, Cork, Ireland

I hope for art based on its merits, not its labels.
Lynda Loughnane, Artist, Mayfield Arts, Cork, Ireland

Where is learning-disabled culture? Why has it failed to make much of a mark on the mainstream of either culture or life? The answer is that it is still relatively invisible. By working side-by-side with learning-disabled people it is possible to slowly

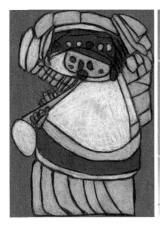

uncover the world they find engaging and interesting. I guess the simplest question is this: 'if the arts had been invented by learning-disabled people, what would they look like?'
Peter Shelton, First Movement

Inclusive artists should be valued as the important radicals that they are, fulfilling the democratic ambition of the arts and expanding their relevance to everyone.
Timothy Franklin, Friction Arts, Manchester

Platforms for visual artists with learning disabilities in cultural institutions are key if directors and curators are going to participate in developing inclusive networks where artists with learning disabilities take the lead in developing their own pro-grammes. Intoart's hope for the future is that the voices of more artists with learning disabilities will be heard by those in a position to help build these platforms and to make change happen.
Sam Jones, Intoart

Drawing helps you do something with your life, that you have the knowledge and skills of what you are good at. Plus it gives you something to achieve and it makes you experiment with where you want to go.
Clifton Wright, Intoart

I think it important that we remain watchful whenever terms like [inclusion] are used. Instead I favour 'interaction' and 'engagement' … It is not good enough just to segregate people in 'relaxed performances' or create specialist companies or one-off programmes. We need a consistent approach within arts education and training. We need the specialist company and the mainstream company willing to collaborate. We need to support learning-disabled artists to become cultural lead-ers in their own right. There are great performers, like musician Jez Colborne at Mind the Gap or singer Lizzie Emeh at Heart n Soul, whose work has won interna-tional critical acclaim … These artists really are the pioneers of a new future. Let's not slip back into the old models that favour process over product, or group over individual. Why not have it all?

The future of Inclusive Arts

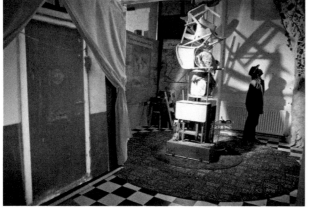

From left to right
Friction Arts, UK
Echoes project
2013

Ntiense Eno
Amooquaye, Intoart,
UK
**Beauties Have
Cosmetics
Collection**
Indian ink on paper
2014

Heavy Load, UK
Stay Up Late
campaign
2010

Candoco Dance
Company, UK
Notturnino
Choreographed by
Thomas Hauert

Sarah Pickthall,
Andy Kee,
Cusp Inc, UK
Sprungdigi.com
launch film, 2014

There are still huge dilemmas around payment for work, Access to Work and the Independent Living Fund. To find yourself in the benefits maze is to wake up in a living nightmare where the walls constantly move and a route that was once available is there no more. Goodness knows how a talented learning-disabled person would find their way through without help. No, I'm wary of [the term] inclusion. I'm in favour of interaction, engagement and inter-dependence.
Tim Wheeler, former Artistic Director, Mind the Gap

I was lucky enough to be a member of Heavy Load and we ended up playing gigs across the world, taking our chaotic and energetic live shows to sometimes unsuspecting audiences. Once we were asked by a well-meaning support worker to explain some members of the band had learning disabilities before we performed. Of course we offered no such 'apology', but did turn our amps up a notch – this incident strengthened our resolve to just do what we did ... I'd love to see more collaboration between learning-disabled artists and 'mainstream' artists ... I'd love to see artists breaking through into mainstream situations as I believe the quality of the work will speak for itself ... I also hope that artists can find other ways to fund their work (outside of the traditional arts organization-getting-grant-funding model) ... The reason Heavy Load worked so well was we never had any grant funding, which meant we never filled in an evaluation form and just followed our collective noses. A very exciting and liberating thing to do!

So my main hope is that artists with learning disabilities are supported to GET IT OUT THERE!
Paul Richards, Stay Up Late

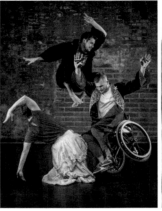

I hope that the future of Inclusive Arts can start with equality, rather than aiming towards it. By starting with equality, meaningful interactions can happen with and through art in terms that are productive for each individual.
Dr Esther Sayers, Centre for Arts and Learning, Goldsmiths College

Collaboration with others that you KNOW will benefit both sides, is ALWAYS a must! By collaborating, you combine your efforts to create something that will move mountains. As one, we are each but a link of a chain, but combine that chain with several links, and we, the entire chain will become unstoppable! Me and Tom have always done well before with our show-stopping collaborations ... we will push that notion one step further when we control the film industry. Somehow.
Michael Smith and Tom Stubbs, Bristol-based award-winning animators

Inclusion is about letting go of your assumptions about who cannot take part in what you do, and making what you do easy to understand so it's not only good for people with learning difficulties but all people.
Andy Kee, Youth Worker, Cusp Inc

As Artistic Co-Director of Candoco Dance Company, I have worked with a rich variety of disabled and non-disabled dancers. Artistically, this mix of people always brings out bold investigation of movement idiosyncrasies which communicate directly to an audience. The inclusive work inspires the ambition to be a professional performer for disabled and non-disabled alike.
Stine Nilsen, Artistic Co-Director, Candoco Dance Company

Inspired by our colleagues – the Rocket Artists in Brighton, we believe that Dutch art students and artists with learning disabilities may be of great added value for each other ... contributing to the personal development of the artists.
Kunstwerkplaats, Amsterdam

Oily Cart theatre is close-up and highly interactive so that our audiences become co-creators. It is a theatre that challenges conventions of the place and the time of performance. ... The seat, the ceiling, the texture of a costume must all have as much potential as a character moving and talking off in the distance. My hope is that in the

The future of Inclusive Arts

future all theatre will come to incorporate more and more of these interactive and multi-sensory elements – better suited to communicate with those in our society who do not rely on the standard languages of sound and vision, and who wish to engage with their art and their entertainment not as passive receivers but as dynamic participants.
Tim Webb, Oily Cart Theatre Company

People with profound and multiple learning disabilities remain some of the most marginalized in our communities; the support they receive from staff will often be a critical factor in the quality of participation they have …
Melaneia Warwick, Pria Arts

Restless Dance Theatre wants to see inclusive dance recognized as an authentic dance form in its own right. We want Inclusive Arts to be a stepping stone to an inclusive society where everyone has the right to express themselves creatively.
Nick Hughes, Company Manager, Restless Dance Theatre, Adelaide, Australia

I hope working inclusively becomes embedded in contemporary art, dance and theatre practice … That artists with disabilities continue to receive the support they need to be able to fully and equally contribute to contemporary arts practice and that artists with disabilities are recognized for their contribution to contemporary arts practice …
Sarah Archdeacon, Director of Corali Dance

▶ **Left to Right**
Michael Smith, Tom Stubbs, UK
Light and Dark
Film still
2008

Oily Cart, UK
Pool Piece
2008

Arendjan Talstra, Kunstwerkplaats, Holland
Family
Ceramic
18 × 23 × 8 cm
2013

Cameron Morgan, Project Ability, UK
Cameron's Way: Coast to Coast Installation
Commissioned for Generation: 25 years of Contemporary Art in Scotland
Future plans include public residency making a new wall painting in the Project Ability gallery space, Glasgow

Pria Arts, UK
Charlotte Hawkins, Melaneia Warwick
2014

Caitlin Moloney, Chris Dyke, Restless Dance Theatre, Australia

◀ Sok Kret and Chakada
Epic Arts, Cambodia
Creative Partners
2014

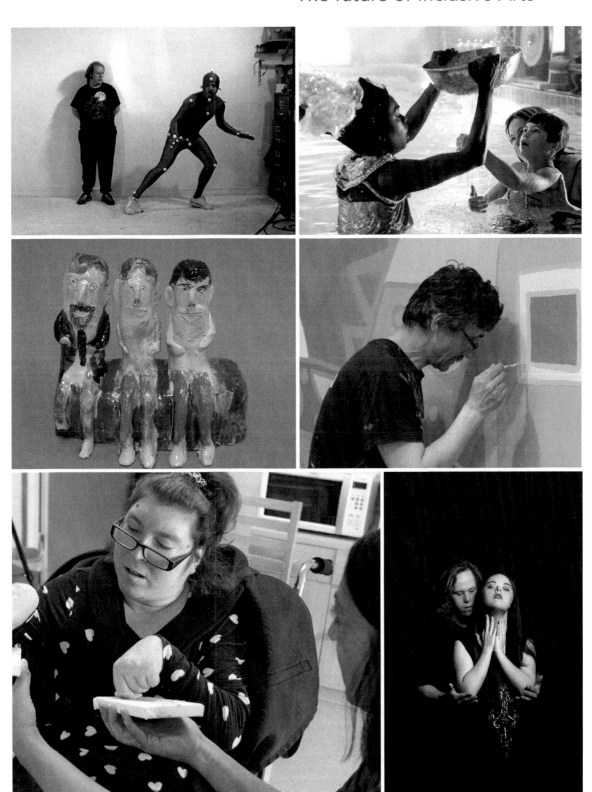

What is the future for learning-disabled arts education?

Many contributors to this chapter call for an increase in respect and recognition of people with learning disabilities' artistic talent. One way that this could happen is through greater access to opportunities to work in mainstream arts environments and greater professional accreditation of work. Not to make learning-disabled artists 'the same as' any so-called 'mainstream' artists, but rather to give them a springboard, contacts, experience and qualifications from which to launch their practices. As Goodley and Moore (2002, p. 87) write about the performing arts of people with learning difficulty (sic): 'The lack of a national system of accreditation seriously constrains the career opportunities of people who are interested in working in this field'. Furthermore, there is no nationally recognized effort to move forward in a common direction. This is particularly important in the UK because so many funding streams are now reliant on accredited courses.

One problem that must be overcome is that most learning-disabled people who are in arts training get stuck at the Entry Level or Level 1, yet it is not until the higher levels of training (such as a Level 4 Foundation Course) that the expertise of the staff and their expectations of what art, music or drama is shift to a level that is appropriate for learning-disabled people' creative outputs. Put simply, at this level a kettle doesn't have to look like a kettle anymore. Thus talented learning-disabled people who want to study seriously need to be able to access the right type of higher-level arts education. This would be an education based on co-inquiry and a respect for difference, and that involves the practice of freedom rather than domination, including the freedom to inquire (Freire 1972).

◀ KCAT purpose-built
Inclusive Arts building,
Kilkenny, Ireland

TV-Glad, Denmark
Student Ursula Mille
Jensenat, Glad
Vocational School
Glad Foundation's
goal is broad inclusion
in society with
particular emphasis
on the job market

▶ Inventura, Czech
Republic
**Earthlings, who are
you voting for?**
Film stills
2010

There has been considerable change in the perception of and potential for people with learning disabilities within the arts in the UK in recent years. Learning-disabled artists, organizations and companies are increasing their public profile and having more control over the work they produce. The Disability Discrimination Act (1995) (now Equality Act 2010), the Valuing People White Paper (2001) and changes to the regulations for permitted working have helped to support this change. However, as we have outlined, learning-disabled people are excluded from higher levels of art education because of the way in which courses are designed and delivered. At the University of Brighton, the Rockets work alongside Masters students to deliver higher-level training for those students, to receive professional development opportunities and to practice as artists. This model works well – the Rocket Artists get the benefit of working alongside university students, access to equipment and staff expertise, without any expectation to fit into the current learning structures or be an academic. However, they don't get official qualifications. Currently this isn't an expressed concern, the Rockets tell us they just want to make, exhibit and sell their work. However, it is important that narrowly constructed academic models of art education continue to be challenged.

Most arts foundation and degree courses rely on an academic model of education where there remains an expectation that students can articulate their learning and practice through speaking and writing. Therefore at the moment in higher education we cannot teach learning-disabled people degree-level art unless they are also able to produce verbal and written articulations of their practice. This stems from a pressure on art in higher education to legitimize itself through academic concepts and analysis – letting the art speak for itself leaves artists vulnerable to critiques of pointlessness. The idea of the brilliant but non-academic artist is too challenging for the higher education sector. Equally, the idea of interdependence

and collaborative, cooperative ways of working is a challenge to the norms of individual competitiveness that often animate education more broadly.

Thus at times social, political and educational forces work against the sort of ethos of encounter and collaborative endeavour that we advocate in this book and that many others have articulated in their aspirations for the future. Whilst pursuing 'individual professionalization' might make sense for some talented artists, others will benefit from a more collective approach. Thus simply mirroring the changes that have happened in social care systems over the past decade – direct payments, individualized budgets, personalized services and the enlargement of choice for learning-disabled adults – is not enough. For, whilst these changes and the push towards self-directed support in the UK in recent years have been positive for those who have the capacity and networks to take advantage of these schemes, others risk occupying an increasingly isolated social position as a result of these changes (Roulstone and Morgan 2009).

What Inclusive Arts training requires is a change in the ethos of education and society more broadly. A focus on process and listening through the arts, and the other criteria for quality practice we identify in Chapter Three, could be a helpful move in the right direction here. The Rockets are just the start of a process of chipping away at accepted 'norms' within higher education. We recognize that there is more work to be done. Educators need to keep asking:

- What does it mean to know?
- What do we need to know to be artists?
- How can we validate or assess inclusively?

Brave new assessment strategies need to be developed that question what constitutes learning and how this can be demonstrated or witnessed. Learning-disabled people need to be involved in such developments from the outset, and in skills development for Inclusive Arts workers. While some people have found bespoke ways to include people with mild learning disabilities, this model of inclusion is often normalizing and puts the responsibility to fit in on the learning-disabled person. More significant adjustments to arts education are required in order for a two-way process of inclusion to occur. This requires us to challenge existing norms within the education system and accept that working alongside learning-disabled people is more expensive due to small numbers and high staff ratios. The language of 'reasonable adjustments' is not necessarily enough here. Rather, people's values, beliefs and common-sense assumptions about what art is, and who can make art, must be questioned. In a sense, it is literally not a 'reasonable situation', and thus being reasonable to address it is inadequate. One answer could be to develop inclusive assessment methods (through visual documentation, video diaries, etc.) on a selection of arts foundation or degree-level modules. These modules would be suitable for all students and would also be welcomed in arts education, where a high proportion of students have dyslexia.

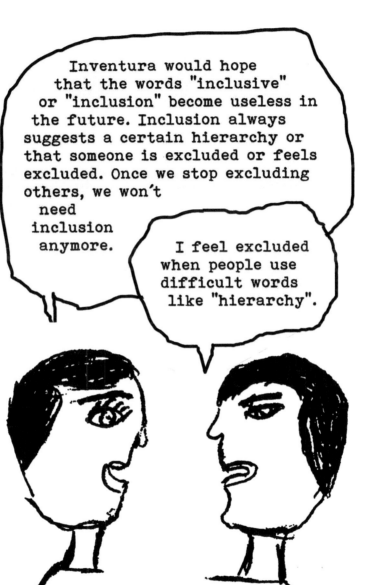

▲ Inventura, Czech Republic
Collaborative illustration responding to
'what is the future for inclusive arts?'
Drawing by Šárka Hojaková
2014

How can learning-disabled artists go professional?

While there are a number of learning-disabled actors now on mainstream televi-sion (for examples, see the Dark Horse theatre company), and the Cúig artists in Mayfield House, Cork are paid as artists, these are notable exceptions. For most learning-disabled artists, routes into paid work are few and far between. In or-der for people to become employed in this sector, not only do there need to be forms of accreditation and training that enable routes into work, there also needs to be a growing audience for work and changes from the outset of their educa-tion. This means tackling barriers to participation in the arts. In the UK, Mencap identified through its research with young learning-disabled people that money, transport, accessibility, feeling supported, feeling welcome and accessible infor-mation are key barriers to be overcome if more young people are to be involved in arts activities (Mencap 2009). The UK Department of Health argues that, more broadly, there is a need to 'grow the presumption of employability' (DH 2009, p. 15) through promoting the fact that learning-disabled people can have careers. For the cultural sector, this requires role models and close partnership working between statutory, voluntary and private agencies, with funding streams brought together to map out employment paths in the sector (Arts Council 2005).

Since 2003 a new scheme called 'Permitted Work' has been created, enabling learning-disabled people in the UK to earn up to £66 a week without jeopardizing their benefits. Though is a small amount, it does enable learning-disabled peo-ple to do some paid work as a stepping stone to future employment. However, discrimination in the sector and barriers for learning-disabled arts organizations who are seeking to professionalize must be confronted before even £66 a week is a realistic ambition. For many learning-disabled arts organizations, these barriers include: a lack of sustained involvement with mainstream arts organizations; not being seen as capable artists in their own right; lack of sustainable income; lack of defined artistic vision; few staff involved with arts backgrounds; low fees for staff; lack of training; limited capacity; and lack of networking (Arts Council 2005).

In order to address these issues, it is important that learning-disabled artists and arts workers are promoted and their talent utilized. Existing projects also need clear exit strategies that link to future opportunities or sustainable sources of fund-ing so that talented individuals can further their careers and be involved in appli-cation, planning and delivery of artistic vision. This requires extended and genuine partnerships with mainstream organizations. It also requires access to good quality critique that can appreciate the skill level and work of performers in their own terms, but be confident to criticize. Artists, facilitators, educators and critics need to build their confidence in critiquing this work in order to avoid an 'isn't it all lovely' approach.

Sources of funding also matter, and a base of funding from arts councils or other public or private foundation grants (rather than from social care settings) is impor-tant for enhancing respect from other artists and arts organizations (cf. Goodley and Moore 2002). Uncertainty around funding can perpetuate low morale in the sector, so clearly long-term funding and partnership working is very important. Ultimately

opportunities need to be seized where they can, but it is important not to compromise on the quality of the artistic output or the process of working together.

What is the significance of Inclusive Arts for all, and how can support worker buy-in be ensured?

Many of the views expressed here are from the 'public-facing' side of Inclusive Arts Practice. However, not all learning-disabled people will want to display or perform their work, or have opportunities to qualify in this field. Access to the arts is still very important for these people because the arts can help aid communication and foster confidence, choice and self-empowerment. These are all important features of practice that we discuss in Chapter One, and to which Kate Adams from Project Art Works draws attention in her conversation in Chapter Four.

It is also very important that participation in arts activities is not undermined by a lack of understanding or enthusiasm from support workers. Attempts need to be made to develop mutual understanding between these different professions (Goodley and Moore 2002). Sometimes attending your private view might be more important than finishing your dinner, yet those who are given a duty of care may not see that as a priority. As Goodley and Moore write:

> Often people with learning difficulties are subjected to constant vigilance ... from parents who worry ... and from staff who are bound by an accountability to 'health and safety' policies of services. Being watched means that people with learning disabilities often have to account for their past and future actions, which are then assessed in terms of risk, appropriateness and suitability. Therefore when they attempt to do things there is always the possibility of inappropriate and disabling support ...
>
> (Goodley and Moore 2002, p. 116)

This 'inappropriate and disabling support' is a barrier that arts practitioners must try to overcome. For there is dignity in risk, and low expectations from others can threaten a person's capacity for self-expression and self-determination. Mencap offers simple guides to the benefits of arts activities that can help communicate to support workers the value of what is being achieved (Mencap 2008).

How can Inclusive Arts help advance the human rights of learning-disabled people and achieve social justice?

The politics of Inclusive Artwork is not always explicit; however, for some practitioners it has been useful to have a working definition of social justice. Often the term 'social justice' is understood to imply fairness and mutual obligation in society, that is, where we are responsible for one another and ensure that all have equal chances to succeed in life. This requires a redistribution of opportunities when life chances are not distributed equally.

The future of Inclusive Arts

John Rawls (1971), one of the most influential thinkers on social justice, argues for a balance between social equality and individual freedom. However, social equality and individual freedom sometimes exist in tension. We have found the work of Martha Nussbaum (2003) and her capabilities approach instructive here. She suggests that at a minimum, for human rights and social justice to be secured, it is important that the following 'capabilities' are protected. Given the ongoing challenges to learning-disabled people' basic human rights, we think these are very important to keep in mind when practising as an Inclusive Artist, for artistic forms of communication, relation and expression can help contribute to ensuring these capabilities are secured for learning-disabled people.

The central human capabilities

Life

Bodily health

1. Bodily integrity – being able to move freely; to be secure against violent assault; to have opportunities for sexual satisfaction and reproductive choice

2. Senses, imagination, and thought – being able to use the senses, to imagine, think, and reason, and to do these things in a 'truly human' way informed and cultivated by an adequate education; being able to use imagination and thought in connection with experiencing and producing works and events of one's own choice

3. Emotions – being able to have attachments to things and people outside ourselves; to love those who love and care for us, to grieve at their absence; in general, to love, to grieve, to experience longing, gratitude, and justified anger; not having one's emotional development blighted by fear and anxiety

4. Practical reason – being able to form a conception of the good and to engage in the planning of one's life

5. Affiliation – being able to live with and toward others, to engage in various forms of social interaction; having a social basis of self-respect and non-humiliation; being able to be treated as a dignified being whose worth is equal to that of others

6. Other species – being able to live with concern for and in relation to animals, plants, and the world of nature

7. Play – being able to laugh, to play, to enjoy recreational activities

8. Control over one's political and material environment

(Adapted from Nussbaum 2003)

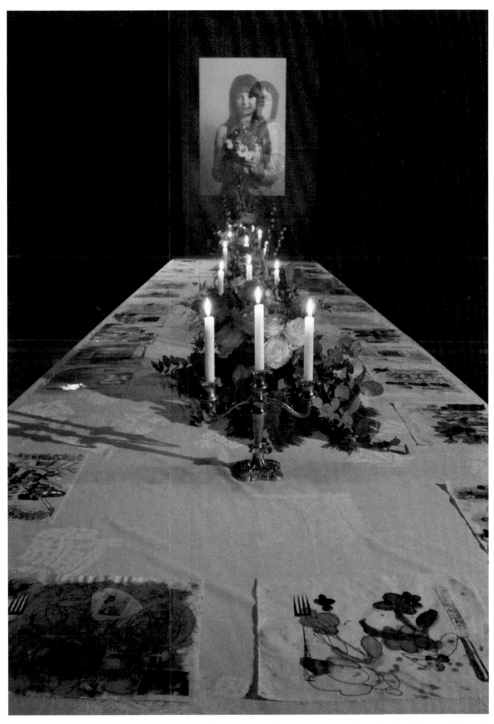

▲ Rocket Artists, University of Brighton students and staff
Remembrance project
Photographs, flowers, visual art
2009

Made in response to the death of the much loved, inspirational Rocket Artist Andrew Apicella.

How can Inclusive Arts work explore themes such as sex, sexuality, nudity and death?

There are few taboos that the art world in general has not transgressed. However, for learning-disabled artists, love, sex, sexuality, nudity and death are aspects of existence that often remain taboo within the context of their everyday lives in social care settings. We think challenging work that seeks to explore such aspects of human existence is important and should not be shied away from. Obviously, trusting relationships need to be established that ensure any work is beneficial rather than exploitative, and there might be other logistical, ethical and behavioural considerations. However, we do not think work should avoid supposedly sensitive or taboo topics just because some of the people we work alongside have complex communication needs. Otherwise we risk reinforcing the social position of learning-disabled people whose human rights, including sexual rights, have historically been ignored and whose loving relationships have been trivialized (Goodley and Moore 2002, p. 121).

Music, performing and visual arts can help to give recognition and validation to the role of love and sex in the lives of learning-disabled people, and in doing so also push at the frontiers of art. Some groups have used their performance art as a form of direct advocacy. For example, the Lawnmowers group in Newcastle and Inventura in Prague have explored the sexual and political rights of learning-disabled people in their productions, while Alice Fox has led life drawing work with learning-disabled people in which the most important aim was to develop the confidence of the group to feel comfortable looking at nudity. During another piece of work, Alice helped facilitate an exploration and commemoration of deaths of residents that the Rockets were having to confront in their care home environments. Here love, death and memory intertwine in the work – accessible themes to which all humanity can relate.

▶ John Cull
Rocket Artists
Untitled
Pastel on paper
2010

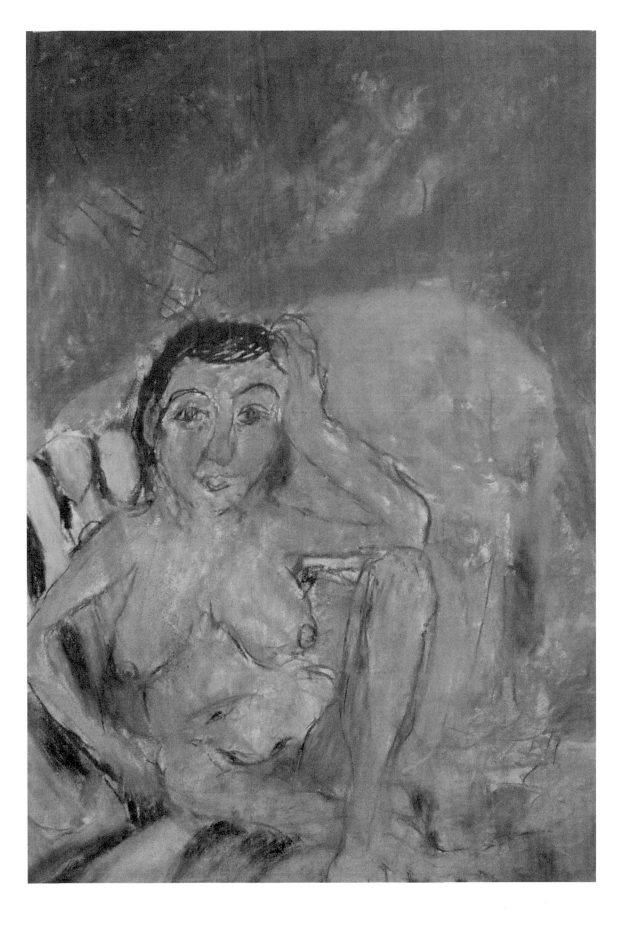

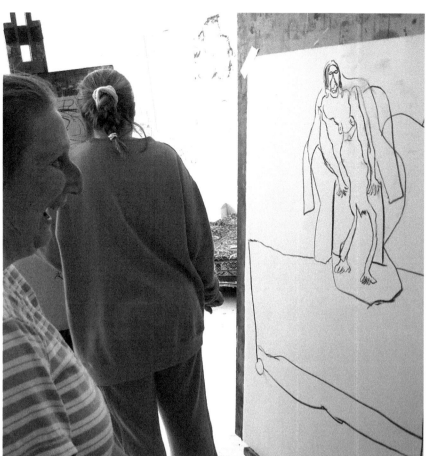

Rocket Artists
Life drawing

This page
Patricia Morgan,
Desmond Lake,
Louella Forrest

Facing page
Left to right
Shirley Hart,
Louella Forrest,
Louella Forrest,
Desmond Lake
2004

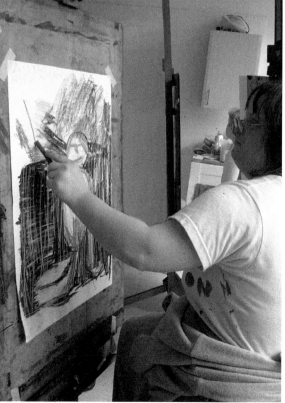

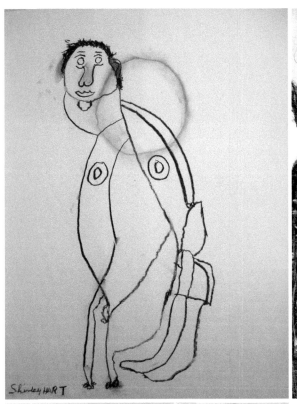
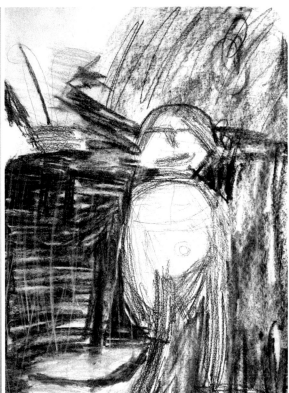
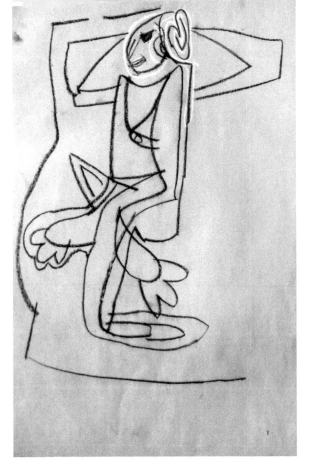

As part of any desirable future for Inclusive Arts, we hope for more transformative spaces of encounter and exchange that are nurturing of 'everyday epic' moments and open to all. We envisage a future that embraces difference and welcomes the life-affirming antagonism and dissonance of truly inspiring, accepting and intimate work.

Alice Fox and Hannah Macpherson

▶ Rocket Artists
Rockets Mean Business
Photo Peter Gates
2012

191

What this part of the book is about

- Learning-disabled artists, their art organizations, art partners, curators and gallery directors tell us what they hope for the future of Inclusive Arts

- We talk about training and jobs for learning-disabled artists

- We also talk about the rights of everyone to be treated with dignity and respect and to have creative and educational experiences

Who decides who's included?

References

Arts Council (2005) 'Mapping Learning Disability Arts in the North West', London: ADA inc. with Jo Verrent/UK Arts Council Publications. www.artscouncil.org.uk/media/uploads/documents/news/phpyrxhga.pdf

DH (2001) 'Valuing People: A New Strategy for Learning Disability for the 21st Century', White Paper, Cm 5086, London: Department of Health. www.gov.uk/government/uploads/system/uploads/attachment_data/file/250877/5086.pdf

DH (2009) *Valuing Employment Now: Real Jobs for people with Learning Disabilities*, London: Department of Health Publications.

Goodley, D. and Moore, M. (2002) *Disability Arts against Exclusion*, Birmingham: British Institute of Learning Disabilities Publications.

Freire, P. (1972) *Pedagogy of the Oppressed*, London: Penguin.

Mencap (2008) 'The arts and people with profound and multiple learning disabilities (PMLD)', London: Mencap (accessed 18 July 2014). www.mencap.org.uk/sites/default/files/documents/2009-12/2008.292%20The%20arts%20and%20people%20with%20profound%20and%20multiple%20learning%20disabilities.pdf

Mencap (2009) 'Youth Arts Consultation: Young People with a Learning Disability', London: Mencap (accessed 18 July 2014). www.mencap.org.uk/sites/default/files/documents/Youth%20Arts%20Consultaion%20England%20(1)_0.pdf

Nussbaum, M. (2003) 'Capabilities as fundamental entitlements: Sen and social justice', *Feminist Economics*, 9(2/3): 33–59.

Rawls, J. (1971) *A Theory of Justice*, Cambridge, MA: Harvard University Press.

Roulstone, A. and Morgan, H. (2009) 'Neo-liberal individualism or self-directed support: Are we all speaking the same language on modernising adult social care?', *Social Policy and Society*, 8(3): 333–345.

Change (2010) 'Talking about sex and relationships: the views of young people with learning disabilities', http://disability-studies.leeds.ac.uk/files/library/change-final-report-read-copy.pdf (accessed 1st September 2014).

▶ Kelvin Burke, Jo Offer
Rocket Artists
What next?
Thinking about the future, making plans for more work together
2014

Future

How you think?

Permissions

We are grateful for permission to reproduce the following images:

Page xvi Corali and Rocket Artists, Smudged, photography Andrew Kingham and Rocket Artists.

Page 3 Stopgap Dance Company, Trespass, photography Hugo Glendinning.

Page 4 Glad Theatre, The Shadows, photography Morten Sletten.

Page 5 Station 17, photography Thomas Liehr. Side by Side performance, Bethan Kendrick, photography David Fernandes.

Page 8 Tina Jenner, Rocket Artists, photography Peter Gates.

Page 9 Ntiense Eno Amooquaye, Intoart, photography Josef Konczak.

Page 10 Wild Things 3 CD cover, www.saywhatmedia.co.uk. Rocket Artists, Going Places, photography Jane Fox, Kelvin Burke, Jo Offer.

Page 13 Desmond Lake, Rocket Artists, photography Peter Gates.

Page 14 Restless Dance Theatre, photography Shane Reid, performers: Andrew Pandos, Caitlin Moloney, Nigel Henderson.

Page 15 Louella Forrest, NHS, photography Peter Gates.

Page 20 Joseph Gregory, Rocket Artists, photography Peter Gates.

Page 21 Heavy Load, photography Morgan White, performers: Simon Barker, Micheal White, Jimmy Nichols, Paul Richards.

Page 22 Rocket Artists, Measures of Bodies, photography Andrew Kingham.

Page 24 Rocket Artists, 'No' Apron, photography Peter Gates.

Page 26 Project Art Works, photography Alice Jacobs.

Page 39 Rocket Artists, Measures of Bodies, photography Andrew Kingham.

Page 43 Louella Forrest, Rocket Artists, Side by Side exhibition, photography David Fernandes.

Page 52-53 Side by Side performance curation, photography David Fernandes.

Page 56 Side by Side delegates' bag, Rocket Artists, photography Peter Gates.

Page 57 Andrew Pike, KCAT, Side by Side symposium, photography David Fernandes.

Page 58-61 Side by Side symposium, Stephen Clarke and Tom Stubbs, JUMPcuts.

Page 68 Rocket Artists, photography Jane Fox. Ntiense Eno Amooquaye, Intoart, photography Josef Konczak.

Page 71 Judith Scott, Creative Growth, photography Ben Blackwell.

Page 99 Rocket Artists, Remembrance Project, portrait photography Andrew Kingham.

Page 106 Dean Rodney (also page 107) photograph by Pau Ros. Mark Williams (also page 107) photograph by Caroline Purday. Declan Kennedy and Andrew Pike, KCAT (also page 112) photography by KCAT. Kate Adams, Project Art Works (also Page 115) photography by Project Art Works. Charlotte Hollinshead (also page 122) photograph by Shelley Davis. Bethan Kendrick and Jacobus Flynn, Corali, photography by Corali.

Page 108 Dean Rodney Singers, photography Pau Ros / artwork Adele Jeffs. Dean Rodney Singers installation, photography Tim Mitchell.

Page 114 Andrew Pike, KCAT, animation still, photography by KCAT.

Page 124 Action Space, Tennis balls, photograpy by Charlotte Hollinshead.

Page 126 Nnena Kalu, Action Space, photography Charlotte Hollinshead.

Page 129 Corali, photography Sabine Pfluger, performers: Jackie Ryan, Bethan Kendrick, Housing Hassan (DJ), Graham Evans.

Page 132 Rocket Artists, Measures of Bodies, photography Andrew Kingham.

Page 136 Rocket Artists and Corali, Smudged, photography Andrew Kingham and Rocket Artists.

Page 137 Louella Forrest, Rocket Artists, NHS pouches, photography Peter Gates.

Page 150-151 List of 50 social impacts, François Matarasso, rgu.academia.edu/françoismatarasso. Reproduced by kind permission.

Page 152 Five Value Clusters, Wolf Brown. Re-visualized with kind permission by Peter Gates.

Page 156-157 Rocket Artists, Measures of Bodies, photography Andrew Kingham and Rocket Artists.

Page 159 Rocket Artists, Overalls, photography Jane Fox.

Page 166 Edmond Brooks-Beckman and Louella Forrest, Rocket Artists, Overalls, photography Andrew Kingham.

Page 169 Arty Party Performance Group, photography Chris Nottingham, 7 Studios. Performers: Chloe Shepherd, Mervyn Bradley.

Page 170 Sarah Watson, Wild Things 3 Jukebox, photography David Fernandes. John Mullins, Trisha Donnelly, Creative Growth, photography by Creative Growth.

Permissions

Page 171 Station 17, photography Chantal Weber. Stopgap Dance Company, The Awakening, photography Chris Parkes, left to right: Hannah Sampson, Nadenh Poan, Chris Pavia, Amy Butler.

Page 172 Graeae Theatre Company, Bent, photography Patrick Baldwin, performers: David Ellington, Milton Lopes. Ich bin O.K photography Bernhard Kummer, performers: Hana Zanin, Anna Prokopova, Johanna Ortmayr, Clara Horvath. Ailbhe Barrett, Mayfield Arts, photography Mayfield Arts.

Page 173 Angela Burchill, Mayfield Arts, photography by Mayfield Arts. Zach Frith, First Movement, photography by First Movement, Clifton Wright, Intoart, photography by Intoart.

Page 174 Echoes project, Simon Walker, Friction Arts, photography Chris Keenan. Ntiense Eno Amooquaye, Intoart, photography by Intoart.

Page 175 Heavy Load, photography Morgan White, performers: Simon Barker, Micheal White, Jimmy Nichols, Paul Richards, Mick Williams. Candoco Dance Company, Notturnino, photography Benedict Johnson, performers: Konstantinos Papamatthaiakis, Rick Rodgers, Andrew Graham. Sarah Pickthall, Andy Kee, Cusp Inc., by Danny Weinstein

Page 176 Epic Arts, photography Dan Cordell.

Page 177 Michael Smith and Tom Stubbs, film stills by Stephen Clarke, Biggerhouse Film. Oily Cart, Pool Piece, photography Patrick Baldwin. Arendjan Talstra, Kunstwerkplaats, photography Kunstwerkplaats. Cameron Morgan, Project Ability, photography Bérengère Chabanis. Pria Arts, photography Eve Turner-Lee. Restless Dance Theatre, photography Shane Reid, performers: Caitlin Moloney, Chris Dyke.

Page 178 KCAT Art and Study Centre, photography Declan Kennedy. TV Glad, photography Eric Norsker.

Page 179 Inventura, photography Radek Hlaváček, film stills from the film 'Earthlings, who are you voting for?' Director Linda Kallistová Jablonská and Inventura team.

Page 181 Inventura, drawing by Šárka Hojaková.

Page 185 Rocket Artists, Remembrance Project, photography Andrew Kingham.

Page 191 Rockets Mean Business, photography Peter Gates.

Page 199 Patricia Morgan, Rocket Artists.

Cover: Rocket Artists 'Suspected of what?' photograph by Peter Gates. Left to right: Kelvin Burke, Jo Offer, Joseph Gregory, Alice Fox, Louella Forrest.

All other photography (pp.17,18, 27, 29, 36, 40, 44, 45, 46, 49, 51, 55, 78, 84, 88, 90, 92, 93, 95, 104, 138, 139, 144, 145, 147, 187, 188, 189, 198, 199) by Rocket Artists. Illustrations by Kelvin Burke and Jo Offer

▶ Patricia Morgan
Rocket Artists
Untitled
Acrylic on board
2004

Every effort has been made to obtain permission to reproduce copyright material. If any proper acknowledgement has not been made, or permission not received, we invite copyright holders to inform the publishers of the oversight.

198

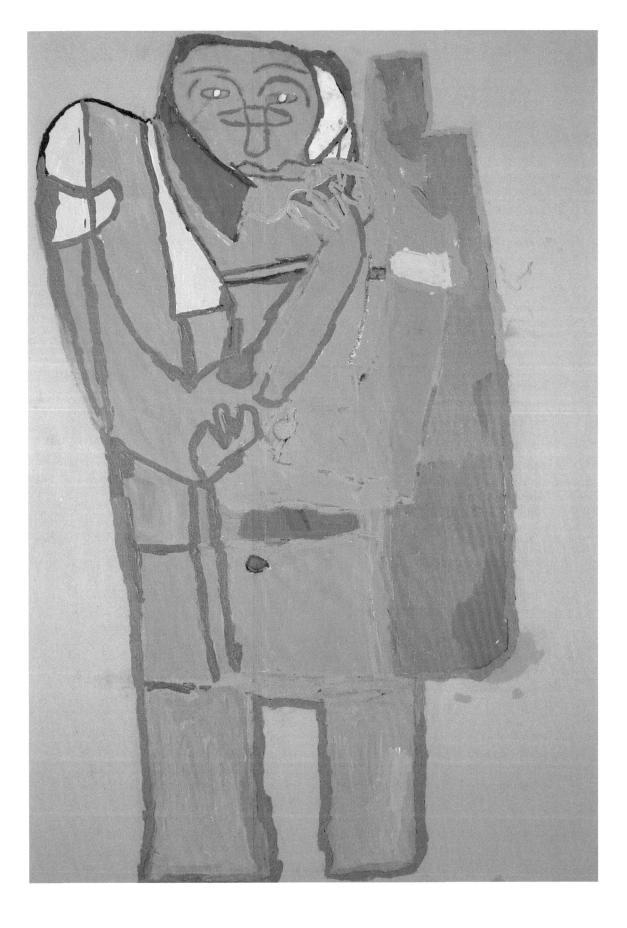

Index

Page numbers in **bold** refer to figures.

Index

Index

Index